a short life of trouble

The publisher gratefully acknowledges the generous contribution to this book provided by Ann Hatch.

The publisher also gratefully acknowledges the generous support of the Art Endowment Fund of the University of California Press Foundation.

a short life of trouble

forty years in the new york art world

marcia tucker

edited, and with an afterword, by liza lou

UNIVERSITY OF CALIFORNIA PRESS
BERKELEY LOS ANGELES LONDON

University of California Press, one of the most distinguished university presses in the United States, enriches lives around the world by advancing scholarship in the humanities, social sciences, and natural sciences. Its activities are supported by the UC Press Foundation and by philanthropic contributions from individuals and institutions. For more information, visit www.ucpress.edu.

University of California Press
Berkeley and Los Angeles, California

University of California Press, Ltd.
London, England

Marcia Tucker's comments on the New Museum's beginnings on pp. 133–35 are a revised version of an interview, "Empowerment and Responsibility," by M. Pachmanová, *n.paradoxa* online issue 19 (May 2006); her remarks on Tehching Hsieh on pp. 162–63 are excerpted and reworked from her essay "No Title" in *Buddha Mind in Contemporary Art*, edited by Jacquelynn Baas and Mary Jane Jacob (Berkeley: University of California Press, 2004).

The epigraph on p. 138 is used by permission from "Lubbock Woman," lyrics by Terry Allen, Copyright 1977, Green Shoes Pub., BMI. The lyrics on p. 139 are from Rosalie Sorrels's adaptation of U. Utah Phillips's "Starlight on the Rails," On Strike Music, BMI. All photography credits appear on page 215.

Every effort has been made to identify and locate the rightful copyright holders of all material not specifically commissioned for use in this publication and to secure permission, where applicable, for reuse of all such material. Credit, if and as available, has been provided for all borrowed material either on-page, on the copyright page, or in an acknowledgment section of the book. Any error, omission, or failure to obtain authorization with respect to material copyrighted by other sources has been either unavoidable or unintentional. The author and publisher welcome any information that would allow them to correct future reprints.

Library of Congress Cataloging-in-Publication Data
Tucker, Marcia.
 A short life of trouble : forty years in the New York art world / Marcia Tucker ; edited and with an afterword by Liza Lou.
 p. cm.
 Includes index.
 ISBN 978-0-520-25700-9 (cloth : alk. paper)
 1. Tucker, Marcia. 2. Art museum curators—United States—Biography.
3. Art critics—United States—Biography. I. Lou, Liza, 1969– II. Title.
 N406.T83A3 2008
 709.2—dc22
 [B] 2008013976

Manufactured in the United States of America

17 16 15 14 13 12 11 10 09 08
10 9 8 7 6 5 4 3 2 1

The paper used in this publication meets the minimum requirements of ANSI/NISO Z39.48-1992 (R 1997) (*Permanence of Paper*).

FOR RUBY

Everybody has a plan until you hit them.

MIKE TYSON

contents

PROLOGUE / 1

ONE / 1945–1956 / 3

TWO / 1957–1959 / 13

THREE / 1960–1962 / 26

FOUR / 1963–1964 / 46

FIVE / 1965–1968 / 65

SIX / 1969–1970 / 79

SEVEN / 1970–1974 / 91

EIGHT / 1974–1976 / 108

NINE / 1977–1980 / 120

TEN / 1980–1983 / 138

ELEVEN / 1983–1984 / 149

TWELVE / 1984–1993 / 160

THIRTEEN / 1994–1995 / 175

FOURTEEN / 1997 / 183

FIFTEEN / 1998–2004 / 191

AFTERWORD BY LIZA LOU / 199

AUTHOR'S ACKNOWLEDGMENTS / 205

EDITOR'S ACKNOWLEDGMENTS / 207

INDEX / 209

CREDITS / 215

PHOTOGRAPHS FOLLOW PAGE / 152

prologue

Works of art are like people. Some you don't feel like spending time with after you've met. Others seem interesting, but you're overscheduled and don't want to make any more commitments. You can always look them up later, right? Once in a while, you fall madly in love and have a wild affair—until someone else comes along and steals your heart. And sometimes you become friends and the friendship grows and deepens and lasts a lifetime.

The work I like most is always the art I don't understand—the stuff that sticks in my mind but eludes me in every other way. It nags at me, making sure that when I least expect it, it'll interrupt my dinner or my sleep with stupid questions, like "Why do I make you uncomfortable? Why can't you just accept me as I am?"

As with people, I've made errors of judgment, mostly because I have a predilection for the margins. I always feel that the margins tell you more than the center of the page ever could.

Loving the margins is risky, because you're not only in unfamiliar territory, but often in hostile terrain as well. Studio visits are particularly fraught with hazards when the work is a radical departure from anything you've seen before. I never made the mistake of oohing and aahing over the space or asking where I could get one of those adorable little lamps before even glancing at the work on the walls. But I did walk into an artist's studio

and look around in confusion for his work, only to find that the enormous table I'd thrown my coat on was the art.

It takes a while to get the hang of it, to learn to listen carefully to what an artist is saying, to suspend judgment, to avoid thinking about whether or not you can "use" the art you're looking at. When I first started going to studios, I was looking for work that met my own terms, even if I couldn't quite define them. But after a while, I realized that I was approaching the whole enterprise from the wrong end. I needed to find out what the work's terms were, and then see if I could stretch my own understanding to meet them.

one: 1945-1956

My mother, Dorothy, whom everyone called Dora, had the even features of a classical goddess—cool hazel eyes, a generous mouth with teeth like ivory Chiclets, a flawless vanilla and peach complexion, and a sprinkling of pale freckles across her perfect, straight nose, all deliciously framed by a mass of copper hair. Her Pre-Raphaelite proportions—tiny waist, long legs, generous bosom, graceful arms and hands—made anything she wore look as though it had been designed just for her.

I, on the other hand, came into my classic middle-aged Jewish lady looks early on. My body, by the time I was twelve, pot-bellied, with tiny shoulders, skinny arms, and spindly, knock-kneed legs, looked like the result of an alien abduction. My face, hidden behind thick black harlequin-shaped rhinestone-studded glasses, wasn't exactly what I'd hoped for, either. I was cursed with incisors that had been pushed outward because too many teeth crowded my undersized mouth, and the only advantage to my vampirelike fangs was that I could use them to scare my little brother. When my upper lip began to look like corrugated cardboard, I got braces, the kind that turned my mouth into a small arsenal of double and triple rubber bands that stretched from top to bottom, front to back, and could snap loose without warning to strike anyone unlucky enough to be in the vicinity. I wore the fist-sized iron maiden from the time I was fourteen until I was a sophomore in college, with a single break for my senior prom, courtesy of

my kindly orthodontist, with whom, of necessity, I'd developed an intimate, long-term relationship.

As for my nose, I discovered it one day while standing in front of my mother's blue glass vanity table, looking into the big round mirror that housed her face as she put it on each morning. Trying to figure out if lipstick and a pair of tweezers could make me as beautiful as she was, I picked up a little handheld mirror and swung it around experimentally, catching sight of my profile. It was a vision for which years of full-frontal mirror gazing had left me hopelessly unprepared. As if summoned by my shock, my mother appeared behind me, her hair a fiery halo framing her exquisite face. A long moment of silence, then a discouraging sigh. "You'll grow into your looks," she said.

She was right—now my looks fit me perfectly.

Looking at the tiny black-and-white images that are proof of my lineage, I'm torn between envy at my mother's charm and self-assurance and another sensation that's somewhere between longing and despair. My mother, while beautiful and glamorous, was also our day-to-day disciplinarian, which made it tough to get close to her. She could find fault with anything: my nails were dirty, my hair wasn't combed properly, my posture was bad, I made noise when I walked. Still, I was in Olympic training to win her affection, which I did whenever I brought home straight A's, dressed according to her specifications, or cleaned my room perfectly. Otherwise, I had the sinking feeling that once again I had failed to place.

———

In 1953, going to Miami Beach was as exotic as going to the moon, only better because it was in Technicolor. In the taxi, windows down, we sped along avenues lined with palm trees, their leaves gently flapping in the breeze like the wings of prehistoric birds. Broad boulevards with sprawling cotton-candy-colored art deco hotels and apartment houses whizzed by. The streets teemed with fat, pink-faced men in tropical shirts sporting blondes, bare-legged and tanned, on their arms. My parents, my brother, my grandmother, and I were staying at the rose and white Delano Hotel, which glistened in the heat like a strange, somnolent monster. I was sharing a room with my grandmother, who was "recuperating." I didn't know what that entailed, but it couldn't have been all bad, because it meant that I had her all to myself.

Grandma Ida was a big-bosomed, deceptively stern-faced woman who had emigrated from Russia with my Grandpa Jake, and re-created, as best she could, the comfortable Old World in the midst of a modern, unfamiliar new one called Brooklyn. She would emerge from a kitchen filled with delicious smells, parting the noodles that were drying in long strands overhead, to take me in her arms and cover me with kisses. Then she'd perch me, triumphant, on a tall stool next to her to help cook.

My grandmother was as full of praise as my mother was critical.

"Get your hair out of your eyes!" my mother nagged.

"*Tatteleh,* what beautiful curls!" my Grandma would crow.

"Why can't you stand up straight?" my mother complained.

"*Kenna hurra,* she's so graceful, like a little ballerina," Grandma parried.

"What on earth do you think you're wearing?" my mother wailed, one of her favorite laments.

"That dress is almost as gorgeous as you are," Grandma would say, even though it sagged hopelessly on my skinny frame.

My grandmother was clearly the only person in the world who understood me. And here we were, alone together at last, in our very own pink and cream wallpapered room, with pale green silk curtains on the windows overlooking the pool, flamingo-shaped bedside lamps, and a turquoise and yellow floral rug covering the cool expanse of floor. Giggling, I pulled my pajamas from my suitcase. "Which ones do you like better?" I asked, holding the ballerina pair in one hand and the clowns in the other. I heard her laugh, and as she turned, half-undressed, to answer me, I saw that where there should have been a breast, the left side of my grandmother's chest was an enormous plane of raw scar tissue. I stopped mid-sentence, my jaw gaping and terror flooding my body, but she came toward me and, taking my hand in both of hers, said gently, "This you should worry about? This is nothing. I had cancer, now it's gone. See? The scar gets better every day!" And lifting her arms to do a little dance, she sing-songed, "I can move almost as good as before!" She put her arms around me to give me a gentle kiss, and then slowly put her nightgown on, but not before I had a chance to take a really good look at what wasn't there.

The image of my grandmother smiling down at me engraved itself on my retina, crisp and bright. While I saw the scars as clearly as I saw her sweet smile, they didn't fill me with dread. They were just there, that's all.

When my parents were courting, my father wrote to my mother almost every day. He called her his "dear, dear Crackerjacks." He reassured her that the long wait—seven years!—till he finished law school and they could get married was worthwhile. But by the time they were married and had kids—first me and, five years later, my brother, Warren—the longing they'd once felt for each other had stretched thin and was weaving itself into a pattern of frustration and disappointment. The biggest tension between them was the question of money, which my parents seemed to talk about with more animation than anything else.

My mother wanted my father to be successful, and he tried to please her, to bring a smile back to her face. But making money took work and time, a lot of it, and there was never enough of either to fill the void. My father worked constantly, and my mother didn't take to being a housewife. She was never a great reader, which would have helped to fill the lonely hours, and she was partially deaf, which isolated her even further, and at that time hearing aids were as yet imperfect and, anyway, far beyond her means.

She was a mediocre cook for whom supper was a package of frozen blintzes, the insides still chilled to a crunch, or a gray flank steak that had spent its final hours bleeding wearily into our sink. My mother wasn't much on the playground front, either. I don't remember her ever playing with me or my brother when we were little. She was obsessively meticulous but hated housekeeping, a contradiction that was guaranteed to keep her on edge. She must have been bored silly, stuck at home day after day with two kids and nothing more than an occasional mah-jongg game to challenge her mind.

The summer I was twelve, we left our little apartment in Brooklyn and moved to the other side of the world—Upper Montclair, New Jersey. It was a tiny ranch house with a yard, only a few houses up from the much less prestigious lower Bloomfield town line, but to my dad, ownership of a house in the suburbs was a firm step up the social ladder into the middle class. My parents seemed thrilled to be out of Brooklyn and loved the extra room, the screened back porch and little yard, and the fact that the house was theirs. They slowly began to make new friends. Most kids, however, don't do well with change, and my brother and I were no exception. My brother became increasingly withdrawn, and I began to write a daily litany of woes that ultimately became dozens of journals I kept in order to make sense of my life.

The one thing none of us counted on, especially my mother, was that within a year of moving, she was hospitalized. When she was released two

weeks later, it was as though she had left her heart, mind, and body behind. No matter how much I begged my father to tell me what was happening, he kept silent. I'm sure that he and my relatives thought it was better not to tell the children, ostensibly to spare us the pain of that knowledge, but it did the opposite. Not knowing kept us in a state of perpetual fear and uncertainty.

Rummaging in her drawers one day when she was at the doctor's, I found part of the answer. There, tucked away behind a pile of girdles and stockings, was a beige brassiere with wide straps and an empty inner pocket on one side. Lying next to it were the rounded foam shapes that matched the pocket. They looked practical and ordinary, but I recoiled, deeply unsettled. I knew instantly that my mother had lost a breast, but I still didn't know what that meant. I didn't know that she had breast cancer or that she'd just had a radical mastectomy, a painful, crippling operation in which they removed the breast, the lymph nodes, and the muscles of the chest wall. I didn't know that the follow-up treatment was massive doses of radiation and steroids.

Within months of beginning treatment, my mother went from a slender, melancholic beauty to a bloated, disfigured bundle of nerves, her hair lying over her forehead in sparse strands, her life in shreds. For most of the day, she sat hunched at the kitchen table, staring into space, her useless arm straining to burst its sleeve, her chin propped in her good hand. My own adolescent body was just beginning to take shape while my mother's was falling apart, and my stomach was chronically twisted with guilt. I was sure that it was all my fault.

My father found his escape in his work and in books, and I learned to do the same. At twelve, I wanted so much to be my father's pride that I went straight to the bookcase whenever I had a spare moment. The mahogany console in our living room was crammed with literary goodies. Dozens of red and gold volumes of *The Encyclopaedia Britannica* marched neatly along the bottom shelves, and one level up was a set of identically bound books by Poe, Hawthorne, Swinburne, Milton, Pope, Swift, and Dickens. When I had read just about all the books we owned, I moved over to the Montclair library, determined to read every single volume in it, starting with the A's. My eyes were bigger than my abilities, and I soon began to select what caught my fancy. The range of books I read was broad and included everything from *Anne of Green Gables* to *Beowulf* to *The Fountainhead* to *The Invisible Man*. Every few days, the librarian happily loaded me down with books to take home. One day, when my mother saw the toppling pile I was

carrying and realized I was actually reading all those books, she forbade me to read more than one book a day, because she said I was ruining my eyes. This measure was to no avail, since I would read during the hours that she thought I was doing my homework and I would stay awake until she was asleep in order to continue to read, eventually fulfilling my mother's prophecy—I ruined my eyes. That's how I came to add the thick glasses, constantly slipping down my big nose, to a face that already sported a mouth full of crooked teeth, wires, and rubber bands.

I had long hair, chewed gum, spoke with a pronounced Brooklyn accent, and was more interested in shooting marbles or linoleum guns in a corner lot than I was in boys or clothes. Kids at school called me "Turtle," "Four-Eyes," and "Swamp." I may not have been beautiful, but I was popular in my own way. I formed the Ugly Club with my closest misfit friends. The Ugly Club had card-carrying members (I made the cards, each with a personal caricature), officers (the positions rotated among the founders every few months), and a theme song parodying the one the Mouseketeers were famous for: "U-G-L Y-C-L U-B ugly too! / Ugly Club! Ugly Club! / Forever we will hang our noses low, low, low, low! / Come along and sing our song and join the Ugly Club! / U-G-L Y-C-L U-B ugly too!" Well, *we* thought it was clever, and after one blowout Ugly Club party, everybody started clamoring to get in. "Vengeance is mine," saith the teenage reject.

I can see our family unit, circa 1953, sitting in front of the television in the burnt-orange and avocado-green living room of our new house, just after everything has been unpacked and we are settled in. Warren is perched on a hassock, forefinger permanently lodged in his mouth even though he's eight years old. My own gangly body is slouched on the spotless shag rug, and my parents are settled behind me on the plastic-covered sofa. It's Sunday night and we're watching Ed Sullivan, which always puts us in a relatively good mood. My mother, hairbrush in hand, begins to untangle the knots in my uncontrollably curly hair. Her task accomplished, she unexpectedly continues to brush, lulling me into a stupor of pleasure and relief. "She loves me, she loves me not," I chant under my breath as the brush smoothes the curls. "She loves me, she loves me not." I want *The Ed Sullivan Show* to last forever, or at least long enough so that when she stops it will be on the right phrase.

I desperately want things to work out. I want my parents to be in love with each other. I want my mother to smile, I want my father to be rich and

my brother to stop crying. I want to be pretty and popular, too, but I know it's not going to happen. I am what I am. We are what we are.

My kid brother was an adorable curly-haired little boy who didn't give my parents any trouble, at least not until they started giving it to him. As a baby, he got a lot of attention, but it didn't last long. He was eight years old when my mother got sick, and no one paid much attention to him after that.

My father hardly ever did the normal things most dads did with their sons. He never coached him or came out to cheer him at a ball game, never took him on a trip, never spent much time with him at all except to make sure that his chores were done, his clarinet practice was perfect, and his homework was finished on time. My brother pleaded with my father to play with him, to do something with him, just the two of them, but my father was too busy. When Warren complained in a small, sad voice that my father didn't love him, the answer was always the same: "What haven't I given you? You have everything—a bicycle, clarinet lessons, good clothes, a room of your own. Why don't you appreciate all the things I've done for you?" And he'd stomp off.

The sicker my mother got, the more my father stayed away. My dad focused his energies on moving our family into the upper middle class, although as a criminal lawyer, no matter how dedicated, he wasn't ever going to make a lot of money. When we lived in Brooklyn, his business came mostly from the Italians who lived on our own block. When we moved to New Jersey, my father's clientele changed from Italian to Jewish, despite the widely held assumption—at least among the Jews—that there were no Jewish criminals. But my father's law practice was always based in our local community. Despite his efforts, some of the people he represented were convicted and couldn't pay him. The ones whose cases he won usually weren't all that well-off either. Years later, my father told me there were times when we were so broke, we didn't have seven cents to buy pepper.

To my mother's disappointment, my father didn't push to look for wealthier clients, nor would he charge more than he thought was fair. He took on negligence and criminal cases of all kinds, explaining to us as we sat in the kitchen watching him reenact the day's trial, "It's about the law, you see. Everyone is entitled to the benefit of a fair trial, and guilt is only determined by a jury of one's peers. Until then, you're presumed innocent." He accepted cases he must have known he couldn't win because he loved the challenge of trying them and believed in the justice system. Sometimes, though, he'd

come home triumphant, full of exuberant goodwill, bearing expensive gifts for my mother that usually involved something made of alligator. Then, at supper, he'd hold forth, reenacting the trial with drama and flair, playing all parts, saving the denouement—the one detail the prosecution had neglected but that my father had caught—for last. Those evenings were a pleasure for all of us, because my father was a good trial lawyer and, by definition, a good actor. He shaped his stories artfully, leaving us in suspense as he left the kitchen for a moment to get a fresh cigar from the humidor.

My father was the first and only lawyer among his colleagues to hire an African American as his junior partner. When Bob Burns joined the firm, I remember my dad telling us that he was losing business because he had hired a black lawyer. He told the clients who complained that he had hired the very best young lawyer he could find, and if they didn't want his services, they could go elsewhere. And they did, at least some of them. But my father held his ground, and his business picked up again once people realized that he'd simply been telling the truth.

I was seventeen years old, and I thought Bob was absolutely the greatest. He wasn't that far from my own age, at least in my estimation—it's easy to feel very grown-up when you're not—and one Saturday at the office after a morning of companionable banter, he invited me out for an evening with some of his friends. They were attractive, middle-class, smart young African American men with advanced degrees, and I was wowed. We went to a jazz club in Harlem, where I had a great time playing the sophisticate, drinking Southern Comfort and pretending I was a jazz aficionado.

I wrote in my journal:

November 27, 1956
My name is still Marcia. Thank God. At least there's one thing I can recognize about myself. I still have dark hair, I still have a large nose and I still have the same general shape, plus about twelve pounds.

I am now a cynical young adult (I use the term loosely) who has come into direct contact with poetry, poets, pseudo-intellectuals, sex, James Joyce, jazz and older men. At times I can see myself as I really am—a childish and vague personality, striving to improve and to live up to standards which have the advantage (a doubtful one) of being different.

I am, to use a cliché, world weary. At any rate, my name is still Marcia.

Bob stayed with my dad for several years, until he left to work in Harlem "to defend his own people," as he put it. My dad threw a farewell party for

him when he left, inviting his lawyer friends and clients, especially the clients who had refused to work with Bob when he first started. Although my father was sad to see him leave, he was happy for Bob. Decades passed before I heard his name again, when he surfaced as "Bobby" Burns, one of the defense attorneys in the 1989 Central Park jogger case. I felt personally let down when he didn't win the case, even though my heart and soul were with the woman who'd been attacked.

My favorite activity from the time I was in kindergarten until I went away to college was to drive with my father to his office on Sunday mornings and wait in the huge musty law library down the hall while he did a half-day's work. Then he would take me to lunch at Schrafft's, where he would buy us hot fudge sundaes and we would catch up on the week, his and mine.

As he locked the office door behind him, he'd point to the opaque glass panel where his name was etched, telling me with a proud smile, "Someday this door will read 'Emmanuel Silverman and Daughter, Esqs.'" In the early 1950s, there weren't too many women lawyers in sight, so his desire to have me as his partner was both unusual and a sign of extraordinary confidence.

In spite of my father's plans for me, I wanted to be an artist. The fact that it never came easily to me was beside the point.

When I was twelve, my aunt gave me a modeling set for my birthday, the kind that came in a long, flat box and had strips of different-colored clay lined up like the fat bars of a xylophone. Two wooden modeling sticks were included in the box, but when I unwrapped the thick plastic and began to play around with the dazzling pliable color, I discovered that the tools were too big for what I wanted to do. I ran upstairs to grab the implements I really needed—pins, needles, and safety pins, whose various-size points could be used to pick up and attach an eye, carve fingers into a tiny hand, or incise waves on a head of hair. The first figures I made were a girl and a boy, each about an inch and a half high. Before I knew it, Saturday morning had become night and I had made over fifty figures.

Each one became increasingly elaborate, acquiring a personality, a function, a wardrobe, and a starring role in my imagination. I was considering branching out into buildings and houses when it occurred to me that my characters were in mortal danger. They could be squashed into oblivion because they were so small that someone might not notice they were there.

Then I had an idea. Why not bake my figures? They might become brittle, but at least they wouldn't get flattened like chewing gum if I accidentally left them out. I knew that a low heat was best—received wisdom from a craft teacher—and so one afternoon when no one else was home I set the oven to 200 degrees, lined up my treasures on a cookie sheet, and put them in to bake. I was very pleased with myself for having worked out a solution on my own.

When the timer pinged, I raced to open the oven. Little puddles of melted color dotted the tray like bright, swirled miniature sugar cookies. With a howl of despair, I collapsed on the kitchen floor. Underneath my grief that day a resolution was hardening into cement: I would never, ever again create something thinking that I would be able to preserve it.

Still, making art was what I liked doing the most and what I thought I was best at, and I never wanted to stop. There was no such thing as time when I was working. My family problems disappeared, my loneliness evaporated, self-consciousness flew out the window. I felt light and energetic and just, well, *there.* When in my senior year of high school I was named Class Artist, I thought my fate was sealed.

two: 1957-1959

When I was thirteen, my mother told me not to act so smart or I'd never have a boyfriend. When I was eighteen, she told me that unless I learned to cook and my ironing improved drastically, I'd be an old maid. Her three positive rules for success were: "Keep your legs crossed, don't wear more than three colors at once, and never go out of the house without a girdle."

In 1957, I was accepted into the art program at the Cooper Union in New York, but my parents felt that the Connecticut College for Women was more appropriate for me. Perhaps it was the school's proximity to Yale, the logical source of suitable husbands, that was so appealing to them, but I felt like an anomaly among all those upper-class, socially acceptable Christian girls.

By my sophomore year, I'd decided that I needed a change from just about everything. I'd had enough of my circle-pinned classmates, the dark library stacks, the bland food. I wanted an adventure, and I knew that it was the last thing in the world my parents would let me have. So I strategized.

First, I applied to go abroad for my junior year, to immerse myself in art history through a program run by Sweet Briar College. France sounded good, especially since French was the only foreign language I'd ever studied and the Paris program satisfied my most important requirement, which was that there be an entire ocean between my destination and New Jersey. When I got the news that I'd been accepted, I called my parents and told

them I wanted to transfer to the University of Pennsylvania. I needed to take more studio art courses, I explained. I absolutely *had* to go to a coed school—the one thing they definitely did *not* want me to do, because they were afraid that I'd lose my virginity prematurely.

No, I told them, nothing was going to change my mind.

I had them worried. Days of frantic phone calls from them had no effect on my decision. When I'd brought the pot to just the right temperature—a degree or two short of boiling—I casually mentioned that I'd been accepted to the junior year abroad program in Paris. No, I didn't want to go, I wanted to go to Penn. Hadn't they understood a *single* thing I'd been saying?

And that's how I came to board the *Mauretania* with my steamer trunk filled with clothes, books, and a year's worth of toilet paper and sanitary napkins, which my mother insisted didn't exist on the other side of the world.

About a week after we landed, I met Henri, an Edwardian-looking, for-real count whose only profession was to be gainfully unemployed. He was solidly built, with thick black hair swept back from a clear forehead, brown eyes that sparkled, a straight nose, and square white teeth in a perfectly shaped mouth, the whole set off by a dashing mustache and a clipped beard that framed his handsome face. Henri was charming and courtly and made me laugh. At an outdoor café in the town of Tours, where our Sweet Briar group attended language school, he proudly told me in French that he had been studying English with some American sailors. "Oh," I said, "that's wonderful. What have you learned so far?" "Fock yoo!" he yelled enthusiastically, which, he said, was what his tutors had taught him was the proper way to say "Thank you." I politely suggested that he demonstrate the remainder of his English phrases in private. Perhaps alone with me? I was interested in honing my own skills, too—linguistic and otherwise. Plus, he was sweet, attentive, indisputably romantic, and from time to time wore a monocle, which I found outrageously sexy.

I left Tours at the end of six weeks for Paris, where I was going to board with a Parisian family, the Egnells, who I'd heard were nice and had a lot of children. Thirteen of them, to be precise—plus two Swedish au pairs, a Spanish cook, a Portuguese housekeeper, and four of us American girls from the Sweet Briar program. They lived in the fashionable 16th arrondissement, in an elegant four-story house with dozens of rooms, each full to bursting with furniture, utensils, people, and activities. It was almost impossible to tell whether you were in the pantry or someone's bedroom,

in the library or in the laundry room. Chaos reigned, but no one seemed to find it at all disturbing, least of all Monsieur and Madame. Still young and openly affectionate, they laughed all the time and seemed to enjoy their rambunctious household, taking pleasure in constantly correcting everyone's French. Madame was barely over five feet tall and looked much too delicate to have produced all those offspring, but she was intense and energetic, darting gracefully from task to task, child to child. Monsieur, tall and serene, was liable to bump into you if you weren't watching out, because he always had his nose in a book. Languages flew with abandon, cultures clashed and melded, kids dripped jam and chocolate, classical music played at all hours. Altogether there were twenty-three of us—twenty-four when we added Henri, who followed me to Paris a few weeks later, having no job to keep him in Tours. He also arrived with no source of income and no place to live. Realizing our dilemma, the Egnells immediately offered Henri a mattress in the *salle de bain,* for which we were both infinitely grateful.

About a month later, they hit on an even better idea. "We know you two would like to have some privacy," Madame remarked, "and we've been thinking that if we gave you the money that your parents are paying us for room and board, you'd be able to find a small apartment together. No one would ever have to know about it." We accepted their offer instantly, me weeping, Henri kissing Monsieur on both cheeks. After a brief search, we found a tiny maid's room on the eighth floor of an apartment building on the Place des Saussaies, near Boulevard Haussmann, just across from the Préfecture de Police.

The walkup was a vertical gym whose habitués could be found collapsed and panting on the upper landings, their groceries dropped like barbells beside them. The apartment itself was a nondescript box, but we furnished it with wooden crates that we found in the street and covered with oilcloth—a big one for our table, two little ones for chairs, and an even smaller one for a nightstand. There was a mattress on the floor with a cheap Indian bedspread, a pail, a broom, a large orange plastic bucket and a smaller yellow one, eating utensils, and two cooking pots from the Marché aux Pûces.

We were a household. The room's best feature was a single small window, high up, with a partial view of the Paris rooftops. My mother would have airlifted me out of there immediately if she'd seen the *chiotte à l'anglaise,* as they called the tiled hole in the floor and two footrests that our entire floor shared. That toilet never worked properly, and I resorted to wearing rubber boots to avoid getting soaked from knee to ankle when I flushed. The

tank leaked from above, too, so I added a rain hat before trudging down the hall with my flashlight each morning. The only other amenity was a sink with a wire mesh grating over it, so that you could get water from the faucet but couldn't wash anything directly in the basin. At night, we filled our two buckets and washed the dishes first, then our clothes, then ourselves, and went to bed by candlelight, shivering under the thin covers. My parents' room and board money was enough to cover the rent, but there wasn't a lot left over for food, so we lived largely on a diet of beer and French fries.

I found a part-time job working for the editor of the Club des Livres Chrétiens, translating Negro spirituals—music that I loved—from English to French for an illustrated publication. I adored everything about the job, even the apartment where we worked. The editor's wife was an interior decorator, and she had painted their walls in brilliant shades of scarlet, cerulean, and lime green and then let their three young children loose, giving each of them a wall of their own to paint. I thought the results were spectacular.

Henri also found temporary work in an office, a feat we celebrated by spending his first paycheck before he'd even received it. The job didn't last long enough to see a second one. He only had one white shirt, and every night I'd wash it and hang it up to drip dry for the next morning. One evening, cold and exhausted, we fell into bed without supper, and in the morning I was mortified to find that I'd forgotten to wash the shirt. He missed work that day, but he begged me not to worry about it and even made it a holiday by accompanying me to class at the École du Louvre. When he showed up at his job the next day, though, they dismissed him. I can't imagine that the single absence did it, but I bore the burden of guilt the rest of the year. It never occurred to me that he could have washed his own shirt or even worn it dirty that one time. It was still the 1950s, and I was madly in love.

I didn't see money as an issue, anyway, probably because we didn't have any. I went to art history classes, took French at the Alliance Française, and studied life drawing at the Académie de la Grande Chaumière.

From time to time, my parents would call me in the early morning at the Egnells', whose generosity went so far as to propel Madame into her tiny Deux Chevaux and send her speeding across town, where she'd race up the eight flights of stairs and knock on our door with the announcement, *"Mar-CEE-ah, tes parents!!!"* She'd hustle me down to the car, stuff me into the seat next to her, and off we'd career, back to the 16th, where I'd call my parents

and pretend to have just woken up after a long night of studying *l'école de David.*

My year abroad changed me in ways both trivial and profound. First, my looks. The week after I arrived in Paris, I decided to get a new hairdo so no one could ever suspect me of being an American. I went to a local salon, where they teased and ratted my hair into an immense, towering cone, its outer layer smoothed and lacquered into place. I was instructed to wrap my head in tissue at night, and I faithfully followed orders, using some of the many rolls of toilet paper my mother had sent along with me. Once every two weeks, I'd visit the salon to have the precarious cone adjusted, a process that was more like medieval martyrdom than a beauty treatment. After a few months, I gave up and Henri and I spent hours untangling one small section of snarl until my head was sore, but at last it began to look more like human hair than an osprey's nest.

My new hairdo may have prevented me from being identified as an American, but it did nothing to change my looking Jewish. It was 1959, the year that anti-Semitism hit France with gale force and the war in Algeria raged out of control. One morning, I walked out of my building on my way to the métro, and saw in huge red letters on the wall opposite, *"MORT AUX JUIFS! JUIFS EN IS-RAEL!"* This was crowned by a big, dripping black swastika. I froze. Why would they suddenly want the Jews dead? Or at the very least, according to the sign, back in Israel? I felt as though I'd been fogged in, isolated in a cocoon of work and romance, and here I was, suddenly blinded in the headlights. I hurried to get a paper, but there wasn't anything in the news to help me make sense of it. Over the next few weeks, swastikas and anti-Semitic slogans began to appear everywhere, blinking on one after another like lights on a Christmas tree.

One Friday evening, just after the editor had paid me, Henri and I decided to splurge, taking the métro to a popular student bistro for dinner. It was one of many restaurants in a long, narrow courtyard in Saint-Germain specializing in cheap steaks (in other words, horse meat), French fries, and salad. The communal tables were crowded with people chattering, laughing, guzzling carafes of red wine, unwinding after the workweek. We shared our table with about a half dozen young men and women, the women in bright dresses, heavy makeup, and lots of jewelry, all of them talking animatedly in heavily accented French.

We said hello briefly and were concentrating on our meal when an enormous wet mass hit my cheek with enough force to topple me into the person next to me. Shocked, I turned to see what had happened. At the next table, a group of students were on their feet, balling up their napkins and dousing them in their water glasses, screaming, "*SALE JUIVE! Putain! Vas te faire foutre!*" ("Dirty Jew! Whore! Go fuck yourself!") as they hurled the balls at me, their faces twisted with hatred. Henri stood up, pale, and yelled back at them, "I feel sorry for you, for your ignorance, your blindness, your stupidity. But you'll have God to answer to." He made the sign of the cross, grabbed my hand, and with wet napkins pelting us, we left the restaurant, heads high.

Outside, he put his arms around my shaking shoulders, and when I looked up I realized that there was a small crowd of people standing silently around us, some of whom had been at our table. One young woman held out her handkerchief. A slender, bearded man handed us a brown paper parcel containing the remains of our dinner, which had been paid for. "We're so sorry," they murmured. "They're just children, they don't know what they're saying. Please come and have a coffee with us," they insisted. They led us off down a maze of tiny, cobbled streets to a small café, helped us dry off, and we settled in. They told us that they were Algerians who had originally come to Paris as students and decided to stay. The more we ate and drank and shared stories—about our studies, our families, our backgrounds, our futures—the less important the incident in the restaurant became.

The charming, animated young woman next to me had been telling me about her aunt, who dreamt of going to school but instead had been married at twelve and had five children before she was nineteen. I asked her over the din about her own plans. Was she still a student? What had she been studying? She looked across the table at her companions, who stopped talking for a moment and looked uncomfortable. "Well," she said, "school didn't really work out. We needed to earn money to send home."

"And?" I asked.

"We work at night," she replied, head down.

"Doing what?" I was confused.

Then she looked up, took a breath, and smiled. "We're prostitutes," she said. "The guys look after us, they find us work. Good money, decent hours, and we're all friends. It's not bad. Really." She laughed. "You don't get to choose your customers, but it still beats cleaning house."

We talked until it was time for them to take the métro to Pigalle for work. Hugs and kisses all round, promises to meet again before too long. But we never saw them again.

―――――

My parents began to call more often, urging me to come home. They were frightened and couldn't make sense of what was happening in Paris. Neither could I, but it would have taken more than graffiti and a few wet napkins to get me to leave the country, much less to leave Henri. Instead, I told them that I was going on vacation to see some of Europe till things quieted down, and Henri and I took off for Germany of all places, to visit Dieter, a friend who had moved back to Bad Vilbel, just north of Frankfurt. I told my parents that I was on a camping trip with a girlfriend named Brigitta and neglected to mention that Germany was on the itinerary. No one in my family would ever talk about the war or the Nazis, but I wanted to see Germany for myself and form my own opinion.

I didn't know that, thanks to the giant Jewish Collective Unconscious, I was walking around with a dormant case of the heebie-jeebies (a newer version of "Come the Pogrom"), but it erupted on the train to Cologne. Henri and I were curled into exhausted lumps in our *couchettes* on the overnight train when the door to our compartment was flung open and we were blinded by spotlights. The coffinlike space was suddenly packed with uniformed men, yelling, *"Achtung! Achtung! Passporten! Achtung!"* In a split second, I was a cowering mess, curled into a ball in the corner of my bunk with my hands over my head. By the time I had resumed breathing and the passports had been handed back with apologies for disturbing us, I realized that going to Germany for fun may not have been the brightest idea I'd ever had. But it wasn't like a miniature railroad where the train would just loop back to Paris.

After we arrived, we took a bus to a campground by the banks of the Nidda River, where we set up our mini tent and sleeping bags, went grocery shopping, and, after supper, sat drinking wine by the fire. We breathed the fresh air, watched the stars, and woke the next morning to sunshine and the smell of grass and flowers.

It was a glorious, balmy spring day, and we were like kids let out of school early, exuberant at being out in the country after so many months in Paris

(in my case, in the library). We decided to rent a canoe for a trip on the river and set off gleefully, struggling to keep the little vessel upright and to paddle at the same time. Perched in the back of the boat, I was busy trying to figure out how to use my oar (something I hadn't learned on the streets of Brooklyn), while Henri tried to maneuver us upstream.

And there we were, happily wobbling along the narrow river, the trees above us casting lacy shadows on the water, the birds singing, and the smell of the river filling our city noses with a finer perfume than the Paris streets offered. Up ahead, we saw a picturesque group of fishermen, their round nets and fishing rods extended from the bank, and as we floated past them I raised my hand in greeting, letting go of the paddle briefly. At the same time, Henri dug deeper with his, so that our boat veered sharply into the bank where the group was seated. They were old men in vests and boots, shirts open at the neck, sleeves rolled, with their caps tilted to keep out the sun. We laughed apologetically, trying to steer in the opposite direction, when, without warning, the man nearest us began to shout, lifting his iron-rimmed net and bringing it down with uncanny force on Henri's shoulder. Henri fell over, clutching his paralyzed arm, and within seconds another old man picked up his rod and began to whip at me. The others joined in, screaming in German, beating at us with anything at hand, including our paddles. I was stunned by a blow across the head and fell back heavily over the stern, feeling something wet on my face. I looked wildly around for Henri, who was desperately fighting back with his own oar, and promptly fainted.

When I opened my eyes, I was propped up on a sofa in the campground manager's cabin, the sound of approaching sirens echoing painfully in my ears. Paramedics carried me into the ambulance and, with Henri crouched beside me, raced us to a nearby hospital, where they patched me up, gave me some antibiotics and painkillers, and let me go. Henri had called Dieter, whose parents had a farm outside town. When we reached the hospital door, they were waiting for us in their car. Driving back to the farm, I drifted in and out of a sedated sleep, hearing their conversation but understanding little of the German, except for the word *soldaten*—soldiers—repeated several times. I was taken to a big, soft bed with a down comforter and hand-fed some delicious soup. Then I conked out—for several days.

We spent a week at the farmhouse with Dieter's mother doing her best imitation of my Grandma Ida and his father glancing in at me from time to time with a worried look. Henri healed more quickly from the beating than I did, and although his shoulder was still stiff and painful, he was

mobile. One day, he came back from an excursion to the campground with news: he had spoken to the man who rented the boat to us and had then gone to lodge a complaint with the police. The manager called the men who had beaten us "crazed Nazis" and told Henri that they'd become more aggressive in recent months, attacking anyone who looked "Semitic." But he also said that he was sure the police wouldn't do anything about it. Others had complained, without any response other than a few polite phrases of regret. "There's nothing I can do," he said. "I'm so sorry."

The day before we left Bad Vilbel to return to Paris, Dieter and his parents threw a farewell picnic for us, inviting some friends from the area and sending us all out to a field behind the farmhouse with two huge wicker hampers stuffed with bread, cheese, sausages, fruit, beer, and wine. We sat on blankets spread out on the grass, eating and drinking, singing, and struggling to communicate in a combination of French, English, and German. The more we drank, of course, the more successful we were, and we stayed wrapped in that warm and fuzzy blanket of international goodwill that comes so easily to the young and inebriated. By the time we'd hugged everyone goodbye and weaved merrily off to bed, the nightmare of that dreadful afternoon had been largely replaced by a sense of friendship and commonality with another, very different, generation of Germans.

I tried to explain this to my parents in a long, heartfelt letter telling them about my visit (minus the beating, of course) and pleading with them to understand that today's Germany was not yesterday's. But the letter had exactly the opposite effect. Once they found out that I'd defied them by visiting Germany, my parents discontinued my small living allowance. Heaven had spit out the last of its pennies. Worse, for me, was that they hadn't even tried to understand what I'd finally experienced firsthand, which was that stereotypes such as "all Germans are Nazis" may have evolved for a good reason, but that those same stereotypes break down for a good reason, too. Which, after all, was the whole motive for going abroad in the first place.

———

I worried constantly about what my parents would say when they found out about Henri. My entertaining a Catholic in my bed might cause either of them to have a heart attack or stroke, which would lead to certain death,

a great way to avoid the pain and humiliation of my "marrying out." How was I going to convince them that my real life had begun the moment I set foot on French soil, that Henri was the only man I'd ever loved or would love, and that I was going to live in France forever?

I wasn't. If I wanted to get married, I'd have to do it on my own and *then* let them in on it, so I paid a visit to the American Embassy to find out how. The woman I spoke with was polite and just the slightest bit amused. She told me that I might be eighteen, but I still couldn't get married in France without my parents' permission. Trust the French not to make anything easy for a foreigner. As I left, I told myself with a sigh that what I needed to do was ace my exams, go back to the States with a glowing record, and come back to France the minute I'd finished school, when I'd be twenty-one and legal.

My courses began with the early Renaissance in the 1400s and continued through late-eighteenth-century neoclassicism. Walking around the galleries of the Louvre freely, before the museum was open to the public, was a privilege I'd never imagined possible. I could examine the brushstrokes on a Ruisdael landscape, spend as much time as I wanted scrutinizing the background detail in a van Eyck or van der Weyden, and feel my being meld into the artist's mind, hand, and eye.

But the glowing record part was harder than I had thought. The exams, oral and written, were terrifying, designed to convince an American student that the French were superior in every way. For the oral part, you entered an enormous room with a long table at its head, where five stern professors in dark suits were seated. You walked the length of the room toward them, shook hands formally with each, and then reached into a bowl to withdraw a slip of paper on which your destiny was written. There, in formal French script with its elegant curlicues of blue ink, was the name of an artist and the title of a work. Instantly, you were supposed to launch into a learned discourse on all aspects of the work, the artist, the school, the period, and even the condition of the canvas, delivered in rapid-fire French while a loud timer ticked the minutes away—ten, to be exact. Then the bell went off, you stopped mid-sentence, shook hands again, and exited. Two weeks later, you found out if you'd passed. If you were intimidated by the lineup of scowling judges, or if you pulled a slip of paper on a painting or an artist you didn't know, or if your French wasn't up to snuff, you were history. But I found the professors' pomposity amusing. I'd been studying hard enough so that I wasn't stumped by the obscure work I picked out—a painting by the mid-eighteenth-century Dutch artist Limborch—and my French, *grâce*

à Henri, was just fine, thank you. So I triumphed for the first time in my spotty academic career.

But I had to go home when it was over, and that felt like going to prison. Henri and I took one last trip together, through Italy to Belgrade and Sarajevo and back up to France, delirious with each other's company. Never mind the endless train ride from Paris to Yugoslavia, where the compartments slowly filled with people and their children, food, live chickens and ducks, and paraphernalia; never mind that we stood most of the time, jammed into a corridor, unable to pee because someone was sleeping in the filthy bathroom; never mind that we were so hungry we were ready to eat any escaping chicken in its natural state. We were in love, and it was our last chance to be together.

At Le Havre, I stood on the deck of the *Queen Elizabeth* and watched Henri's waving figure fade into the distance as my innards began to consume themselves. I stayed in my bunk for most of the trip, occasionally slipping into the dining room to pick at food that tasted like chipped brick. Late at night, I'd sit outside staring at the ocean from a deck chair, a blanket pulled up to my chin. When the boat entered New York harbor a week later, my classmates lined up at the rail, cheering and weeping with joy as we passed the Statue of Liberty. I, on the other hand, could read the inscription quite clearly: "Abandon Hope, All Ye Who Enter Here."

My father met me at the boat and drove me home in near silence. When we got back, I found out why. My mother had been in and out of the hospital every few weeks, dying slowly and without adequate medication to deaden her pain or calm her fears. My father's asthma had turned into emphysema and he was sleeping with an oxygen tank at his bedside, a solution only slightly less expensive than hiring a night nurse. My brother, ignored in the midst of the crisis, had withdrawn so far into himself that the shades to his soul seemed to be down and the door locked for good.

I adjusted to life back in New Jersey by shutting off all feeling during the day and opening the valve only late at night, tears soaking the mattress. Henri's last letter had ended with the devastating sentence, "I'll live with you or not at all."

A month had passed when my father came into my room in the middle of the night, sat at the edge of my bed, and put his hand on my shoulder

as I sobbed into the pillow. "What's wrong, honey?" he asked. "What on earth is making you so unhappy?"

Out came the truth about my relationship with Henri—at least, as much as I could blurt out through my hiccups. And then I told him about Henri's family.

Henri had taken me to meet his parents and his tiny, wrinkled grandmother who lived with them almost immediately after I met him. They lived just outside Tours in a beautiful old farmhouse. Henri's parents were so nice to me that at first I thought something was surely the matter. They were Catholic and knew I was Jewish, after all, but his father kissed my hand gallantly and smiled at me with affection and his mother greeted me with hugs.

I later found out that during the German occupation of France in the early 1940s, Henri's family had run the local underground railway, tunneling Jews out of France into Switzerland. Single-handedly, they had saved the lives of hundreds of Jews, until Henri's father had been reported to the authorities by a suspicious neighbor. He was arrested, dragged to Gestapo headquarters, beaten, and then taken to the *Kommandant* for questioning. Once the soldiers were out of the room and the door closed, the *Kommandant* grabbed him and whispered, "Start screaming, and do it well!" and, crashing his chair against the wall repeatedly, barked question after question at him while his "prisoner" pleaded for mercy. After a while, he called the soldiers back in. Throwing Henri's father across the room at them, he yelled, "He's useless, he's just a stupid peasant, he doesn't know a thing. Let him go."

Henri's father never fully recovered from the first beating and walked with a limp from then on, but he was alive, and the knowledge that there was even one turncoat within the Nazi ranks who used his position to save Jewish lives gave him the heart to keep the passageway open until the war ended.

When I finished talking, my dad was silent for a long time.

"It's all over now," I thought. "You're an idiot to have told him about Henri and his family, because all it'll do is make everything worse." My misery ratcheted up one more notch.

Then, incredibly, my father said in a low voice, "I understand. I'll give you the money to bring Henri over here. I'll fix it with your mother, don't worry. I can't stand seeing you this way. I want you to be happy. If that's what it takes, I'll do it."

I stopped crying and stared at him. "You're not kidding?" I asked. "You'd actually do this for me?"

"I give you my word," said my father, kissing me on the cheek. "Now go to sleep."

The next morning when I woke up, I was weak. I thought I was sick until I realized that what I was feeling was relief. I grabbed a pen and paper and scribbled a note to Henri. "Come immediately," I wrote. "My father will pay your passage! Just tell me what boat you'll be on. I can't believe it, we can finally be together!" I raced to the post office to send it off and waited nervously for his answer. When it finally came, I wanted to kiss him and kill him at the same time.

"My darling," he wrote, "I am so glad you told your father. It is terrible to have to keep such a secret. But I cannot take his money. It isn't right for him to pay my passage. I must do this myself, and I will. I have a new job, in an office, and I am saving everything I can so that I can buy my ticket. I won't be able to come until Christmas, but trust me, I will be there."

My father told me how much he respected Henri's decision, and I went back to my summer job, unable to concentrate, edgy with waiting. Our letters flew back and forth across the ocean, full of love and hope and dreams and plans, until one day I opened his envelope and read: "*Ma chérie,* I cannot believe my bad news, but I am drafted despite my medical deferment. I must report in one week. They are sending me to Algeria."

It was his last letter. Less than a month later, he was killed in action.

three: 1960–1962

It was Yom Kippur, there were no classes, and I was lying low in my room, collapsed in a lingering miasma of grief. Consumed by the loss of Henri, I had relegated my mother's illness to the back of my mind.

When the call came, I threw my toothbrush, some underwear, and my only dress into a bag and raced out of the dorm, scrambling to make the train. Four hours later, I arrived in the city just in time to catch a taxi to the Port Authority Bus Terminal for the bus out to Montclair—only I'd forgotten about money. In the cab, I realized that I didn't have enough for the taxi *and* the bus and started to bawl helplessly. Ignoring the obvious, the turbaned cabdriver asked if I was all right.

I blurted out, "My mother's dead, she *died,* and I have no money!" He immediately turned off the meter, sped to the Port Authority, and dropped me at the door, wishing me luck as I fled inside, searching hopelessly for a Kleenex and the few crumpled dollar bills hidden in the torn linings of my coat pockets. I boarded the bus, and twenty minutes later I was home.

My father was pacing up and down in front of the house, waiting for me. Without a word, he opened the car door, and we drove in silence all the way back to my grandmother's house in Brooklyn, where my aunt and uncle had been living since she'd died. Inside, weeping relatives crowded the

darkened living room. As we entered, they parted and then closed back around us. My father stood at the center, head bowed, shoulders heaving, while my brother wandered around the perimeter.

We were a cavalcade. Down Coney Island Avenue, up Ocean Parkway, past the multicolored brick brownstones and the once-classy apartment buildings, off we went to the funeral parlor to view my mother's remains. Although I had told myself over and over again that this was inevitable, I still couldn't get used to the fact that she was dead.

My relatives swarmed around, muttering nonstop in low voices, wringing their hands, the women mopping their eyes with lace hankies, each of them eager to show that her grief was more extreme, more profound, more meaningful, than anyone else's—especially mine. They'd always been at pains to let me know exactly whose fault it was that my mother was sick. And here she was, lying in her mahogany casket, proof of my infidelity and general bad attitude.

"You were away during the worst of it," noted one.

"If you hadn't gone so far away on that junior year in France thing, she might have wanted to live longer," affirmed another.

"It's too bad that you never were able to make your mother happy," sniffed a third. The funeral parlor had pinky beige walls, muted lighting, and gray carpets. I walked down a long hallway, into the open doorway of Viewing Room 3, and slowly approached the open casket. Inside, my mother was lying in a bed of white organza, with a silly lace cap tied over her head to hide her few remaining strands of rust-colored hair. Her nose was stuck up at an unnatural angle and her face was bloated, tinged grayish green, with two bright pink rouge spots on her cheeks, deep red lipstick, and lavender eye shadow. Someone else had put on her face for her, and it was all wrong. She is definitely not my mother, I thought, yet she unmistakably is—or was. I was confused, unhinged, gorged with grief, and at the same time I had the feeling that I was watching myself from a vantage point just above where I was standing. I was looking down at my mother's body while looking at myself looking down at her, a double vision that both fascinated and nauseated me.

Warren was standing just inside the door, greeting people as though this were a cocktail party instead of our mother's funeral. He smiled, shook hands, embraced the appropriate friends and relatives, and acted totally normal—that is, normal for some other, very different set of circumstances. I took a seat so that the casket was out of range and watched him out of the

corner of my eye. I felt as though we were in some oddball sci-fi movie where something strange and bad was about to happen. Except that it already had.

———

The last time I spoke to my mother or saw her alive, I had come home from school and gone straight to the hospital.

"Remember when I die that you did it," she yelled. "Go back to your friends, to whatever you were doing that's so important." Then she laboriously turned over in her bed to face the wall. "I'm sorry," I said. No answer. Shrugging my shoulders, I went out the door and got back on the train.

Almost twenty years later, curled up in an armchair, I watched a TV documentary about a woman dying of cancer. She'd let her husband record the process from beginning to end, and the film was a painful, poignant exploration of illness, love, dissolution, and death. Within minutes, I became unglued, sobbing in great gulping waves. On the screen was a woman who was deeply loved by her husband and who clearly loved him, yet as she moved closer to dying she abused and rejected him, pushing him away from her in a sneering, icy way that was completely out of keeping with their devoted relationship. Suddenly, I understood. She pushed him away to speed up the process of separation; she wanted to make him angry and resentful and destroy whatever feeling he had for her *before* she died, so that the final separation would be less painful for them both.

Twisted and terrible, her rejection was shockingly familiar, down to her very words and gestures. She turned her back on the person she cared about most, in exactly the same way my mother had turned her back on me. Until that moment, I had thought my mother had hated me, that she had died feeling nothing but anger and disappointment toward me. Her last gesture had been to tell me to get lost. The idea that she might have pushed me away because she loved me was like a jolt of electricity down my spine.

———

Six months after we buried my mother, Warren, barely fifteen, took a dozen Tuinals that he stole from my father's copious collection of soporifics and kissed the world goodbye. He did it on the living room couch, though, just

in case my father happened to come home in time to save him. When he woke up in the local emergency room, my father pulled strings and got him into Hillside, a psychiatric hospital in Queens that had a decent reputation, especially for treating adolescents.

After a few months, when he was allowed to have visitors, my dad and I drove out together, sitting mutely side by side in the front seat, each of us locked into our own anxiety about what we would find when we got there. It was reassuring. The well-kept red brick buildings and the rolling lawn, trees, and benches looked apple-pie normal to me, more like a school than an insane asylum. When we called for Warren in the ward he'd been assigned to, everything seemed so nice I decided that no one could possibly be chained to the bed or wrestled off in a straitjacket there. The people who wandered around the halls and grounds appeared normal enough, but when I looked carefully, they struck me as being just a little off, as though they were living in a *Twilight Zone* episode, where everything was slightly skewed. The younger patients seemed to move in slow motion, and every so often I'd catch one of them swaying rhythmically back and forth or picking obsessively at some body part. My brother seemed reassuringly ordinary—though he stared out into space instead of looking at me when I spoke, and for him a monosyllable constituted a full sentence.

Later, I scrawled across a page of my journal, "It's some screwed up life. Daddy sick—mother dead—Warren disturbed. I long to be a little girl again, and to curl up in a big warm bed and find warmth. I long for my old beautiful dreams that vanished in an instant."

———

Back at college, I became a serious folk music groupie. When I discovered that nearby Yale had weekly concerts, I became a constant, eager presence. To my astonishment, all my favorite singers were performing—the Carter Family, Doc Watson and Clarence Ashley, Joan Baez, still unknown outside an inner sanctum of followers. There I was, a wild-haired, pale young thing sitting smack in the middle of the front row, gazing up adoringly at my heroes and humming along to the music until some nearby purist would glare at me to stop.

In desperation, longing to do what I couldn't, I pleaded with Liza, two years my junior and my best friend at college, to help me. She was a tall, slim blonde with an ethereal face and angelic smile, and she played the

guitar and sang in a pure, lilting soprano. Miraculously, she agreed to teach me to sing harmony—a tough job when I was the student.

As a small child just tall enough to reach the dials of the radio in our tiny kitchen in Brooklyn, I'd stretch up on tiptoe, turn the knob, and wait till I could hear, through the crackle, Jimmie Rodgers's lonesome blues yodel, the silver threads of "Happy Trails" by Roy Rogers and the Sons of the Pioneers, or Gene Autry crooning "Back in the Saddle Again." Cowboy music was like peanut butter and honey to me—deliciously gritty, sweet, and satisfying, a complete meal. The tunes were simple to sing along to, and sing along I did—loudly, joyously, unselfconsciously—whenever I got a chance to reach up and twist that radio dial for myself.

Unfortunately, my passion and my talents didn't match up. At a cousin's birthday party when I was six, one of my aunts asked me for a command performance, a solo, of "Happy Birthday to You." "Just hold on a sec, hon', while I run and grab the tape recorder," she said. As she held it up to my face, I warbled away blissfully, enjoying the laughter exploding behind me. The grownups seemed delighted. Later, I overheard my parents talking about that hysterically funny tape. "Whose side of the family did she get her total lack of musical talent from?" my mother laughed. "Well," my father concurred, "at least she's consistent. One note, loud and clear, for the entire song. But you've got to admit, she gave it everything she's got."

In fifth grade, I joined our school chorus, and I sang away ecstatically, unchecked, until I had my first taste of professionalism in the form of a new choral teacher who took her job seriously. After she started looking at me with a quizzical expression during rehearsals, I took to mouthing the words. Not a lot of fun for me, but she did stop staring. I made it through a whole two months of musical pantomime when she announced that from then on we were going to have auditions at the beginning of each season. It finally sank in, painfully, that I simply couldn't sing, that I'd been born with a tin ear and a wooden tongue.

Even Liza, sweetheart that she was, admitted that I had a ways to go before we could perform together at the local café. Still, she was determined not to let my failure to carry a tune stop us. And after weeks of practice, working late into the night on "House of the Rising Sun," "John Henry," "I Know Where I'm Going," and "I Am a Man of Constant Sorrow," we decided to give it a try. One evening at the open mike, with a couple of drinks under our belts for courage, we got up and went through our

routine—Liza played guitar and I plunked away methodically on my new Autoharp.

During school breaks, Liza and I volunteered at Izzy Young's Folklore Center on MacDougal Street in New York, where we stood around in our secondhand clothing, with our long hair, white lipstick, and kohl-blackened eyes, directing potential buyers to the paid staff people who actually knew what they were doing. One day, we were at the front of the store, thumbing through the most recent records, when the door opened and a redheaded young man ambled in, carrying a banjo case. We stopped him with our questions as soon as he got through the door: "Hi! What kind of banjo is that? What else do you play? Do you sing, too? Where are you from?"

His name was John Cohen, and he told us that he belonged to a group called the New Lost City Ramblers. We oohed and aahed, looking at the record covers he pulled out of his beat-up briefcase. "Where can we hear you?"

The door opened again, and a slight, homely guy with curly hair and a big nose, dwarfed by a ragged denim jacket, came in. We hardly gave him a glance as he sidled off into the depths of the long, narrow store, and by the time John took out his banjo to give us a tune, we had forgotten about him. Then, to our astonishment, as John began to sing "When First unto This Country a Stranger I Came," the intruder chimed in, singing harmony in a high, thin, drawling voice. We were stunned, but before we could ask him who he was and what he was up to, he had slipped past us out the door.

Later that night, heading up MacDougal Street past Café Wha?, I saw him sleeping in the doorway. "How could such a terrific singer be a bum?" I wondered. Or had he just gotten locked out of the pad he was staying at?

Several months passed. My friend Max Ochs, a cousin of the folksinger Phil Ochs, dragged a bunch of us to Gerde's Folk City to hear a controversial new performer named Bob Dylan. We recognized Joan Baez, ethereally beautiful, sitting at the table next to us, entranced by that same pathetic-looking kid—only this time he had a big guitar slung over his shoulder, a harmonica on a metal harness, and a dark, gravelly voice that galvanized the audience and sent us all into a frenzy of debate. None of us knew if he was singing like that because he *wanted* to or *why* he would want to. We weren't sure if it was folk music, or what it was exactly. A lot of my friends hated his music, but I thought I'd died and gone to heaven, where St. Peter was enthusiastically greeting me at the gates, complimenting me on my

extraordinary musical taste. When it came to my own singing, however, despair was the operative word.

———————

During the last semester of college, I spent a weekend at a nearby university painting sets for a theater production, where I noticed one of the stagehands skulking around the back of the theater dressed in a beat-up motorcycle jacket, a turtleneck sweater, baggy khaki pants, and heavy work boots. He was tall and reed thin, and his chest was inverted like a comma by a lifetime of bad posture. I was sure that the deep scowl on his face hinted at a complex past and a troubled, even dangerous, future. I was smitten.

Michael, I discovered quickly, was shy. Because he was so quiet, when he told me anything about himself I felt privy to an inner life that I was sure no one else had access to. He was an aspiring musician, mostly guitar and some piano, but he said he didn't like to play in public, which also meant in front of me.

His sense of equanimity, though, clinched the deal. For Michael, the tiniest insect and the temples of Angkor Wat were equally wondrous. He gave everything his full attention, staring for hours at a time at the ocean, sitting perfectly still listening to the crickets on the lawn, reading a book with the concentration of a Zen master.

Late one night, lying on the narrow bed in his grimy, spartan dorm room, Michael turned to me, took my hand in his, and impulsively kissed my palm.

"I've been thinking," he said, looking up at the ceiling, "that maybe we should get married." There was a long pause while he stared up. Then, turning his face toward mine, he said, "So? Do you want to marry me?"

I stroked his cheek, sighed, and said no. Marriage was too grown-up for me. I was twenty, almost two years older than Michael. I'd just begun to live and didn't want to be tied down. Besides, Michael had no plan for his life. He had no money, no particular ambition, and he didn't seem sure what he wanted to do when he finished school at the end of the year. My refusal added a bittersweet, doomed flavor to our affair—we could live together, but marriage wasn't an option.

———————

When I graduated college in June 1961, I answered an ad in the *New York Times* and was hired by the Museum of Modern Art as a secretary to William Lieberman, head of the Department of Drawings and Prints.

I'd had lots of experience with secretarial work because I'd spent several summers working for my father, learning to take dictation by inventing a form of shorthand that I still use to take notes. ("U 2 cn bcm a scty n 6 wks!") Being a legal secretary was no easy matter and my father was a tough taskmaster, so I'd gotten quite good at it. After high school, I'd also had temporary summer jobs as a secretary, working for the vice president of *Newsweek* and then for the president of Schiff Toys.

I arrived early and stayed late because I was such a slow typist at first, but no one ever suspected that I wasn't the real thing. The only problem with this new job was that Bill, though famed for his photographic memory and ability to get what he wanted for the museum, had a notorious temper, which he lost at the slightest provocation—and often without any provocation at all. I sat at my desk, for the most part pretending to be a smart, diligent deaf-mute. Not a peep out of me except "Yes, sir," "No, sir," and "Of course, sir," and I was always discreet when opening packages containing sexy briefs or amorous billets-doux from a famous someone who'd forgotten to mark them "Personal."

Despite the unpredictability of working for a temperamental and demanding boss, I loved being at the museum, the first I'd ever visited—with my dad when I was ten—and one whose treasures had left me open-mouthed.

I felt privileged to be able to walk through the empty galleries, greeting familiar paintings and sculptures as old friends, stopping to make new ones of works I had seen only in textbooks, and being able to use the library to find out as much as I could about the art and the artists. As an insider at such a prestigious institution, albeit a lowly one, I felt that my love of art now had a degree of authority. Although it was becoming clear that there was no chance of advancement, because the more useful I was to my boss, the more he'd want to keep me as his secretary, I needed the sixty-five-dollar-a-week paycheck.

By then, Michael and I were living in the Village, in a ground-floor tenement apartment next door to Snooky's, a luncheonette that served as the neighborhood drug hangout. Once you'd undone the two deadbolts and the police lock to our place, you found yourself in a dingy room with three red brick walls and a short partition dividing one of the walls in half. To the left of the door stood a bathtub that was never used for bathing because it

was permanently rust-stained and roach-infested. Michael and I covered it with a wooden board, on which we arranged a hotplate, an electric coffeepot, our dishes, and a few cooking utensils. For showers, we booked Mondays, Wednesdays, and Fridays at the apartment of two of my college friends who lived around the corner. We called it our spa.

In one corner of our apartment was a tiny, airless room with a toilet but no light fixture. The WC was illuminated by the candles that we burned on the sill of the boarded-up window, great for atmosphere but less than ideal for hygiene—not that we would have cleaned the bathroom anyhow. I remember hearing my father, standing just outside our door, warning the date he'd brought with him, "My daughter has no facilities." He meant, of course, "Don't use the bathroom whatever you do!"

Our place was always full of visitors, among them my brother and one or two of his friends, all released into my care on an occasional weekend pass from Hillside. There were also musicians, bikers, friends of high school friends, and the occasional friend-of-a-friend-of-a-friend who was passing through and needed a temporary pad. There was never enough food, so I became expert at stretching the spaghetti sauce by adding flour and a tiny bit of food coloring.

Occasionally, my dad would show up at the apartment without calling first, causing problems for everyone. He had no idea that Michael and I were a couple. He'd only met him twice, and I'd implied that Michael was just a casual friend. Even as such, I could tell my father didn't like him— he never looked him in the eye or spoke to him directly. So our houseguests had to be told what not to say in order to keep our illusion father-proof. To avoid an unexpected encounter, we'd established a secret knock that let us know if the person on the other side of the door was friend or father. "Knock three times, wait, then knock again three times," was how we explained it. Any time we heard a normal knock, Michael, usually half-naked, would flee to the back of the room, struggle with the window, and squeeze his lanky frame out onto the fire escape, where he'd hang out till the coast was clear.

One night in the dead of winter, Michael and I were about to sit down on the bed and dine on one of my fried-bologna casseroles when my dad showed up at the door. I shoved our plates under the bed while Michael jumped out onto the fire escape in his underwear. When I opened the door, I already had my coat in my hand, and I pushed my dad along before he could glance inside. Still, poor Michael was half-frozen by the time he heard the door close behind us.

I suggested to my dad that we go have coffee. Once we were seated in a booth at Snooky's, I told him about my new job as a secretary to a museum curator, trying to make it sound more interesting and important than it really was.

"There are only four of us in the department," I said, "and everything that goes on comes across my desk. People don't understand how complex it is to build up a collection. You have to find the work, get the funds to buy it, convince the board that it's a worthwhile acquisition, and then do the scholarship." I took a breath, trying to slow down. "That means tracking the exhibition history of the work, writing about its significance, its place in the collection. Not to mention conserving and restoring the work you already own. And that doesn't even include organizing exhibitions of the work that's already in the collection." Of course, as a secretary, I just sorted the mail, answered the phone, and took dictation. But I left that part out.

I nattered on, covering up my disappointment at not being able to tell him what really mattered. I certainly couldn't talk to him about Michael, about how painful it was to have to keep our relationship a secret. I couldn't tell him about how we couldn't afford to go to a doctor when we got sick, about my fears of getting pregnant, my worry about Michael's inability to find a job. And I most certainly couldn't talk to him about what was most important to me, which was my relationship with *him*.

Instead, I put a good face on things. I tried to sound optimistic about my chances of being promoted at the museum, went on about the interesting friends I'd made, about how lively—but completely safe!—the neighborhood was, how much fun it was to learn to manage my own finances.

I was sure that I'd failed him. I wasn't a success by his standards, since I could barely support myself. I not only hadn't become his partner, but I'd refused even to consider going to law school. I hadn't moved to the suburbs with him, even though his emphysema had gotten worse and he was frightened and desperate for my companionship. I had refused, despite his constant reminders that his apartment was big enough for us to share and wouldn't cost me anything. Instead, I was living in a place that, in my dad's view, was only a short step up from a hovel. Still, it was my life, and I was determined to live it my way.

One Friday, about eight months after I'd started working at the museum, I was hunched over my desk typing, my sack dress bunched around my knees, a stray hair falling in my eyes. I was finishing up a pile of letters Bill had thrown on my desk just as I was about to leave. It was now almost 7:00 P.M. I was hungry and cross-eyed from typing when he came marching out of his office. His shadow fell across the keys.

"I need you to work tomorrow," he said. "Be here at 9:00."

"I'm so sorry," I said, "but if you'd given me some notice, I would have been happy to help. I've already promised my brother that I'd visit him in the hospital. Saturday's the only day they let him have visitors." He pursed his lips, blowing an impatient puff of air through his nose, then turned on his heels and went back into his office, slamming the door behind him. Before I could stand up, the door opened again.

He stood in front of me, a silver cup full of pencils in his hand. Pencil maintenance was part of my job. An essential one, I gathered from the look on his face.

"I thought I told you to sharpen these," he screeched. "They are not sharpened! Why aren't they sharpened?!" he bellowed.

I smiled and said, "Because you're not doing it the right way. You stick them up your ass and turn hard, that's what does it."

He turned white, then pink, then purplish red. "You're fired!" he screamed. "Get out of here this minute!"

And so I did. I crammed my meager personal effects into my bag and walked out the door.

Fresh from my first firing, I leapt onto Michael's lap and told him what I'd done. He didn't look quite as happy as I had hoped he would, but after a celebratory drink or two he calmed down and we stared out into space, trying to envision our future.

"What now?" he asked finally.

"How about an adventure?" I suggested. "Why don't we go on a road trip? Peg and Peter are out in San Francisco; why not visit them?"

"But how are we going to get there?" Michael asked.

"Motorcycle!" I said, leaping up. "Kingsley's trying to sell his, so why don't *we* buy it? We can sublet this place, and the museum still has to pay me for the two weeks I just worked."

Our friend Kingsley was planning to audition to take lute lessons from a famous teacher. A BSA bike and the lute didn't exactly go together. Two weeks and two hundred dollars later, the bike was ours. We sublet the apartment to Harry Jackson, the singer and artist who was once briefly married to the painter Grace Hartigan. Then, in our beat-up leather jackets, we took off for parts unknown—Connecticut. We had to learn to ride the damned thing first.

Kingsley dropped the bike off at Michael's parents' house, hanging around long enough to give us a rudimentary lesson in how this intimidating new mode of transportation worked. He then clapped Michael on the back, kissed my cheek, and, with a wink, wished us luck.

Michael took the first turn, jumping on the starter, revving up the motor, and wobbling up and down the driveway, spewing gravel as he turned too fast in front of the garage. I was less successful. I nearly broke my ankle trying to kick-start the heavy bike, and I knew that it would take me a whole lot longer to get comfortable enough to drive. I decided to wait till we were actually on the road. After an hour of practice, Michael took off through town, returning nerve-wracked but triumphant. He thought he should practice for another half day before we loaded up and started for Baltimore, our first stop, that afternoon.

With a wooden rack, tin-lined saddlebags, a pup tent, two sleeping bags, a duffel full of clothes, a nested set of cooking pans, a Bunsen burner, basic food supplies, and a stack of *Zap* comics, we roared away. No one mentioned goggles, sunscreen, insect repellent, gloves, helmets, or boots. No one warned us that Baltimore was over three hundred miles away, much too far for greenhorn riders to tackle in half a day. By the time we arrived at our friend's house nine hours later, our faces were raw and blistered, our bodies cramped with exhaustion, our legs shaking so hard we could barely stand. Our nerves were shot. We spent two days there, mostly sleeping, before we felt ready to go on.

This time, we were prepared. By the time we got halfway across the country, we were experts. We had invented a system of hand signals so that we could send each other important messages, like "I have to pee right now," or "It's time to look for a place to pitch the tent," or "Isn't that the coolest thing you've ever seen?" I could make sandwiches while riding at seventy miles an hour, using Michael's back as a screen so the bread didn't fly out of my hands, and I could even read if the scenery became too dreary.

The best part of the trip was waking up to crisp air, an enormous sky, the sound of birds, and a whole new set of smells. Instead of exhaust, we

breathed the scent of pine trees, of dry desert wind, of fresh snow fallen on the surrounding mountaintops, the tang of the Utah salt flats. We learned to look for scorpions and spiders in our boots before we put them on; to pack up our food in a metal container hidden away from the tent at night; to use the woods for a toilet with dispatch and economy; and to think of an ice-cold bath as refreshing.

In the late afternoon of the tenth day, we crossed the Golden Gate Bridge into San Francisco and began to look for Green Street in North Beach, where our friends Peg and Peter Newcomer were living. To our confusion, North Beach wasn't on the water at all, but in the middle of the city. In fact, it looked a lot like the Village we had just left, except that it had steep hills, trolley cars, and pastel houses instead of brick tenements. We sat on the curb in front of their door, stunned. We had come three thousand miles only to find ourselves, more or less, back where we had started.

Michael was the realist. "Don't cry," he said. "It's bound to be different. We'll stay awhile, get some money together, and then head for the ocean. We'll find a place to live on our own. You'll see, everything will be fine."

By midsummer, I was working as a Western Girl, doing secretarial temp jobs. Michael was looking for carpentry work, and Peg and Peter were tired of us. We were living on their back porch, sleeping in our sleeping bags and trying to stay out of their way. We waited till they left in the morning before we used the bathroom. They had made a line down the middle of the refrigerator with gaffer's tape, and we'd open the door to find their half packed with meat, vegetables, fruit, and cheese, while ours sported a lone jar of peanut butter, some white bread, a container of milk, and sometimes a few slices of bologna. It was time to go.

Michael decided that we should get married, proposing for the second time. This time, I thought, "Why not?" We decided to go to Mexico, where we were convinced that being under twenty-one wouldn't be a problem.

Leaving the bike in a garage at the border, we took a bus to Ensenada, where we quickly bought matching heavy Mexican silver wedding bands at one of the ubiquitous tourist shops selling jewelry and trinkets, and walked hand in hand to the town hall.

We filled out the forms and waited in the dimly lit reception area for an hour before we got in to see the person in charge of marriage licenses. He

didn't even raise his head, just held out his hand for our passports and papers. Giving them a cursory glance, he said, *"Usted necesita una copia de sus certificados del nacimiento."*

We needed birth certificates? No one had ever mentioned them. It was supposed to be easy to get married in Mexico. Maybe there was someone in the building who spoke English.

"Inglés?" we asked. He jerked his thumb to the left, toward another, larger room down the corridor.

We waited again. This time, the irritated mustached official looked at our papers and said, no, no birth certificate, but you need the tests, *"la prueba de la sangre y de la sífilis"*—blood and VD. He motioned us to the next desk, where another guardian of the public interest informed us that once we got our medical tests, we'd have to stay for a week while they processed the whole thing.

We gave up. We had an early nonwedding enchilada dinner and by the third shot of tequila swore that we'd get married in New York just as soon as I turned twenty-one in April. We got back on the bus to California, retrieved the bike, and started back across the country.

The lone journal entry for that year reads, "We had a fine, relaxed summer enjoying each other's company."

———

Michael and I finally got married on December 15, 1962, eight months later than planned. It was snowing, the weather echoing our relatives' feelings about the event. No one in my family except for my brother approved of our union, but as far as I was concerned, that was more incentive than deterrent.

It was harder than we thought, though, to find someone who would marry us. The rabbis we spoke to insisted that Michael convert first, a matter that would have taken a long course of study, a bar mitzvah, and, according to several of the Conservative rabbis, circumcision. Since we were both atheists, this seemed too far to go just to please my family. The Christian minister we spoke to was also reluctant. He didn't come right out and say he thought it was wrong for us to get married, just that we should wait, maybe even forever. Then at last, through the Ethical Culture Society, we found someone who said he would be happy to perform an "interfaith" marriage, the most dignified term we'd heard thus far, at his office in the Stephen Wise Free Synagogue.

We got dressed in our tiny apartment—I wore a red velvet dress and Michael cut his hair short, shaved his beard, and wore a rented tuxedo—and we took a cab uptown to the synagogue, holding hands and staring out at the thick white flakes that covered the city like confectioners' sugar. We found my father, Warren, and Michael's family huddled together in the hallway outside the rabbi's office, looking like dazed animals seeking shelter. We kissed everyone hello, hoping they would brighten up, considering that the occasion was supposed to be happy. Suddenly, my father broke away from the group, wheezing and choking. His face became blue and mottled, and he began to suck desperately on his inhaler. He was heading into an asthma attack before the ceremony had begun. In despair, I grabbed his arm and pulled him to the end of the corridor, where I turned on him.

"If you ruin this for me," I hissed, "I will never forgive you as long as I live! This is my goddamned wedding. You stop it right this minute!" And for the first and last time in his life, he took orders from his own child. Within fifteen minutes, he was breathing normally, and the ceremony went ahead as planned. I had three swift martinis upon entering the reception and then felt much better.

Once Michael and I were married, it seemed I never had enough hours or enough room to paint. There was time, though, to go to museums, to pore over reproductions in glossy art books in the library, to read and talk about art. I had my hands full with graduate school at New York University's Institute of Fine Arts. If I was going to get a master's degree, I had to study every minute I could, especially now that finals were coming up. Now, *that* was my idea of a good time. I told myself that eventually I would be able to get back to my painting.

I found a day job working for an artist, something that sounded wildly glamorous to an eager young novice like myself. René Bouché came across as a compact Frenchman with deep, soulful eyes, elegant manners, and a charming accent. Actually, he was a Czechoslovakian Jew who had changed his name and his accent to fit more comfortably into high society, to create the illusion among the rich and famous patrons who paid for his flattering portraits and his extravagant life that he was one of them. By now, he was.

There were many plusses to working for René. He lived on the Upper East Side, just a block away from the Institute, so at the end of a workday I was able to race to class. Another job benefit was my buddy and confidant Pedro, who was housekeeper, cook, chauffeur, and anything else René and his wife, Denise, known as Den-Den, needed him to be. Pedro, who was in his early fifties and looked two decades younger, was a total blast. Once he'd served the bigwigs, he made lunch for the two of us, and we'd sit in the kitchen eating his delicious food, chatting amiably about our lives, joking about being the hired help, and drinking endless cups of the best coffee I'd ever tasted.

Den-Den was British, a spoiled blonde wisp of a thing who was cute, friendly, forgetful, and helpless. In a bright light, you could see that she was actually closer to forty than to thirty, although she still behaved like a little girl. She had no sense of what anything was worth and threw stuff away with abandon, so that Pedro and I found amazing treasures in the trash: a cashmere scarf that was probably the wrong color, a pair of broken silver candlesticks, loose change, an occasional cufflink or pair of earrings, a lace slip, bottles of unused perfume. Food never went to waste, either. Every night, Pedro packed up a doggy bag of leftovers that became our supper and often Michael's lunch the next day. Weekends, sustained only by my fried-bologna casseroles, were tough.

On Pedro's day off, I had to make breakfast for Den-Den: one three-minute egg in a porcelain eggcup; toast with butter, no crusts; a cruet of raspberry jam and one of apricot; fresh-squeezed grapefruit juice; and a pot of Lapsang souchong, with milk. I then had to sort the mail, slitting the envelopes and putting them in the slot at one side of the wicker tray, magazines in the other; place a single rose in a silver bud vase; arrange it and the silverware and the linen napkin; and without spilling the contents, carry the wickedly heavy contraption down the stairs to her bedroom, where she slept in until 10:30 every morning. Opening the drapes, I would set the tray over her lap, plump up the pillows behind her, and make sure she was propped up and fully awake before leaving.

Although I felt invisible most of the day, the job had few drawbacks and even the occasional reward in the form of meeting famous writers and artists who came to have their portraits painted. Like the wrinkled, gray-haired older gentleman who arrived late for his first sitting, stumbling out of the coffin-size guest elevator straight into me. Flustered, he mumbled something about being held up in traffic, shrugged out of his heavy coat, leaving it in a heap on the floor, and lumbered into the studio. I hung the coat carefully in the closet, wondered briefly who he was, and got back to work.

Several hours later, the studio door opened and I heard René's voice bid the visitor goodbye. It was my job to get his coat and show him back out. Smiling politely, I held the coat open for him to put on. He turned his back to me, put one arm into the sleeve, then followed with the other. He got the second arm into the armhole all right, but it refused to go through, and he pulled it out. I stood patiently while he made a second attempt and a third, without success. Exasperated, he turned to look over his shoulder at me, made a face, and with brute force and a ripping sound, pushed through the sleeve till his hand emerged triumphant at the other end. Then, with a wink, he was gone, trailing a faint whiff of cigarettes and wine.

A few minutes later, René emerged with a handful of wet brushes for me to clean, asking me as he handed them over, "Have you ever read any of his stuff?"

"I'm not sure," I said, shamefaced. "He looked familiar, but I didn't recognize him."

"That was Auden, the poet," René said. "I don't much like his books, but I think I'm probably in the minority."

Auden? I had helped W. H. Auden put his coat on? Auden had a hole in his lining? Auden had torn his sleeve? W. H. *himself* had winked at me? I had been *that* close to genius and hadn't even known it.

———————

Memorial Day weekend 1963, Michael and I took a break from the city to visit friends in the country, eating, sleeping, playing Frisbee, reading, and making music. Which is how we came to be heading back home on that gorgeous spring day, happy to be alive, happy to be together.

While Michael was finding a place to park the bike, I started upstairs, humming and dragging my bag behind me. We now lived on the third floor, in a railroad flat that consisted of a kitchenette with a tub, a closet toilet, and a living room that doubled as our bedroom. We had brought with us the red carpet from our previous place, now stained and worn, and a vinyl porch chair, which enjoyed pride of place across from our bed.

When I reached our door, panting from the climb, I saw that it was ajar. I pushed it open with my elbow, wondering for a second if we'd been broken into. More likely, one of our friends had used the spare key above the doorjamb to get in and had forgotten to close the door.

"Helloooo!" I called out. "Anybody home?" There was a noise, and I turned to see two of my upstairs neighbors, standing in my kitchen. "Hey, what are *you* doing here?" I asked cheerfully. An awkward silence. I looked more closely. There was something in Jeff's face that I couldn't read, but I knew it wasn't good. Joel avoided my eyes.

"For God's sake, what's up?" I asked. "You look like hell."

Jeff opened his mouth, and abruptly closed it again. Then it opened and the words came out and hung in the air like banners.

"Your father died."

———————

It was insufferable, sitting shiva in my stocking feet with the shades drawn and the mirrors draped. Friends of my father's, friends of friends, relatives, distant cousins, clients, and more relatives milled around, sniffling, grabbing my hands earnestly, telling me how sorry they were, how upset I must be, telling me the coffee cake was on the counter, the casserole was in the oven, a fresh pot of coffee was brewing. Daddy was carried out in a body bag by two cops who didn't even notice when they banged him carelessly against the doorjamb.

Relatives tiptoed in and out, shaking their heads, sighing deeply. They told stories about my father, but not to me. They ignored Michael, who seemed not to notice; his eyes were constantly seeking out mine.

I was sitting shiva because everyone had told me that not to observe this basic Jewish tradition would be disrespectful to the dead. What they really meant was disrespectful to *them,* since my father couldn't have cared less. He didn't even believe in God. He confessed this to me on the way to his office one Sunday morning when I was fourteen years old, and he swore me to secrecy. But my relatives' ability to get their own way was not to be underestimated, and I caved in without so much as a whimper. I was too tired to fight with anyone about anything. I knew that they were making me miserable and that I was making them miserable, too, in some way that they were not willing to tell me.

It was incomprehensible to me to be without parents. I kept wondering who would be proud of me. What's worse, I felt that I'd failed them both. I'd amounted to absolutely nothing. My mother hadn't gotten to see me graduate from college, and I had nothing to show for the education my

father had worked so hard to give me except a menial job and an unemployed husband.

On the fourth day of mourning, I dragged myself out of bed red-eyed and shaking. Michael put his arms gently around me, kissed me on the top of my head, and told me he loved me. Then he looked at me intently and said, "You don't have to do this anymore if you don't want to. We can always leave."

"How can we leave?" I asked. "They'll kill me. I still have two days of this left."

"We can call your relatives and tell them we're going away for the weekend," Michael continued. "As for the rest, we'll just put a sign on the door. After all, he was *your* father. Shouldn't you be able to do this your own way?"

I shut my eyes and saw the ocean, and when I opened them again, I said, "Let's get out of here. I want to go to Montauk."

I made the calls, explaining in a dull voice that I just couldn't stay in the apartment any longer. While Michael got the bike, I threw a handful of things into a backpack, uncovered the mirrors, opened the shades, turned off the flame under the coffeepot, and locked the door behind me with relief.

Michael was downstairs, waiting. I climbed on behind him, fastened my helmet, zipped up my jacket, and we were off, over the Queensboro Bridge and onto the Long Island Expressway. I suddenly realized that the seat beneath me felt odd. I tapped Michael and yelled into his ear, "Something's loose!" He pulled over and we got off to see what was up. Sure enough, one of the big nuts that held the seat to the frame had worked its way out, and although the seat was still fastened in three places, it didn't feel all that secure.

We left the expressway to find a phone booth, got the name of a nearby bike shop in Queens, and swung around to find a replacement. We were cruising down an empty Woodside Avenue, looking for the shop, when suddenly a dark speeding shape on the right came up behind us so fast that we couldn't move or turn. With a sickening crunch, the left front bumper of the car smashed into the bike and then into my right side. As I fell, I watched Michael fly forward in very slow motion, up into the air and out in a huge arc against the sky. My head hit the pavement and bounced. My nose and cheek scraped the sidewalk, and I heard my leg snap.

Time became elastic. A minute felt like a year, and then, gradually, I began to see Michael's blurry face in front of me. I watched his mouth move but couldn't make out what he was saying. It was very quiet, even peaceful; the sky was a particularly beautiful shade of blue gray, with a puffy cloud floating in it like cappuccino foam. From far away, I heard sirens, and

I thought about the length of the sound waves it takes to produce that distinctive in-and-out whine and wondered idly what they were racing to. A fire, perhaps? An accident? Then something hard slid under my neck and I was being lifted onto a stretcher and shoved into an ambulance. I yelled, "Michael! *Michael!*" but no sound came out. Someone covered my face with an oxygen mask, and I thought, "Oh, so that's what's happening, I'm dying, but it's not that bad, nothing hurts."

Doors swung open and shut. There was a shiny table and lots of doctors and nurses. They rolled me onto the table, and suddenly there was a pain that was absolutely amazing, as though someone had taken a burning poker and shoved it up my leg, from the bottom of my arch to the middle of my thigh. They cut away my clothes and someone tried to get my boots off with a saw, and they were all talking at once. One of them was yelling at me, telling me how stupid I was to ride a motorcycle. "You kids are all alike, you don't know what the fuck you're doing." I kept wondering how someone could talk to me like that when I was so helpless, when I hurt so much. I begged them to give me something to stop the pain. A doctor came into my line of sight and said, "Young lady, we're going to have to fix this leg. But we can't give you anything yet because we have to know what the damage is, and you've got to be conscious and able to feel in order for us to do our job."

They held me down and set my leg, which was broken in five places, while I screamed and cried and pleaded. When it was over, they wheeled me upstairs and left me lying on the gurney in the corridor because the ward was full. It was nighttime, and the lights were out. I was terrified, feeling as though my body had been broken in a thousand places, with shards of bone sticking out everywhere, sure that my insides had ruptured and were leaking blood, that I'd never be able to hear or see or taste again, and I started to cry with great choking, gasping sobs, crying for my father to help me, please, come and get me out of here.

Then I understood, with all the power of a single, devastating thought: my dad was dead. He was never going to come and get me; he was never going to be able to help. I was alone, and nothing would ever be the same again.

four: 1963-1964

Reality is the leading cause of stress among those in touch with it.

JANE WAGNER

When I called René from the hospital just before I went home, he told me not to come back to work. The replacement I had found for him and trained while I was still in the hospital was doing fine, he said, and it would be too hard for him to make the change back right now.

We had given up our apartment because I hadn't had the money to pay the rent while I was hospitalized. Michael had been staying with Jeffrey, a high school friend of mine who had moved to a ramshackle walkup in the East Village. To buy some time, we asked Jeffrey if I could move in, too.

His apartment was dark and bare of all but the basics—two beds, a couple of beat-up chairs salvaged from the street, bare lightbulbs dangling from the ceilings, a smelly sofa, and some cracked china. He was happy to share his place, especially since he was almost never home—we later found out that was because he was out selling drugs.

I had a long, hard rehab ahead. I still couldn't walk, and it would be another month or so before I'd even be able to use crutches. It took a lot of work to carry me and my cast up the stairs, and it didn't look as if I would be going back down anytime soon. While Michael was out looking for a job that never materialized, I resigned myself to being a shut-in.

One bright spot was the regular visits from our friend Harry Jackson. He was born a Shapiro in New Jersey, did a brief stint as an Abstract Expressionist painter, and ultimately transformed himself into Harry Jackson, one

of the world's best-known Western artists, whose realistic sculptures of horses and cowboy riders were coveted and prized by collectors of the genre. He was also a fantastic singer and raconteur, with a mental filing cabinet crammed with hundreds of songs and stories. He'd show up with a bottle of Jack Daniels, pour us a drink, and then launch into a recital of cowboy songs, dirty ballads, and "brag talk"—Wild West, Paul Bunyonesque exaggerations that were an art form in themselves.

Aside from Harry, visitors were sparse. Hardly anyone wanted to sit with me while I complained about my life. I had become an expert whiner, having taken lessons from my family, who flaunted their whining skills at ritual gatherings at my aunt and uncle's house in New Jersey.

Their dire predictions about my future, the ones they trotted out whenever I showed the slightest signs of having a mind of my own, had come to pass. I was in a cast from hip to toe, black-and-blue all over, unable even to get myself to the toilet without help. Because of my willfulness, my arrogant refusal to live the life they knew was best for me, I had no job, no money, no place to live, no future, and hardly any friends. I was a study in misery, and their faces said, "I told you so."

One day, Michael came bounding up the stairs, triumphant. He'd found a small house for us to live in, with a yard and a screened porch, about fifty minutes outside the city, in Spring Valley, New York. It was owned by a pale, overweight recluse named Jerry, who seemed not to care who lived in it, and the rent was reasonable.

In the summer of 1963, we packed up our meager possessions and left for the wilderness. At least, that's what it was to me. The house was near a Hassidic compound, which meant that it was quiet. It had a kitchen, a bathroom, a living room, a bedroom, and a sleeping loft that could accommodate several guests—absolute luxury. The biggest problem was money—we both needed jobs.

One night, the cupboard yielded up its final contents, a package of Minute Rice. We used the last of our milk to make rice pudding, divided it into three portions: one for Michael, one for me, and one for Circe, our cat. The next day, spurred into action by the idea that we might starve, Michael found work as a house painter.

The Nordstroms—Carl and his wife, Jane—were his first employers, and they were so kind that we were suspicious at first. Carl was a sociology professor who loved books, young people, and animated discussions, and the house was filled to overflowing with all three. Jane, who not only had a day job, but also ran marathons, was the kind of mother I knew heaven had

dropped directly into the kitchen solely to show the world how to do it right. Their four daughters were appealing and talented; they laughed a lot and actually seemed to enjoy being with each other and with their parents. Unheard of.

Most people thought Michael was sullen when he was really just shy, but not the Nordstroms. They fed him lunch on the job, and they were interested in him. In fact, they seemed to *like* him.

No sooner had Carl heard about my dilemma than he recruited me for the job of transcribing tapes for a book he was writing with his friend and colleague Edgar Friedenberg. The book, *Society's Children*, was about ressentiment, a kind of "free-floating resentment" that influenced what and how children learned. I sat at my typewriter, right leg propped on a stool, tape recorder attached to a foot pedal I could operate with my good foot, and typed out the material as fast as I could. I'd had plenty of practice with my dad's Dictaphone, so it was easy—and interesting—work. The Nordstroms fronted us money to buy some groceries and added to our small stash of food with homemade bread, jam, cookies, vegetables from the garden, and an occasional "extra" casserole that they just happened to have lying around the house. With our combined paychecks, we were able to just make the rent.

It had taken months to process my father's will, but now, when we were finally beginning to drag ourselves out of the quicksand on our own, I received a twenty-thousand-dollar insurance check and a handful of stock certificates. With a joyous laugh, Michael loaded me and my crutches into the car, and we sped to a bank to deposit our riches. There was some resistance on the teller's part when I insisted that they give me fifty dollars back in cash, but eventually a kindly bank officer intervened and I swung out on my crutches with what to me was a fortune in bills clenched in my fist.

Our first stop was the department store Alexander's, where with Michael's help I picked out a couple of long, flowing caftans. Then we went to an Indian restaurant in the East Village to gorge ourselves on samosas and curry and yogurt drinks. Finally, we made a triumphant exit from a grocery store, where we had amassed several bottles of Chianti and a medium-sized mountain of groceries.

We drove back to Spring Valley, certain that life had taken a turn for the better.

Our riches didn't last long. The hospital bill ate up most of my father's legacy, and I used the rest to re-enroll at the Institute, determined to finish

what I had started and get my master's degree. Still, we felt lucky. I stopped moping and got to work.

It's a short bus ride from Spring Valley to the Port Authority Bus Terminal, but if you're on crutches with your leg in a cast, it's a Himalayan trek. Michael would hoist me onto the bus at the Spring Valley stop, and the bus driver would help me negotiate the climb back down when we reached the city. Once inside the terminal, I still had to get out to Forty-second Street, into a cab, and over to school on Seventy-eighth Street.

I was a good student—especially now that there was no one else around, like my parents, to care about my grades—but sitting in a metal folding chair with my leg stuck out at an awkward angle for a three-hour class was brutal, and staying awake in the dark lecture hall while the slides clicked on and off was out of the question. It was time to move back to the city.

We found a place on Eighth Street between Fifth and Sixth Avenues, across the street from the former Whitney Museum, now the New York Studio School. It was a second-story, "two-rooms-plus-an-alcove" apartment whose square footage was about the same as your average bathroom. But the bedroom and living room each had a tall, thin window that looked out onto the gardens of the elegant Ninth Street brownstones behind our building, and the neighbors on our floor were musicians from a group called the Hawks. We thought the music they blasted through the adjoining walls was fabulous. They were also friendly, so occasionally we'd go next door to listen to them play. Eventually, they became the Band, signed by Bob Dylan to accompany him on his 1965–66 world tour.

———

Michael and I decided to go to Europe together before school started again in the fall and before it was time to get serious about finding real jobs. We settled on Greece as our main destination. I'd taken a course in Greek art and architecture with Peter von Blanckenhagen, which had culminated in an extraordinary lecture on the Parthenon friezes, and I couldn't wait to see them in person. Von B., as his students called him, was a wizened, hunchbacked professor with a heavy German accent and an uncanny knack for making dead monuments come alive and insinuate themselves into your life forever. He explained how the Parthenon friezes were the first visual record of mortality. First, as the frieze unfolds, are the animals, who are

mortal but don't know it; then the gods, who are immortal but couldn't care less; then the centaurs, half god, half animal, on the cusp of understanding; and then human beings, confronted with the absolute knowledge that they—we—are going to die.

My insatiable appetite for Greek monuments turned out to be in direct proportion to my diminishing interest in food. I started to feel queasy almost immediately after we arrived and soon reached the point where, faced with a fragrant, steaming mound of moussaka, a plate of crisp spanakopita, and a frosted glass of retsina, my taste buds stood at attention while my stomach went AWOL. I began to lose it at just about every historical site we visited. I was unwilling to give up my research but was mortified at my involuntary defilement of the world's greatest artistic and cultural legacies. When Michael realized that I was expelling my food more often than I was keeping it down, he suggested I see a doctor. By then we were in Heraklion, where I decided that I was not going to let a Cretan doctor distract me from my hot pursuit of the Minotaur. I agreed to go only when Michael told me that he wouldn't accompany me on any more archaeological excursions until I did. I reluctantly made an appointment with the only doctor we could find in Agios Nikolaos, the little port town we'd moved on to.

The doctor's English was pretty good and he had a kindly manner, so I took a deep breath and explained my predicament. He took my pulse, checked my heart and blood pressure, made me say "aaahhh," and felt my stomach. Then he requested a urine sample, and I sat down outside to wait for the results.

An hour and a half later, he called us in. "Congratulations!" he said to Michael, clapping him on the back. "You going to be father!"

"Wait a minute," I interrupted. "I couldn't possibly be pregnant. I'm taking birth control pills."

"It happen sometime pills do not work," the doctor said. "Be happy. What, you not want baby?" His incredulity at the thought stopped any dialogue dead in its tracks.

Baby? I couldn't quite get my churning stomach and motherhood to share the same conceptual space. Was I ready for this? Was Michael? Were our finances? The answer was coming up a resounding "no" on all counts. I paid the bill and, waiting for the receipt, looked around for Michael. He was gone.

The nurse led me to the door and pointed down the street. I thanked her politely in Greek *("Parakalo! Eycharisto!")* and lurched along the narrow, cobblestoned way to the taverna on the corner. There, in its dark, smoky interior, stood Michael, looking uneasy, surrounded by the doctor and a

handful of locals, who were boisterously toasting the birth of his forth-coming first son. Only in Greece, I thought, tucking myself into a corner and ordering a glass of yogurt.

Back in New York, I developed a chronic lower backache that turned nasty. I spent my nights curled into a fetal ball, moaning. One morning, I woke up in sheets drenched with sweat, trembling, unable to stand. My lower back was in a spasm, locked in a slicing, grinding pain. Michael, in a panic, insisted on taking me to the hospital. After a two-hour wait in the emergency room, with Michael holding me while I moaned and writhed, a staff doctor examined me and declared that I wasn't pregnant, but that I had kidney stones.

I found myself back in the hospital with a heaving stomach and a fever of 106. By the time the nurses packed me in ice, I was standing on a river-bank at dusk, looking across at a robed choir that was singing a glorious gospel song—more ethereal and yet more real than anything I'd ever heard. Their arms stretched out toward me, and as I stepped gingerly into the water, their voices grew louder. Another step in, up to my knees, and the singing became more insistent, more compelling. It would have been so easy just to let go and let the current take me to the other side. Instead, I made a huge effort and withdrew. When I woke up the next morning, I was deaf in one ear, but I realized what the Greeks had known for centuries, that death wasn't something to be afraid of.

I was out of the hospital again, this time partly deaf as well as gimpy, and I was desperate for work. Losing my job with René after the motorcycle ac-cident had made things tough, but I had been fond of him and was upset when I heard that he had died of a heart attack over the summer.

I called Den-Den to offer my condolences. "Den-Den," I said. "It's Mar-cia. I am so sorry about René. How are you doing?"

"Oh, *darling*," she cried, "you just can't imagine how perfectly *hideous* it's been, what with all the lawyers and papers to sign and people coming by and trying to decide what to do. It's all so *confusing*. Can't you come to work, *please*, and help me straighten it all out? When are you free?"

"Well," I replied, "it depends. I'm charging by the hour, now. I'm sure I could find some time for you, but I'll have to fit it into my schedule. I still have a lot of medical stuff to take care of."

"Oh, sweetie, how could I *possibly* have forgotten? You were in that *frightful* accident, weren't you? But I'm *sure* you'll be all right. You're young and strong, after all, not all decrepit like poor old Den-Den, right, darling? Shall we say tomorrow, at about 2:00? Can't *wait* to see you! Come round the service entrance, as usual? Ta-*ta!*"

So I went back to work chez Den-Den. It wasn't a bad job, considering I could make my own hours and for the most part we got along quite well. The only real problem I had with the job was getting paid. The lady of the house, having no marital reins on her budget, was given to impulse-buying Dior dresses and Chanel suits for hundreds of dollars, thereby overdrawing her account and leaving her no money with which to pay me.

"*So* sorry, darling," she'd say with a sweet, pathetic look. "I suppose I went and did it this time, didn't I? I simply *must* put the brakes on a teensy-weensy bit, mustn't I? Next week, sweetie, there'll be *more* than enough in the account. I'll just pay you for two weeks when it comes in, then, shall I?"

Poor Den-Den didn't have the foggiest idea that I actually used the money that I earned in order to buy food and that, without money, Michael and I wouldn't eat. I thought it was probably time to get another job.

Actually, it was Den-Den who sent me over to Noma and William Copley's after I sat her down to explain the facts of life. She may have had her head in the clouds, but she was never mean. I know she cared about me; it was just her way of showing it that was sometimes odd.

"They need someone *right* away," she said. "They've just moved back from Paris and they *just* can't manage all alone, poor dears."

So, early the next morning, I rode the elevator up to the Copleys' penthouse on East Sixty-eighth Street and rang their bell. The door was opened by a heavy-set, gray-haired woman with an apron fastened over her uniform and a wooden spoon in her hand. She paused for a moment, taking in my worn trench coat, battered briefcase, and crutches.

"Ah, yes, you're here for Madame," she said and led the way down a corridor to the bedroom at the end. "She's waiting for you."

I knocked, and a low voice called, "Come in, come in!" Noma, slender and sharp-eyed behind her reading glasses, dark hair cropped just below her jaw, was propped up in a four-poster bed, a mass of pillows at her back. She was dressed in tailored midnight blue silk pajamas and surrounded by more mail than I had ever seen in my life outside the post office.

"Den-Den told me you might need help," I said tentatively. Noma patted the bed next to her with an elegant hand and cleared a space.

"Sit down," she said, "and tell me what happened to you."

Unusual job interview, I thought, but what the hell. "My husband and I were in a motorcycle accident," I said, "but it hasn't affected my ability to work, just to walk." I didn't mention the mysterious illness that was eating up my stomach. She gave me an appraising look. "You seem too young to be married." She glanced at my wedding ring. "And where are your parents?" she asked.

"They're dead," I said. "My mother died two years ago, and my father died this year. There's just me and my kid brother."

Another appraising look. "So you're an orphan," she said.

She picked up the phone and pushed an intercom. "Bill? The new secretary is here. I think you should meet her."

I made my way back down the hall to the living room. A short, impish man with a shock of black hair and mischievous eyes gave me the once-over as I swung in on my crutches. He laughed. "You're cute," he said. "You'll do." He shook my hand and told me to make myself at home.

Bill was an artist who, under the name CPLY (pronounced "See-ply"), made flat, cartoonlike paintings, usually featuring a little man in a bowler hat and fuzzy suit with an umbrella, engaged in various antics with one or more naked women. But the paintings were more playful than erotic, covered with a riot of contrasting and repeated stripes, squiggles, dots, flowers, stars, and combinations of decorative patterns. His work was appreciated more by other artists than by dealers, who—with the notable exception of Alexander Iolas, who owned galleries in New York and Europe—thought them too "decorative" to amount to much. Bill himself didn't seem to care what anyone thought of his work, since his mind, like most artists', was focused on painting in his studio every day and hanging out with his artist friends at night.

Bill had a highly developed sense of the absurd. As an infant, he had been adopted from the New York Foundling Hospital, whose windows he could now see from his elegant dining room. His adoptive father, Colonel Copley, had been a rabid conservative who owned a chain of San Diego newspapers. Bill had tried his hand at journalism, but he was too liberal to last long under his father's regime. After his dad died, Bill sold his half of the business to his adoptive brother.

In 1947, Bill decided to open a gallery in Los Angeles—Beverly Hills, to be exact—to show the work of his friends, among them Max Ernst, Victor Brauner, Dorothea Tanning, René Magritte, Francis Picabia, Marcel Duchamp, Man Ray, and Meret Oppenheim, in addition to several younger artists, like H. C. Westermann, Lucas Samaras, and Dieter Roth.

The gallery was hardly a commercial success. He tried to sell a Joseph Cornell for two hundred dollars, but no one would buy it. Bill felt so bad when he couldn't sell work from a show that he'd buy it himself. The result was one of the greatest private collections of Surrealist art anywhere.

At work every day, I gorged myself on Man Ray's *À l'heure de l'observatoire,* with its gargantuan, ethereal lips floating in the sky; Magritte's giant green apple (a version of *La chambre d'écoute*); Picabia's *La nuit español;* Westermann's gorgeous anthropomorphic wooden knot.

After the failure of the gallery, Bill went to Paris with his buddy, Man Ray, where he lived and painted for twelve years. By the time he came back to America in 1961, Pop Art was in full swing and the art world was starting to warm to his work and to that of many of the artists he had championed in his LA gallery. In a later exhibition catalogue, Walter Hopps wrote of Bill's work: "The poetry of sophisticated banality and subversive narrative play had finally come to have a real and sustaining place in American culture as the sixties unfolded. And we should remember that CPLY had been there all along." (*Trust Lust Heed Greed.* New York: Phyllis Kind Gallery, 1991.)

Every day, I fielded calls from Bill's artist friends, from the critics and curators who wrote about his work or his collection, like Hopps and Roland Penrose, or from younger artists, like Donald Judd, Dan Flavin, Vija Celmins, and Christo and Jeanne-Claude.

As for Noma, in addition to being the person in charge of everything—from the dinner menu to the children, to guest lists, to their priceless collection of Surrealist art and artifacts—she was a jeweler, a designer of such witty, extraordinary pieces that my mouth fell open whenever I saw them. She made gold earrings out of Bill's bowler-hatted men, with moveable legs and arms. She made rings in extravagant architectural shapes that were surprisingly comfortable to wear. Her necklaces were stunning burnished collars, chains as finely woven as spiderwebs, tiny jeweled secrets that winked from the hollow of one's throat.

Between Bill and Noma, I was in for an adventure.

Within an hour of being hired, I'd been introduced to Gladys, the cook, and to Billy and Claire, Bill's young children by his first wife. I was immediately installed at a desk in the study equipped with my own phone,

typewriter, and coffeepot. Then Noma and I launched into a lifelong for-better-or-for-worse, in-sickness-and-in-health relationship.

Not that it was easy. Noma was a perfectionist who became irritated if I made a mistake and put an *accent aigu* where an *accent grave* should have been. I thought she was lucky I was fluent in French in the first place, but she had high standards and didn't understand why I couldn't meet all of them all the time. She also had a dreadful habit of calling me very early in the morning on my days off. When the phone rang at 7:00 in the morning, I'd leap up to answer it, terrified that something had happened to my brother. Instead, there was Noma, wanting to know if I'd remembered to get a receipt for the special-delivery letter I'd taken to the post office, or asking if the package I'd sent off last week had ever been delivered. She had me on a very short leash, which sometimes made me want to pee on her hydrant.

But Noma's demands and her over-the-top working habits were tempered by her protectiveness and generosity, and I certainly needed some taking care of. Having used up the money my father had left me, I was broke again, a sad, skinny thing prone to mood swings and exhaustion. I didn't love the work, which was mostly routine filing and letter writing, but I loved Noma and Bill, who treated me like a long-lost niece—so much so that whenever a big dinner party allowed for an extra chair at the table, they'd invite me to join them.

If the occasion was fancy enough, Noma would grab my hand and drag me off to her bedroom, where she'd find something fabulous for me to wear. Whenever Noma reorganized her closet, which was far more often than I'm sure she needed to, I'd come home to our tiny apartment with something new and gorgeous tucked under my arm to show to Michael. Hand-tailored pants, silk blouses, gloves, slips, a pair of exquisite Roger Vivier dress shoes, even a fake leopard-skin coat that Noma insisted Bill's daughter, Claire, had "outgrown."

When Noma was invited to yet another black-tie opening at the Guggenheim Museum, she thought that sending me instead would help my career—and save her from having to show up herself. But I didn't have an evening dress. Noma solemnly led me, the fashion virgin, into her walk-in closet. When she finished with me, I didn't recognize myself. That night, I walked into the museum arm in arm with my old upstairs neighbor, Joel, the only guy I knew who owned a tuxedo. I was wearing a black wool cape, lined in white silk. Once he slipped it from my shoulders and marched it off to the coat check, I stood there, transformed but shaky. I was wearing

Noma's floor-length black Balenciaga gown, sleeveless and backless, with a narrow, deep V-neck cut to the waist. My hair was done up in an elegant French twist, my neck encircled by strands of coral, my ears adorned with matching drop earrings. I had on my satin shoes and carried a silk clutch purse with a pearl button.

I was nervous—scared to death, actually—but I wanted to meet their friends, most of whom were legends to me. Like Andy Warhol. This was long before Andy was Andy; he could actually carry on a conversation in those days. The first time I'd accepted Noma and Bill's invitation to dinner, Andy and I had found ourselves sitting together, two shy birds on a couch, sipping our drinks and looking out at the view. After an awkward silence, I worked up my nerve to ask him what he was doing. Another long silence, and he began to describe his films. "They're long, and kind of boring," he said.

The dinner bell rang. "Gladys means business," Noma announced. "No dillydallying!" I had no experience whatsoever with formal dining, and the glistening array of utensils to the front, side, and center of my plate was daunting. I watched carefully and took my cues from the people on either side of me. I was just beginning to think that I'd done really well for a certified etiquette cretin when the fruit and cheese course arrived. Everyone took a piece of fruit, using a small knife and fork to cut it. If I'd had any sense, I would have picked something squishy, but instead I grabbed an apple. Wielding my implements like a surgeon, I made the first incision. Or tried to. The apple, resisting dissection, escaped, careening down and across the long table while conversation came to a dead stop, as though the sound had suddenly been turned off. After several revolutions of the earth, the runaway fruit finally came to rest in Andy's lap. All eyes were on him. I thought it was too bad the knife wasn't sharp enough for me to cut my wrists. But I'd underestimated Andy. He picked up the offending apple, looked at me, and beamed. "Thanks for sending it over," he said. With a burst of laughter, dinner resumed.

One afternoon, as I was typing away in the empty apartment, the doorbell rang. Bill was at his studio, Noma was visiting a friend, Gladys was out shopping, and the kids were at school. In the event of such wholesale desertion of the premises, it was my job to answer the bell, invite visitors in if appropriate, offer refreshments, and keep them entertained until someone came back who knew what to do with them. I rose dutifully from my labors and hurried to the door. There stood an elderly gentleman in a raincoat, hat

in hand, wisps of white hair haloing his head, with a mildly amused look on his face.

"Anybody home?" he asked with a slight accent. "I told Bill I might drop by this afternoon."

"I'm afraid they're all out," I said, "but please come in. They should be back any minute. Would you like a cup of tea?" I helped him off with his coat, got him settled in the living room, and produced tea and cookies, a task for which I was seriously overqualified, thanks to René and Den-Den. I poured, we sipped, he crunched, and he asked questions.

His accent, I realized with delight, was French, so we quickly switched from English. I was much less shy when I spoke French, perhaps because I felt as though I were someone else, and within ten minutes we were yakking away like old pals. He described his life in France, told me about his wife, why he'd become a U.S. citizen. And I told him about my accident, about graduate school, about my problematic paintings, my dead parents, and my unemployed husband. He leaned forward, elbows on his knees, smiling slightly, completely attentive. Under his gentle questioning, I had just launched into an analysis of why my marriage was falling apart, when I heard the door open. There were Noma and Bill in a flurry of coats and scarves and cold air, filling the entrance to the living room.

"Oh, for heaven's sake," said Noma, rushing over to kiss the visitor on both cheeks. "I'm so sorry we were out. Have you been waiting long?"

"Oh, no," said my new confidant. "Marcia and I have been having a wonderful time."

"I'm so glad," said Noma. She turned to me. "Thanks for keeping Marcel company." I sat there like a stone. Marcel? Marcel *who?* Then it hit me. I'd been telling the great Marcel Duchamp about my life! What on earth had I been thinking? And how could I have been so blind as not to recognize him? Like one of the undead, I stood up, took my coat from the hall closet, and left the apartment, closing the door gently behind me. Once safely outside, I fled down the corridor, chased by embarrassment and remorse.

In an instant, I had reverted to my old awkward, insecure self. I was so shy that instead of taking delight in meeting someone I admired so much, I was mortified. I couldn't believe the legendary Duchamp might have been interested in anything I had to say.

But I learned something: a truly great person has a profound curiosity about the world and the people in it, an interest that encompasses everything

and everyone. Real curiosity, I now know, doesn't leave much room for judgment.

Within a month, Noma decided I needed a title, which she insisted would stand me in good stead for the future. I could hardly imagine what future she was talking about, since I couldn't conceive of any job my education and motley work experience had prepared me for, but I suddenly became the Curator of the Copley Collection. It didn't change my work, but when Noma called *Art News* and told Tom Hess that he ought to hire me, it certainly made a better impression than if she'd insisted that her secretary was the absolutely perfect person to write reviews for the magazine. And he did hire me, because Noma was unstoppable.

The reviews were short—half a paragraph—and paid only about ten dollars each, but I loved being an "official" critic. Although I was never assigned an important show, I enjoyed going to the galleries and trying to sum up an artist's entire career in twenty-five words or less. I also got to write my first article, on the painter Robert Natkin. Although his pastel-colored paintings of floating rectangles weren't the challenging kind of work I preferred, I appreciated having the chance to study them in depth. Natkin himself was generous and outgoing, apparently not insulted that his article had been assigned to a novice. And the article opened other doors. A new art newspaper called the *57th Street Review* had started up, and I was invited to contribute to it.

That year, my first year of married life, I worked like a husky. I was an amanuensis by day, taking a full load of graduate art history classes by night, writing reviews, and somehow trying to paint in between, an endeavor that was beginning to seem more and more like swimming the English Channel. I was too tired to care about why I was even doing it.

To add to my misery, my body refused to settle down and behave. The intermittent nausea originally credited to pregnancy in Greece became constant, and I began to lose weight precipitously. After I had bolted from the lunch table one day, Noma gave me a hard look, picked up the phone, and

within two hours had me in the hands of one of the world's great internists. As I understood it, the trap door to my stomach had stopped working properly, and after the doctor put me on an odd diet—broiled sole, grapes, dry toast, and small amounts of rice—I started gaining weight and some color came back into my face. After a few months, I felt stronger, able to focus at work and to put my heart into graduate school again.

But my improved health didn't solve a major dilemma. I thought I wanted to be an artist, but I realized that I would rather be locked up in the library all weekend than spend a single afternoon facing an empty canvas. I'd been so invested in the idea of living an unconventional life and thought I had to be an artist to do it that I couldn't seriously consider doing anything else. Studying art history was something I loved, and so I took as many courses as I could afford just for the sheer pleasure of it. At that time, most people thought a museum curator was someone who walked around with a feather duster in their hand, and there was certainly no such thing as a curatorial studies program in college.

Then, during a student-teacher conference, José Lopez-Rey, a Goya scholar from whom I was taking a course at the Institute, gave me a piece of advice that turned me around. Sitting in his wood-paneled office, desk and floor covered with books and manuscripts, he looked at me with bright, stern eyes. "You can't be both an artist and an art historian," he said somberly. "You'd do much better to stop fooling around with painting and get down to business. You're a better art historian anyhow." I wasn't sure how he could know this, since he'd never seen my work, but I thanked him and told him that I'd certainly think seriously about what he'd said.

Two weeks later, assessing my most recent series of one-eyed prostitutes laid out against the wall in our minuscule living room, I decided to get serious, which meant thinking about making a real living rather than taking odd jobs to support my artistic endeavors. I immediately turned my back on the one thing I had thought I was most passionate about. I gave up painting.

———

I'd been standing too close to the edge of the subway platform, checking my impulse to push gently off, into the path of an oncoming train. I could hear the shocked cries of the people waiting at the platform, hear the

screech of brakes, see myself being thrown into the air and landing as the wheels rolled over me, crushing my skull.

I was starting to suspect that something was seriously wrong with me. It didn't help that I couldn't sleep, not just because I was afraid of the nightmares that had been haunting me, but because I'd been taking Dexedrine to help me study for exams and now I was hooked on it. My doctor compounded the problem by prescribing strong doses of the stuff when I ran out of the little yellow pills I got from the cut-rate diet doctor that I (and dozens of other normal-sized women) went to on a regular basis.

And I had been hallucinating. Voices accosted me constantly, and though they weren't exactly directive, they would interrupt my train of thought, especially when I was trying to distinguish a Veronese from a Canaletto. I'd be minding my own business nicely, when, out of nowhere, a couple of male voices would start yelling at me: "In an accident, there is money, money, money." Then: "Do you think you're a unique case?" The visions were coming on fast and furious. I looked down at my boot, lying on the floor next to the door, and it sprouted a corpse, sunken-eyed and open-mouthed. Sitting on the couch, I glanced at the throw rug in the living room and, in the blink of an eye, there was a man burning to death in the middle of it.

My journal writing took a strange turn, addressing someone who didn't exist—or a part of me I didn't know about yet: "I love therefore I die. Death of what? I am going through something terrible, please, bear with me. I love you and I hate you, therefore you're rejecting me. Living is a hell and constant torment. I am lying in a sexual death bed, and the room I am dying in is the toaster."

———

Dr. Mohr worked in a small office at the Therapy Center, on Fifth Avenue and Thirteenth Street, where I took a seat and filled out the medical forms.

"Do you have unpleasant dreams?"

"Do you have headaches?"

"Do you feel that other people are watching you?"

I was tempted to write in "All of the above," and I started to giggle, but the receptionist eyed me suspiciously, so I sighed and finished ticking off

the little boxes: "often," "sometimes," "never." Mohr was small, dark, intense, and very young, with thick black glasses and hair on the back of his hands. He wore a formal blue suit and a white shirt with no tie. The office was lit with fluorescent bulbs, and I knew they made me look more haggard than usual, because he looked more like a young Frankenstein than a shrink-in-training. But the price was right, ten bucks a session, and I'd never been in therapy before.

I sat down, took a deep breath, and gave it my best shot. I tried to describe what had been happening to me, but no sooner had I gotten a few sentences out than I could feel a flood of despair run through me. Where to begin? How to *really* explain what was happening, or worse, what had happened way back when? Still, it was a heady feeling to talk to someone whose only concern for fifty minutes was me and who did nothing but listen intently, patiently, and carefully.

I was torn between resentment of Michael's lack of ambition and my love for him. His patience, his sense of ease, the quiet centeredness I'd always found so reassuring now irritated me. The less he did, the more frantic I became. I was a perpetual motion machine, working, studying, worrying, working, complaining, working. One day, Michael calmly called me a castrating bitch. Mohr, my ever-present psychiatric ally, reassured me. "You can't cut it off unless somebody sticks it out for you," he said. Then Michael decided that he hated New York and wanted to move to the country. The country? I thought of trees and grass mostly as recreational props, to be used only when there were no reasonable alternatives. I didn't want to leave the city. My relatives added to the pressure by constantly asking, "So, when is he going to get a job?" and "Just who's wearing the pants in this family?"

But I began to see things I never saw before, and my journal entries became terse analytic discoveries: "The conflicts between me and Michael are the result of the battle I'm waging with myself. When I'm really angry, I take responsibility for everything and everyone instead of facing the anger. I am constantly aware of the image I present, even in moments of extraordinary stress." I started to see that my problem was existential. I was like the waiter in Jean-Paul Sartre's *Being and Nothingness,* who so wants to distance himself from being identified as such that he becomes a perfect imitation of a waiter, an impeccable simulacrum. He does it for so long that the real and the imitation selves meld, and he becomes the very thing he dreaded. Only he doesn't know it. Not that I didn't want to become the person I'd been manufacturing—it's just that schizophrenia seemed too high a price to pay.

I was twenty-four years old, and while my sense of self was slowly coming together, the rest of my world was falling apart. My marriage was the first casualty. On a beautiful spring morning, Michael packed his bags and I walked him downstairs to where our jeep was parked. I climbed into the front with him to say goodbye, but all I could do was cry. When I looked up, I saw that he was crying, too, which glued me to the car seat. How could I let him go when I loved him so much? What would he do without me? Where was he going to live? How would he be able to eat? I finally wrenched myself away, giving him one last desperate kiss, and stumbled back upstairs to an empty apartment.

I needed to put some order into the shambles of my life. I was doing too many things I didn't want to do, seeing too many people I didn't want to see, trying to please everyone all the time. With the afternoon sun casting bars of light on the kitchen counter, I picked up the phone and began to call my so-called friends, most of them only acquaintances or needy hangers-on. One by one, I said goodbye, telling them simply that the relationship wasn't working out, that we were better off not seeing each other again. As I worked my way through the list, I felt lighter and lighter. When I was done, I had two friends left, the ones I really cared about. More than enough, I thought. I felt giddy.

The next day, I gave notice at work. I told Noma that I loved her, that I would never have survived without her, but that I had to move on. I told her that I was thinking of trying my hand at cataloguing private collections, something that required no overhead (other than a ruler, a pencil, and a stack of index cards) and would give me the money and flexibility I needed. She'd always known I'd leave eventually, and I know she was sad, but she was also determined to help me take the next step. She'd make some calls for me, she said.

Scarcely a week after Michael and I split up, I sat alone, virtually friendless, about to be jobless, empty, and at peace for the first time in a long while.

A year later, I flew to Tijuana, where a middle-aged Mexican lawyer in a pale, baggy suit, with dark circles under his eyes, a Zapata mustache, and a

cigar butt clenched in his teeth, met me outside the baggage claim. He drove me to a nondescript hotel overflowing with women like myself, looking for a cheap, fast, legal, and painless end to marriage. Cheap, fast, and legal were easy enough, but in order for a divorce to be painless—relatively speaking—you have to be very pissed off at the person you're divorcing or not care about him at all. In my case, neither was true. I still loved Michael. I vacillated between thinking that getting divorced was a mistake and knowing that we could no longer live together.

When I joined the line at the courthouse to put the seal on the deed, it was anticlimactic. Two minutes of signing papers and I was out, clutching the divorce decree in my hand. I shared a taxi to the airport with three other newly single and equally exhausted women, and we wearily climbed back on the plane to New York.

Once strapped into my seat, I was shocked at what I was feeling. I may have had my doubts about getting married in the first place, but Michael had been at the center of my life for over five years. My failure seemed overwhelming. I wanted to talk to someone about it, to explain what had happened, to get absolution, I suppose, but Michael was hardly going to be the one I could turn to for help, my parents were dead, and my friends had had enough of my troubles. I felt totally alone and despondent.

The plane landed at Kennedy, and I slung my backpack over one shoulder and shuffled off the plane. About the last person in the world I expected to see was my brother, Warren, standing at the gate waiting for me with a worried expression on his face and a bouquet of flowers in his hand. I don't think I'd ever been happier to see him than at that moment. I threw myself into his arms and burst into tears. He drove me home while I blubbered away, trying to explain how bad I was feeling—as though he couldn't see it for himself—and why I wasn't sure I'd done the right thing. My brother listened and didn't try to reassure me or give me advice. When we got to the city, he parked the car near the apartment and locked my bag in the trunk. "What you need is a drink and something to eat," he said, and, steering me by the elbow, he walked me to a café on MacDougal Street. By the time I'd had a glass of wine and some soup, I was feeling better. He took me home, carried my bag upstairs, put my flowers in a mason jar, and calmly waited to make sure that I wasn't going to fall apart before he let himself out of the apartment.

My guru at the time, Herman Hesse, wrote that suicides aren't necessarily people who try to kill themselves, or succeed at it, but those who are always aware that it's an option, who have a feeling that that's how their lives

will end, whether they ever actually do take action or not. That's me, I remember thinking, that's me. There's always the A train.

When I complained to Dr. Mohr that life was just a fucking toilet bowl, he concurred. "But the question is," he said, "can you grow geraniums in it?"

five: 1965-1968

Trying to define yourself is like trying to bite your own teeth.

ALAN WATTS

Just after my divorce, I took over a friend's teaching job at the University of Rhode Island. She was getting divorced, too, and she wanted to get as far away from her ex-husband as possible, short of moving to Tibet. She went back to New York, and I commuted to Kingston for two years.

As a novice academician, I was assigned to the introductory classes, but I felt that I had leeway to be inventive, since the department head wasn't paying much attention to the basic courses. My favorite was art appreciation, the class no one really wanted to teach because, unlike, say, "Sixteenth-Century Folio Editions in the Flemish Lowlands," it did little for a résumé. I threw everything I knew, and much I didn't, into the mix, hoping my students—many of them only a few years younger than I was—could understand that art was important. I wanted them to experience what it was like to make something that wasn't "useful," and to come to respect it. Many were from rural and working-class families where art was considered extraneous, a put-on, or a waste of time. I didn't ask them to actually make artworks because it was an art appreciation course, not a studio class. Instead, I used games and exercises to try to help them to discover their potential to live a creative life.

One exercise I gave required that the students do something they had never done before—something that seriously scared and challenged them and that would take an entire semester to accomplish. A student who had

never cooked a single thing in her entire life produced a soup. Another of my students, an older man, taught himself to tap dance, and he demonstrated for us—he wasn't very good at it, but it was just beautiful. One of my students taught herself to ride a motorcycle, and she got her license the day of our final class. Another taught herself to fix her car. On the last day of class, she dragged in a car engine and proceeded to take it apart and put it back together in front of us. Our jaws were on the ground. Some projects were very personal: one man explained that he had been estranged from his father his whole life and spent the semester reconnecting with him.

I also used theater exercises to help the students to open up, which made my classes look like a scene out of *Zabriskie Point:* pairs of students sitting on the quad with their eyes shut, feeling each other's faces and hands, or taking turns being blindfolded and led across campus; students dropping to the ground without warning to smell the grass, or trying to imitate the sounds of cars, birds, or other students. Early in the semester, I asked each student to choose a partner and to write a detailed description of this person and then of themselves. I kept these till the end of the semester, when I handed them back in preparation for our final class assignment, which was for the students to completely alter their appearance without becoming conspicuous and to meet on the last day of the semester in a public place to try to identify each other.

We agreed to hold our final class at Grand Central Station in New York. Among the truly invisible for that session were a guy in a jumpsuit sweeping up the main waiting room with a huge broom; a priest quietly making his way through the crowd; and a paraplegic in a wheelchair—all classmates.

I gave that same assignment to different classes over several years, each time trying on a new identity for myself. My most convincing transformation was into a Hassidic Jew, complete with black suit, *payis,* yarmulke, *streimel,* and a copy of the *Forverts* clutched in my fist. I copied my mother's father, Grandpa Wald, an Old World Orthodox rabbi with a long beard and a stern countenance. Once I was dressed to go out, though, I wasn't sure I could pull it off, and, holding on to my fur hat, I raced across the street to my painter friend Jane Kaufman's studio. I knocked on her door frantically, yelling, "Jane, Jane, it's me, Marsh, I need your help!" but when she opened up and saw a little old Jewish man, she nearly dislocated her jaw. "It's for a class," I panted, "and I'm too scared to get a taxi by

myself." Jane, ever resourceful, pulled herself together and walked me out to Sixth Avenue, where she hailed a cab, bundled me into the backseat, and said sternly to the cabdriver's enormous Afro, "Take him to Grand Central."

I know that there was supposed to be a lot of tension between African Americans and Orthodox Jews back in the late sixties, but there certainly wasn't any evidence of it in the cabdriver's behavior. He was a sweetheart. He tried making conversation, but I was too nervous to try to sustain my grandfather's thick accent, so he gave up. When we got to the station, the cab was on the wrong side of the street. I reached out a trembling, gloved hand to pay him. Looking back at me thoughtfully, the driver put on his blinking emergency lights, opened the door, and gently escorted me against the traffic to the entrance, where he wished me well. In return, I gratefully muttered the classic Yiddish phrase *"Gey gesunte heit"*: "Go in good health."

<hr />

For over twenty years, I had a best friend who believed in me, was never jealous, and never made me feel bad about anything I'd done or was even thinking of doing. No, she wasn't my imaginary playmate—besides, I was twenty-four years old when we met, *much* too old for that sort of stuff. She was there for me during my breakup with Michael, we took art history classes together at the Institute, and she was my best drinking, gossiping, and movie-going buddy and probably the least likely person in the world for me to take up with, or to have taken up with me. For one thing, she was almost forty years older than I was.

Margaret Scolari Barr was married to Alfred H. Barr, Jr., the first director of the Museum of Modern Art, and her life had been the stuff of legends. Although she was married to a towering figure in the art world, she was formidable in her own right. A well-respected art historian who had taught at Vassar before she met and married Alfred, Marga was fluent in French, German, and English, and so she served as interpreter for him on their many trips to Europe, helping him to gain support for the museum among both artists and patrons. She was also instrumental in helping him to produce his monumental books *Picasso: Forty Years of His Art* (Museum of Modern Art, 1939) and *Matisse: His Art and His Public* (Museum of Modern Art, 1951), as well as other catalogues.

In 1943, Alfred had been fired as director of the museum by the president of the board of trustees, Stephen Clark, who recognized Barr as a great scholar but a weak manager. Barr was offered positions at other museums, but he refused to leave the museum he had helped to start. He asked for and was given a small office in the library, and his annual salary of twelve thousand dollars a year was cut in half. (He would eventually become the director of the collections, until his retirement from the museum in 1967.) To help make ends meet, Marga began teaching at Spence College, where she taught art history courses for the next thirty-seven years.

Marga was dismissive of fame—hers or anyone else's. Her buddies were towering figures like Picasso, Joseph Cornell, Philip Johnson, Bernard Berenson, Leo Steinberg, and John Richardson. Peter von Blanckenhagen, the professor whose dazzling analysis of the Parthenon friezes had picked me up by the scruff of the neck and dropped me in the lap of the Acropolis, was a close friend. She had lots of women friends, too, but theirs weren't household names.

I had collided with her outside Bill and Noma's apartment one day as I careened down the corridor in tears. Michael had called me at work and we had started to fight about moving out of New York, precipitating an outbreak of hysterical caterwauling on my part that was entirely out of proportion to the situation. Since I couldn't explain to him why it was a bad idea—mostly because I wasn't sure that it was—I ran away. It was lunchtime, anyhow, and I needed to go to the bank—probably a better place to be out of control than at work.

The person I slammed into was short and stooped, with white hair wound up in a skinny bun. She wore a long, dark flower-printed dress and sensible oxfords, and her purse was clutched under her arm—at least, it was until I knocked it to the floor. Her blue eyes peered at me more in curiosity than alarm, but I didn't stop to assess the damage because I was racing toward the open elevator doors.

That night, as I contemplated taking a bath in Jack Daniels, the phone rang and a deep, Italian-accented voice boomed out at me, "Is this the residence of *Mah*-sha Tuckah?"

"This is she," I answered meekly. "Can I help you?"

"This is *Mah*-guh Bahh," she answered. "We ran into each other this afternoon."

I took a deep breath. "You mean, I ran into *you*," I said apologetically. "I'm so sorry. I was upset."

"Well, my de-ah, that's *precisely* what I wanted to talk to you about," she shouted. "Noma tells me that you are having a difficult time right now. I have a spare room here on Ninety-sixth Street because my daughter Victori-ah is living abroad this year. I think you should come here and stay for a while."

I made a choking sound.

"Good," she yelled. "I'll make arrangements immediately."

"Wait, wait," I said. "It's really nice of you, but I really can't."

"Well, I do understand, and I'm so sorry you cahn't, but I want you to know that the room is there waiting for you at any time you might need it, even for a few hours. In the meantime, I want to take you to dinner. To-morrow?"

"Fine," I said, feeling my tank emptying out. I had no idea who she was or why she was bothering to be so nice to me. On the other hand, a free dinner wasn't something I would ever turn down.

We met at Chez Madison, on Sixty-ninth Street. It was a dark, musty downstairs pub with mediocre food, but it wasn't crowded and we could talk. Marga was slightly hard-of-hearing and tended to shout, especially when she was enthusiastic, which was great for me. Being deaf in one ear myself, I had the impression that most people mumbled, whereas I understood Marga perfectly. She ordered her favorite drink, a dry vermouth on ice, and I ordered white wine, and we both thought the fish sounded just perfect.

Marga was spectacular. For one thing, that little-old-lady routine was a ruse. I'm sure it served her nicely when she needed it to, but it was more like a clever Halloween costume worn by an outrageously smart, sexy, and wicked person of my very own age. We quickly launched into a lifelong friendship. Unlike most of her friends, I never called her Daisy, and she tended to prefer "my de-*ah*" to "Marcia," perhaps finding it more descriptive of our relationship.

We gabbed on the phone just about every day, had lunch once a week, usually at the Madison, and went to the movies whenever we could. What I liked best was going to her place on Ninety-sixth Street. I'd nod to the doorman, go up in the wood-paneled elevator, and then march briskly down the dark hall to where her door was left open a crack in anticipation of my visit. I'd yell out, "I've arrived!" and from the recesses of the apartment I'd hear her delighted "Ah-ha!" ring out. Marga would scurry around and put her reading glasses and appointment book away, stack papers, then sail into the kitchen, all the while chatting to me about Alfred's mess or the number of mundane things she had to accomplish but couldn't find the time to do.

When she finally settled down, out came the vermouth, the white wine, and the gossip. I'd curl up opposite her on the couch in the gray and white modern living room and drink in the Arps and Mirós and Cornells that filled the walls while we gobbled the olives and Goldfish crackers that seemed to be her main source of nourishment. She told great stories, full of details and observations and rumors and little wicked asides, stories that made me feel like a kid at bedtime who just doesn't want a tale to be over and will do almost anything to prolong its pleasure.

Marga traveled extensively with Alfred before his retirement from MoMA, which kept her out of town a fair amount. She referred to these trips as their "campaigns." When she was out of the city, she was particularly concerned about what was going on in my life and distressed when she wasn't within arm's reach. When I was in a paroxysm of anxiety over my relationship with Michael, she wrote, "It is the worst moment for me to leave as your assistant unpaid mother because so much may happen to upset you and you might need a mattress. Keep me posted and God bless you and watch over you. I hate *hate* to leave you. I am constantly anxious about you. LOVE."

She must have been joking about the mother part, I thought. "Confidante" was more like it. It was only much later that I realized that I'd been blindly collecting surrogate mothers all my life, trying to fill the vast crater of my own mother's absence. The closest thing to a critical comment about me that Marga ever made was when I asked her advice about my hair: "Well, you have a lovely face. I wouldn't mind seeing a little more of it." My hairdo at the time included bangs that came to the top of my nose— like a horse with frontal blinders—but I liked it because I thought it might annoy my mother if her ghost was still floating around the ether.

I loved looking at Marga, especially her nose. It was patrician, with a deep indentation at the bridge. It looked like a nose that belonged in one of Masaccio's fifteenth-century aristocratic profile portraits, where the nose is always such a distinguishing characteristic that it makes you really, really want to know the sitter. Was that nose a result of genetics, or of an injury? I think Marga's nose had been broken, or perhaps she'd had surgery to remove a couple of cancerous spots, but it was a nose full of character and charm, a nose that made me wish my own were just a little more eccentric than it already was.

I was at a party. I was bored and about to leave, when I saw a cute guy watching me from the far end of the loft. He'd come in earlier with a thin, clingy young thing who wrapped herself around him whenever he talked to anyone else, but that didn't stop him from winking at me and giving me the full benefit of a sexy, lopsided grin. He had curly brown hair, a head like a boxer's, and a deep scar running from his hairline to his eyebrow—a hockey accident, he told me as he gave me a slow, head-to-toe look that made me feel he was sizing up the distance from his puck to my net. "Yale," he said offhandedly, when I asked him where he'd gone to school. "Philosophy," he grinned again. "And you?" "Connecticut College," I said, and although he smiled, I could see that I had gone down a notch in his estimation. "Oh, well," I thought, "he's a snob, and anyway, he's taken." And I was out the door.

I'd just started to think about dating again, but I still missed Michael and held on to the hope that perhaps we'd reconnect once we'd had enough time apart to reassess our lives. So I only gave the new guy a fleeting thought.

A week passed. It was 11:30 at night and I was curled up in bed with *The Magus* when the phone rang. A deep voice said, "Hey, it's me, Bob Fiore, let's catch the midnight movie on Times Square." I opened my mouth to tell him I was busy, but I was talking to the dial tone. "Okay," I said to myself, "what do I have to lose?" I ran a brush through my hair, splashed myself with Vent Vert, checked my underwear for holes, and wriggled into my jeans and sweatshirt. On with my cowboy boots, on with my battered leather purse, and I was set to go, a picture in solid black.

A month of midnight movies and countless bourbons later, we were an item. I fell hopelessly in love with his brain, which was a warehouse crammed full of rational opinions about everything, shelves packed with facts and figures about history, science, archaeology, religion, and current events, crates full of rare philosophical arguments, and a huge storage bin devoted to phenomenology alone.

Before a year was out, he had moved into my loft on Twenty-sixth Street, abandoned by a newly famous Roy Lichtenstein and rented to me without so much as a deposit. The place was small, one flight up from a grubby luncheonette, and although it had a huge window at the front facing the street, the light didn't quite reach to the living quarters at the back. The bed, a foam mattress on a wooden platform, was hidden behind a floor-to-ceiling bookcase; across from it was the bathroom, a disaster area with exposed pipes, a toilet, and a rudimentary shower.

No sooner had my new roommate unpacked than he'd built a wall closing off two-thirds of the space, including the one window, to use as his

studio. I still had my big old wooden desk, now moved to a corner on the other side of the bookcase, between the bed and the door, but I didn't care about my reduced space because, after all, I had him. He made films, which I thought of as more important and demanding, not to mention glamorous and expensive, than my own freelance work as a cataloguer of art collections and occasional reviewer for *Art News*. His first film, *Greetings* (Bob was the cinematographer), was directed by Brian De Palma and starred an unknown actor, Robert De Niro. It was an underground hit but a financial bust, saved from ruination by, I am certain, the grudging contribution of a few hundred of my own hard-earned bucks when Bob needed to buy a new blimp for the camera to replace the one that had cracked in the cold before they had even had a chance to start filming.

The movie, which eventually became a video classic, had about half a second of footage of me, enlisted as an unpaid extra for a party scene dominated by a gorgeous blonde actress who couldn't be trusted with a word of dialogue. But there I was, impossibly young and slender, with long dark braids and a joint in my mouth. One day, thirty years later, my husband and daughter rented the video and dragged me into the bedroom to see myself, frozen in time, leaning against the wall of a corridor looking convincingly stoned—because, in fact, I was.

———

In the fall of 1968, I joined a theater workshop led by the avant-garde director Richard Schechner at the Performing Garage on Wooster Street. Four months prior to the workshop, Schechner had presented *Dionysus in '69*, his contemporary retelling of Euripides' *The Bacchae*, at the Garage. It was a raw and sexual performance in which cast members interacted with the audience, whispering and caressing them, licking and kissing. There was nudity, dancing, drums, and blood. It was visceral, a total breakdown of the normal barriers between actor and audience and the concept of a theatrical play. It was playing that led to real pleasure in real time. De Palma, working with Bruce Rubin and Bob, made a film of one of the performances (I'm in the audience), released in 1970.

Schechner's was an intensely physical theater that combined movement with role-playing, and he also brought a knowledge of anthropology, sociology, religious ritual, and folklore to his productions. As a theorist, he

pioneered what is now commonly known as performance studies in the United States.

Although I was deaf in one ear and still had terrible balance from the motorcycle accident, I felt ready to challenge myself in a new way. What I found when I got to the workshop, though, wasn't what I expected. Schechner had just come back from Poland, where he'd met and worked with the famous theater director Jerzy Grotowski. The premise of Grotowski's training was to strip an actor of all props and costumes and plumb the depths of individual experience, emotion, and memory in creating what he called "sacred" theater. His idea was that if the body tried to do something really difficult, the mind would let go and open up, and vice versa.

Schechner used a method of training young actors by similarly stripping them down, demanding that they give themselves over completely to his direction, mentally and physically, but without the spiritual component that was so crucial to Grotowski's theater. In Schechner's case, acting was more about the nature of theater than the nature of the human spirit. It was boot camp without the K rations. We started with Grotowski's physical exercises, which combined movements from yoga, gymnastics, calisthenics, and martial arts, accompanied by elemental sounds from the depths of the body and psyche. The backbends, head- and handstands, pelvic twists, and flying leaps over somersaulting bodies were incredibly rigorous and precise, often executed at breakneck speed. I can tell you with certainty that this Jewish girl from the Jersey suburbs was not cut out for this sort of thing.

I wasn't a member of the Performance Group, Schechner's full-time resident ensemble, but part of the ragtag second string that met mostly once a week—for many hours—and wasn't allowed to perform publicly. A year and a half after our group formed, however, Schechner wanted to take *Dionysus in '69* on the road with his resident company, leaving the rest of us to perform in New York, without pay, while they were away. Disgruntled at being treated like inexperienced freshmen (which we were), we decided to leave the Garage and create an independent company. I don't think it occurred to us that, unlike the cast of *Dionysus,* we weren't professional actors prepared to devote our lives to the discipline. There was also the minor issue that we weren't nearly as good as they were.

The group, in a rare display of decisiveness, went looking for a place in the Catskills where we could spend the summer living and working together. We found a ramshackle, funky old farmhouse with some lovely, wild

acreage in Downsville, New York. It was the quintessential theater commune of the late sixties: nudity at will; silent breakfasts, using only mime to communicate; backbends on the dining room table; revelations of one's deepest secrets while using the toilet; sharing of boyfriends. We were strict about sharing our income, too, although I was the only one with a steady paying job. The two things nobody *was* willing to share were drugs and housework. Of course, our rejection of petit-bourgeois ideology gave us lots of time to attend important orgies and try out new recipes from Peg Bracken's *I Hate to Cook Book*. After a few months, I'd had enough. But I found irresistible and addictive the idea of making something out of nothing, which is the essence of theater.

Performance, no matter how unconventional or informal, offered a new way of understanding art and art making. Unlike painting and sculpture, it wasn't static or object-based, characteristics usually ascribed to the exalted realm of the fine arts. Yet there was a history of performance within the fine arts, too: not only had the Dadaists and Surrealists mixed it all up, but I was now seeing artists like Claes Oldenburg, Robert Rauschenberg, Allan Kaprow, and others presenting events they termed Happenings, which were interdisciplinary and anything but static.

The work of some of the most interesting artists between 1968 and 1971 overlapped at the peripheries of what had once been distinct disciplines. The innovative work of Yvonne Rainer, Steve Paxton, Meredith Monk, and Joan Jonas couldn't easily be categorized as dance or music or theater; it was a hybrid. Sculptors like Nancy Graves, James Lee Byars, Tom Marioni, Chris Burden, and Adrian Piper were making films and doing performances, while Barry Le Va, Eva Hesse, Richard Long, Lynda Benglis, and Richard Serra created works of art whose form was determined by the process of making, much as it was in Schechner's work or that of artist collectives, such as Fluxus, that considered the physical and psychological participation of the audience integral to their work.

And that didn't even begin to cover the artistic ground that was morphing beneath our feet. Change, movement, and challenge to the status quo permeated studios, alternative exhibition spaces, artists' hangouts like Max's Kansas City, and even—albeit rarely—the occasional museum or gallery venue.

———

In 1968, I was still doing freelance work writing reviews for *Art News* and cataloguing collections. One was in Columbus, Ohio—the Ferdinand Howald Collection of American Art—and the other was the personal collection of Marga and Alfred Barr, which Marga asked me to help her with.

The Howald Collection coincided with an area of study I knew well and was considering as the focus for my master's thesis, American art from 1910 to 1930. During the regular trips I was making to the Columbus Gallery of Fine Arts, where the collection was housed, I had access to early modernist works by Charles Sheeler, Arthur Dove, and Marsden Hartley, whose strikingly simple forms and luscious color made me want to learn every single thing there was to know about them, the artists, and the period in which they were made. Other pieces, like Man Ray's 1919 airbrushed still life *Jazz*, introduced me to a technique I'd never seen and made a connection between the language of art and that of music, something particularly close to my heart.

Cataloguing the Barrs' personal collection was a very different experience. I only had to travel to Ninety-sixth Street, and instead of sitting alone in an empty room in a museum basement, surrounded by stacks of books, I worked with Marga at her dining room table, scrutinizing a delicate Cornell box; searching for a letter from Jean Arp that would verify the date, origin, purchase price, and provenance of the bas-relief hanging in their hallway; and spending the lunch hour, both of us with sandwiches in hand, listening as Marga told me anecdotes about visiting Picasso in the South of France on one of their "campaigns."

While I was hunched over the catalogue cards, Bob was usually out with his friends, mostly other filmmakers and the artists and musicians he went to school with: Richard Serra, Philip Glass, Steve Reich, and from time to time their wives and girlfriends—Nancy Graves, JoAnne Akalaitis, Alanna Heiss. We'd go to midnight movies in Times Square several nights a week, and sometimes I'd be included when his friends got together to have dinner, but after a couple of years with him, it became clear that he was more of a loner than I'd thought. Whenever he got a job, he went out early and came home late, too wiped out to say hello. He took off for places like Alaska for weeks at a time, working on projects whose details were a mystery to me.

During one of his absences, I decided it was finally time to clean off my desk at home. Just before I threw out enough paper to reconstitute a small forest, I made one last pass through the trash bin to be sure I hadn't inad-

vertently missed something important. I did a double take. There, about to be consigned to the dumpster outside, was a letter from the director of the Whitney Museum, inviting me to apply for the job of curator. I stared at it, disbelieving. Once I realized that it wasn't a joke or a mistake, I set to work worrying, even though I hadn't even been interviewed for the job. How would I juggle graduate school, teaching, and reviewing, on top of a full-time job? Would I have to give up the freedom I had as a freelance curator?

Marga was wildly encouraging. She was traveling with Alfred when I wrote to tell her the news. She wrote back immediately and said, "This would be a glorious career with financial stability, recognition and authority to put forward artists you believe in. You could just finish your MA and never mind the PhD. No more courses, no cramming for generals, no agonizing thesis. If ever you wanted to go back to teaching, having worked at the Whitney would be an even better recommendation than a PhD. Alfred agrees with me completely and wishes to goodness that you were working in the MoMA. Please do not start up elements of doubt and impediment about preserving your liberty."

I made an appointment and prepared by putting on my best black jacket and skirt, deciding on stockings and high heels rather than my usual cowboy boots. Armed with a scarf, my briefcase, and a few Whitney catalogues, I felt that I had the dress-for-success situation in hand—so that at least I would be able to add the interview to my list of entertaining stories. But when I got to the museum and was ushered into the director's office, I felt the slight but unmistakable flutterings of desire. A job, an office, a secretary, a steady paycheck. And, of course, there was the art. Heady stuff.

John I. H. Baur, known to everyone as Jack, was dressed in a dark suit, a white shirt, and a sober tie, which, I would later discover, was what he always wore. When I walked in, he was slouched comfortably behind his desk, smiling. Surreptitiously glancing over at the bookshelves on the wall, I saw a row of framed pictures of his two daughters. They seemed to be close to my age, both energetic and independent-looking young women, relaxed and smiling self-assuredly into the camera. That put me even further at ease. Baur's questions were routine, kindly, easy to respond to.

"Why did you decide to go into art history?"

"What interests you most in the research you've done lately?"

"What do you think you'd like to do here if you were offered the job?"

We talked for a long time, and when we at last shook hands and said goodbye, the sky outside had darkened. The chill air made me suddenly aware that winter was around the corner, and I hurried home, going over the interview in my mind. It had been, in fact, more like a genuinely enjoyable conversation between peers. Graduate school had given me a thorough knowledge of the work of more established artists, but it seemed that I could also contribute something new to the discussion—a fresh perspective on art being made by my contemporaries, because many of them were my friends. I sensed that this was something the Whitney was actively looking for.

The second interview was daunting. My stockings twisted around in the opposite direction to my garter belt, cutting into my thighs. My shoes hurt, and my hair decided to seek its own escape route the minute the elevator doors opened. David Solinger, president of the board of trustees, had an enormous office with high ceilings, blinding white walls, heavy blue drapes, *old* art, and a rug that amounted to a field hazard. It seemed to take me five minutes in my heels to get from the door to his desk, which was the size of my entire apartment. I sat down in the chair in front of the desk, facing a small, square-jawed man who was so stiff and immaculate that he seemed almost to have been painted in place.

He delivered his questions in high-inquisitional mode.

"What makes you think you'd ever be able to do this job?"

"Are you married? Why not?"

"Do you plan to have children? How can you be sure you won't change your mind?"

It later became illegal to ask these questions in a job interview. But this was 1968, and the women's movement had barely begun. After about a half hour of questioning, I took a breath. "Let me tell you why you don't want to hire a woman. One, I won't be able to do budgets, because, as you know, women can't even balance their own checkbooks. Two, once a month I'll go crazy and no one will be able to reason with me, much less talk to me. Third, and most important, no one will want to take orders from a woman, so I'll be completely ineffectual no matter how smart I am. And of course,

I'll get pregnant within the year, so your investment in me will have been completely wasted."

I got up to leave. Unbelievably, a smile spread across his face. "Sit down," he said, "and let's talk."

A week later, the phone rang, and it was Jack Baur, telling me I'd been hired starting in January.

six: 1969-1970

January 2, 1969, I arrived at the Whitney at 9:00 A.M., took the elevator up to the fifth-floor offices, and introduced myself to the receptionist. She stared at me blankly for a minute, then said, "Oh, yes, Mrs. Tucker should be here shortly, and then she can get you started."

I stared back. "No, I don't think you understand. I *am* Ms. Tucker."

She looked at me doubtfully and rang Jack Baur's secretary to tell her that I'd arrived, then pointed the way down to the basement and my new office behind the library. It was closet-sized, but it had four walls, a door, a desk, and a phone, and most important, it was mine. I was getting settled, hanging my coat on a hook and trying the desk out for size, when Baur knocked on the doorjamb. We smiled, and then he squeezed himself into the extra chair and settled in for a brief speech.

"Marcia, I want to welcome you with the same words James Rorimer used to welcome Henry Geldzahler to the Metropolitan Museum: 'Hello. We don't expect to see a whole lot of you around here from now on.'" I was flabbergasted. My name and Geldzahler's in the same sentence?

"Help yourself to anything you might need," he added, glancing around my little office. "Perhaps you might want to check the storage racks to find some art to hang on the wall." He reached out to shake my hand and left.

When my head cleared, I realized that he'd just told me that this was not an office job. He expected me to be out in the field! I had a graduate degree

in art history, was a budding art critic, and had worked for some major collectors, but the fact that almost all of my friends were artists, writers, musicians, theater people, filmmakers, and art historians was what made me valuable to the museum. None of them were well known at the time, but I was part of a milieu that was changing the way people made, looked at, and thought about contemporary art.

Baur's welcoming comment encouraged me, in the most elegant way, to expand the field to include all of the United States.

I sat there and stared at the phone, thinking that I could call up artists anywhere in the country and ask to visit them in their studios and the answer would almost certainly be yes. It was hard to choose an artist, any artist, right off the bat, though, so I walked over to storage and stood in the huge gray subterranean vault while the art handlers rolled out rack after rack of paintings that I'd seen only in books.

There, unbelievably, was Arshile Gorky's *Portrait of the Artist and His Mother*. I was blinded by the real thing, which was as different from the slides and reproductions I'd seen as Mount Fuji is from its postcard picture. Gorky's mother, her head draped in a pale blue-green scarf, her eyes carrying the full weight of her life, sat immobile in sorrow, resigned, her hands like puffballs at the ends of her arms. The young Gorky stood slightly behind her to the left, looking out at me uncertainly, as if asking whether the tension and love between them were as real to me as they were to him. The whole picture was suffused with light, with energy, with history.

I pointed to it, and without even a glance, the art handlers took it off the rack and marched it over to my office, where it was installed within minutes. I couldn't believe that it was really mine—at least for a while.

For over a year, I lived with this amazing painting on my wall, until one day, in a reverie of gazing, I saw an unmistakable hairline crack creeping across its surface. I had to struggle with my conscience for a minute, thinking the crack wasn't really that bad and it may always have been there even if I hadn't noticed it until now, before calling the art handlers to have it picked up for restoration.

There's nothing like listening to a diatribe of your own making to change your mind. As a young curator, I had the bad habit of looking at a work of art that I didn't understand and announcing emphatically to whoever I was

with, "Jesus, that is a totally *stupid* idea. What on earth do they think they're doing?"

In January 1968, I had taken some of my students from the City University of New York, where I was teaching a class on twentieth-century art, to Bruce Nauman's first show in New York, at Leo Castelli Gallery on East Seventy-seventh Street. "This is junk," I said immediately. But after marching them out of the gallery, onto the street, I marched them all back in because I felt obligated to tell them *why* the work was so bad. The offending piece was a neon spiral spelling out the sentence "The True Artist Helps the World by Revealing Mystical Truths." "Works of art are not jokes," I declared. "They are not made of ordinary materials, and they don't look like a stupid bar sign. Words are not images, either. Images are art, words are literature."

I found Nauman's work upsetting because it didn't fit any of the usual definitions of art. In the midst of my rant, it occurred to me that the reason the work didn't fit any definitions was because he was making art that didn't look like art, and that was only part of what made it important. I went back to the show several times after that, and each time I went, the work revealed something new.

I was starting to see things I didn't normally see, and to understand how Nauman's visual language turned the ordinary world inside out. I realized I was going to have to abandon some of the ways I had previously made judgments about art, and I was leaving myself in suspension about how I would approach works of art in the future. Leo Steinberg once said, "If a work of art disturbs you, it is probably a good work. If you hate it, it's probably great." By the time I got to the Whitney, I couldn't wait to organize a show of Nauman's work.

We were two young curators in our late twenties, hired to strengthen the Whitney's commitment to contemporary art, to present the work of a new generation of artists. We'd been there less than a month, but by late January 1969, because we'd both seen work unlike anything we'd seen before and wanted to show it, Jim Monte and I had decided to collaborate on our first major exhibition. We agreed on what to do and when and how to do it. The only argument came from the artists in the show.

It was the title that bothered them. We were going to call the exhibition *Anti-Form*—a term the sculptor Robert Morris had used to describe ideas

that were central to his recent work, soft sculptures made of heavy industrial felt whose final forms depended on how he cut into it. The other artists also used a variety of unusual materials—sheetrock, neon tubing, flour, air, fishing wire, molten lead—not normally associated with sculpture. Wood, marble, clay, metal, all the run-of-the-mill materials, had gone AWOL. *Anti-Form* seemed an apt name for work that looked, at least to the uninitiated, as if it had no form. The complaints came pouring in.

"The title makes the rest of us look like his followers, even though he basically stole his ideas from us."

"It just doesn't address what's unique to my own work."

" 'Anti-Form' suggests that my work doesn't have any form at all, so I'm afraid I'll have to withdraw from the show unless you change the title."

As brand-new curators, we didn't know that it wasn't the artists' business to mess with our titles, that we could have told them to take a flying leap out the Whitney's fourth-floor window, that we had the authority to do what we wanted. Instead, we decided to change our title to *Anti-Illusion: Procedures/Materials.* At first, I worried that the public wouldn't understand what it meant. "Anti-illusion" might be too obscure, since it was a reference to the critic Clement Greenberg's theory that paintings should be free of both illusion and representation.

But no material was too strange, no challenge too great, when it came to the art itself. To me, it was better than sex, which says more about how stimulating I found the work than about who I was sleeping with at the time. We longed to show the world that art was no longer what everyone thought it was and would never be the same again.

Rafael Ferrer, a young artist from Puerto Rico, upended twenty-eight bushels of leaves and fifteen gigantic blocks of ice on the Whitney's entrance ramp, creating a visual and sensory experience that stopped people cold. It was a perfect introduction to what they'd find inside. In the gallery, Ferrer wanted to build a sixteen-foot-high pile of hay against the wall, first covering it with grease so the hay would stick. No problem, we said, simultaneously reaching for our telephones to locate an ice manufacturer, a farm, and a trucking company. Then we enlisted the chief preparator, the person in charge of actually installing the work, who would surely know what kind of grease wouldn't leave permanent stains on the walls.

Michael Asher, a California artist, planned to create a curtain of air that unsuspecting viewers would pass through. We nodded. Simple enough to construct a fifteen-foot soffit that could beam the air downward.

We reserved a very long wall for Eva Hesse's vast, gangly fiberglass and latex curtain, made in small sections in her cramped Bowery studio, and she was overjoyed to see it in its entirety for the first time. (It was heartbreaking, because it was also the last time; she was dying of a brain tumor caused by the materials she'd been using. No one had told her to use a mask while she was working, but then at that time no one knew how hazardous fiberglass resins were.)

When the Whitney's huge elevator opened onto the fourth floor, visitors would be greeted by an expanse of wall with the show's title and a single work of art that we hoped would epitomize what was to be found on the other side. We chose a piece by Bill Bollinger, a one-and-a-half-ton egg-shaped boulder he had removed, with considerable difficulty and at great expense, from the World Trade Center's excavation site. It raised the Duchampian question, Was it a work of art if the artist had simply found it and transported it to the museum? We thought so: who said art had to be made rather than found? We were sure that the boulder would be a perfect introduction to the show because it raised so many questions about what it was doing there. Nature may have been the original artist, but Bollinger was the one to put it into an appropriate context so people could see it as art. Or at least, so some people could. What was it supposed to represent? Nothing other than itself. What did it all mean? I got used to saying things like, "The most important works of art raise more questions than they answer." I believed it, but it was a tough sell in an art world that demanded answers.

"The exhibition [is designed to] give one much to think about but very little to see," said Hilton Kramer in his *New York Times* review (May 24, 1969). About the exhibition catalogue, he wrote, "The essays are art commentaries that manage to confuse every philosophical issue they touch upon." He was deep in conversation with Kant, whereas we were out dancing with Merleau-Ponty.

There were two ways to curate exhibitions. One was didactic, the other investigative. The first was the gold standard: art historians organized exhibitions to share their expertise with the public, to show them what was worth looking at and how to look at it. The investigative model was rarely used because it meant organizing a show in order to learn something, moving full tilt ahead without really knowing what the result might be. It's what artists, if they are not hacks, do all the time: they work without knowledge of the outcome. Why not take a cue from them?

"I don't know" is the honest answer when you're working investigatively, but it can get you into trouble. You're supposed to know, and if you don't, you're going to be seen as unprofessional rather than adventurous. But if you're commissioning works, you have no idea what they'll turn out to be, especially if the artist changes his or her mind—which happens all the time. I had to forcibly separate a guard from the artist Alan Saret, who, a week after *Anti-Illusion* opened to the public, walked in unannounced and began to rearrange his sculpture in front of visitors. We had invited Lynda Benglis to be in the show with one of the round, fifteen-foot-wide poured-latex paintings we'd seen in her studio, lying on the floor like a psychedelic carpet, but when she arrived with a narrow, forty-foot-long Day-Glo path, we couldn't find a place for it in the museum. Though it appeared in the catalogue, the work couldn't be included in the exhibition.

We also wanted to show a sculpture by Robert Morris that was a ten-foot-long rectangular piece of industrial felt, cut into bands that sagged into thick, elegant swags when the piece was attached to the wall at its corners. We thought this was a perfect example of how the act of making the work could become the work itself. At the last minute, however, Morris changed his mind. Instead of sending the felt, he borrowed fifty thousand dollars from a collector and deposited it in a bank, where it accrued interest for as long as the exhibition lasted. At the end, all that remained were nine framed documents recording the transactions—pure process. It was a very far cry from even the most unconventional art with which the public was familiar. Jim and I told ourselves that at least we'd saved on shipping.

Barry Le Va spent days sifting flour through a mesh screen over the Whitney's slate floor, working almost twenty feet out from a corner. It was a gorgeous and ineffable work, but we hadn't anticipated that some people would wait until the guards had their heads turned to reach under the rope-and-stanchion barrier and draw their initials or place a footprint in the pristine white surface. Their interventions were never intended to be part of the process, but it's easy for artists, and curators, too, to forget that museum visitors may not know what's expected of them.

Bruce Nauman's first corridor piece, *Performance Corridor*, was included in the show; Joel Shapiro's piece was made entirely of tangles of fishing line stapled to the wall; Richard Tuttle's contribution consisted of an octagonal piece of dyed cloth that appeared to have been randomly thrown on the floor. Still to come were performances that would confound people who, used to seeing actors on a stage, didn't understand for the life of them what was going on. Nauman bounced backward into a corner for over an hour

while a woman in the audience, clearly not part of the piece, moaned audibly, "Please, please stop, *please!*" The critics would question why we included the rhythmic, repetitive music of Steve Reich and Philip Glass in an art exhibition. But who said art had to be visual?

The day before the opening, with almost all the work installed, Jim and I stood in the middle of the fourth floor and looked out at our project like proud parents. Just then, there was a commotion, and a bald, spectacled, older man walked toward us, accompanied by the museum's press officer, who hovered over him like a hummingbird at its feeder. No wonder. It was Clement Greenberg, the famous modernist art critic from whom we'd derived our title. His mantra was that painting was valid only insofar as it stayed true to its inherent characteristics: canvas was flat, so the painting had to look flat; paint was paint, not a tool to create an image of anything else. No "pictures," no representations of things, no illusion. The formula left out most of the world's painters. I wondered what he made of our title, *Anti-Illusion,* which his ego probably took as a personal tribute to his own theories but in fact contradicted them. The work we were interested in wasn't about stripping sculpture of all references to things in the real world—no more three-dimensional nudes, for example—but about how the process and the product were one and the same, a new definition of sculpture altogether. There was hardly a painting in sight, unless you called Neil Jenney's pictures paintings, with their childish images of palm trees, a potted plant, pears, and the letter *E.* The bowls of dog food he'd placed beneath them surely confused the issue.

Walking up to Jim, Greenberg simultaneously stuck out his hand and his thick lower lip and said, "Nice work. This was an enormous undertaking. And it's sure to raise a few eyebrows." He chuckled. Jim grinned with pleasure and turned to me. "This is my co-curator, Marcia Tucker," he said. I held out my hand.

"You've done a wonderful job assisting Jim with his show," Greenberg said.

"No," Jim said. "We did it together. It was a collaboration."

Greenberg looked distracted. "Well," he boomed, "you certainly were a huge help." He took Jim by the elbow and led him off to a corner to talk.

The ornate, wood-paneled room, with its parquet floors, wall sconces, and aura of being too good for the minions who occupied it, was dark. Bodies

rustling, the sound of pages being riffled, an errant cough, a suspended moment of expectation. The professor, a handsome man in early middle age, walked to the podium, turned on the reading lamp, cleared his throat, and began. "As early as 1950," he said, "Rothko had not only eliminated all figurative elements from his work, he had reduced the number of rectangles to four or less and abandoned titles entirely."

It was an early evening in the spring of 1969, the *Anti-Illusion* show had just opened at the museum, and short of injecting caffeine directly into an artery, I didn't see how I would be able to stay awake to see the slides, much less to take notes on the material. I didn't care what Rothko had done or not done; I needed sleep. It occurred to me, not for the first time, that I couldn't be a curator at the Whitney and a PhD candidate at the Institute at the same time. But it was my last semester of classes, and I wasn't going to give up now. I had one course left to take, and then I could begin work on my dissertation. It seemed feasible, if I could only stay awake long enough to figure out what the course covered.

I had chosen this particular class, "Art since 1945," because I thought I already knew quite a lot about the subject. The Whitney had hired me on that basis, after all, and they seemed to know what they were doing. I assumed that the course would be easy, that I could pass the exams without studying much, and that the two-hour-long evening classes wouldn't interfere with my curatorial work. The Institute was only four blocks away from the museum, an easy sprint, and I had met the professor at a soiree at his loft, where we had spoken at some length about several works in his collection.

The slides flicked by, accompanied by a rolling, somnolent narrative that made me wish I had a quilt to tuck under my chin. I pinched my upper arm, hard, and tried to pay attention. There was a magnificent crimson, ocher, and cream-colored Clyfford Still painting filling the screen in front of us. The professorial voice seemed to come from a long way away.

". . . the authentic art of our time," he was saying, "as opposed to 'novelty' art, which seems to be so prevalent today, like that girl who makes plastic camels." I was suddenly wide awake. That was Nancy Graves he was talking about, and I had given her a show at the Whitney just two months earlier. She was a grown woman, not a "girl," and the camels were made of straw, mud, and wax, built on a life-size wire armature. No plastic anywhere. And the Clyfford Still he was referring to was familiar because I'd seen it in his loft two years ago. He owned the damned thing.

Several months before, I had visited the Mulberry Street studio that Graves shared with her husband, Richard Serra, a sculptor she'd met when

they were both students at Yale. Their loft was a long, dark cavern, a chaotic mess. Both Dick and Nancy had long, matted hair, and they dressed in bulky layers of old, paint-stained clothes. The bulk was for warmth, because their space heater worked only erratically. When I arrived, Dick said a brusque hello and left immediately. I was there to see her work, and they must have had an agreement about how they handled studio visits when they were both working in the same space. Dick's sculpture filled the front half, looking more like a scrap metal shop than a sculpture studio. In the back, in a cleared area, stood Nancy's work, three enormous, life-size, realistic camels. Camels? In a New York loft? At first, I had no idea what to make of them, but once I'd seen them, I couldn't get them out of my mind.

Graves's work raised complicated issues of representation—what's real, what's illusion, what's the role of art in separating or joining the two. The camels were pushing the boundaries of the avant-garde by using realism to subvert itself, but some might have thought that they were an elaborate hoax—which is the usual response to work that's unfamiliar or challenging.

I sat frozen while the professor droned on, his voice fading into the background. My breath sounded fast and hollow in my head, like a bellows on speed. What was I doing here? I thought education was supposed to be something other than feeding back the professor's own ideas—like maybe learning to think for yourself and doing original research to back up your opinions. That's what I was doing at the Whitney, but it didn't seem to be of value in this particular class. The problem was, not much research material could be found for work that had been made in the past five or ten years, much less five or ten minutes. On whose authority did the professor relegate those camels to the dumpster of "novelty" art? His own? The reviewers'?

I felt my leg muscles twitch, and before I knew it, I was on my feet, shoving my notebook into my briefcase, jostling my way past the knees of annoyed fellow students as I made my way out. Behind me, the next slide clicked into place. I didn't look back. Stepping out into the sunshine, I stood at the top of the marble steps of the James B. Duke House, shielded my eyes, and took a soldierly breath. I had paid hard-earned, nonrefundable money for the semester, which had only just begun. I was within sneezing distance of the advanced degree more prized by my family than a second home in Florida. And I knew that I was never going back to school again. I walked down the steps and turned toward Madison, back to the museum, where I belonged.

In 1968, I went to a church on Sixth Avenue to attend a Redstockings meeting, which was a turning point for me and the beginning of my commitment to feminism. It was extraordinary to find myself at a gathering of hundreds of women, all ages, all professions, straight and lesbian, who had come together to change the world. Even if we hadn't figured out how to go about it, we had a common purpose.

Listening to women tell their stories about discrimination, seduction, rape, abandonment, illegal abortions, custody battles, abuse, and unequal salaries (women always earned less than men for the same work), I felt a sense of recognition and belonging. More than half of us had been cheated on, to our faces and without apology. Date rape was common, although we didn't have a name for it then. Sex? Most of us were faking it, and always had. We laughed at how men could take apart a car engine with delicacy and precision but couldn't find their way around our anatomy. We talked about having kids, about not having them, about wanting them, about wanting them gone. As we came to understand the particular mechanisms by which we, as a "class" and, ironically, a majority, had been oppressed, the first result was rage.

About ten of us formed a consciousness-raising group as a result of the Redstockings meeting—probably the longest-lasting consciousness-raising group in New York, because we would still occasionally meet almost forty years on. Our group participated in marches, planned strikes, facilitated new consciousness-raising groups, and organized to support women both inside and outside art circles.

Feminism changed the way I wrote about art and art history and what goes into museums, and offered new ways of thinking about exhibitions. It provided possibilities for different readings of art history and a broad social context for individual interpretations. It encouraged alternatives to the traditional, textual forms of interpretation, such as oral histories, personal narratives, interactive strategies, and fictions.

Feminism also changed my writing style, which over the years became less formal. But that took time. The style I'd learned at the Institute was engraved on my brain in nineteenth-century cursive: never use the first-person singular (the word "one" is always preferable to "I"); avoid any hint of personal involvement with the subject matter; present yourself in the guise of infallible expert; and, above all, employ copious footnotes, even (or especially) when none are needed. Eventually, though, I stopped writing

with a disembodied voice of authority—I stopped saying "one must consider" and began to talk from a personal perspective.

In February 1969, a civil rights worker from Mississippi named Carol Hanisch wrote a paper titled "The Personal Is the Political," and this became the slogan for the women's movement. Feminist critique was making an impact on my way of thinking on a theoretical level, and I was beginning to understand that yes, the personal *was* the political, even if I hadn't quite gained the courage to put that into practice with regards to my love life.

Bob had gone out with some friends. I didn't ask where or with whom, determined not to question, not to get on his case. I wanted to make things easy, to get close again, so that we could enjoy each other, and I knew it was up to me. I'd found a terrific loft on the East Side, further downtown, that was going to be available in a month, and we'd put a deposit on it. We were making a fresh start. But the nagging thought persisted that it would never get better between us, that moving wouldn't make a bit of difference. I told the thought to go to hell. Back to work.

When I looked up from my work, the clock said 2:00 A.M. No word from Bob. I began pacing. Dawn crept up, turning the loft windows gray, then a luminous mother-of-pearl. The phone rang and jarred me out of the chair, but I was afraid to answer it. Three, then four rings, and I picked it up. The receiver weighed at least twenty pounds. His voice was thin at the other end.

"I'll be home in a while," he said.

"Where the hell have you been?" I cried. "Do you have any idea what I've been going through?" I stopped. Suddenly, I knew exactly what had happened, what it was I'd been so careful not to see all these months, these years. He'd been with Bettina, the long-haired, slender woman who was part of his out-of-town film crew. He'd been with her all along, only this time he'd fallen asleep.

"It's Bettina," I said dully. He didn't answer.

"How could you do this to me?" I asked.

There was a long silence, and then he said matter-of-factly, "Because I don't give a shit about you anymore."

I hung up the phone and cried so much that my eyes sealed shut and I had to put ice on them. He took my savings and moved into the new loft I'd found for us, and everywhere I went I saw him with Bettina. At Joan

Jonas's first performance, where she stood naked and slowly examined every part of her body with a mirror, they were sitting two rows in front of me, kissing. I ran into them on the street, in bars, at gallery openings, at my own openings at the Whitney. But just when I thought he'd taken everything, he inadvertently gave me the best gift of all. When Bob left me, I redoubled my commitment to the women's movement, and although we've had our differences from time to time, for over thirty-five years it's never once lied, stolen, or cheated on me.

seven: 1970-1974

I myself have never been able to find out precisely what feminism is; I only know that people call me a feminist whenever I express sentiments that differentiate me from a doormat.

REBECCA WEST, 1913

The early days of the new wave of feminism, the mid-sixties to early seventies, were packed with conundrums. One very problematic aspect of the movement, of which we were very aware, was that it was almost exclusively a white, upper-middle-class movement. If it was tough for *these* women to get ahead, it was nearly impossible for women of color.

African American women, with the striking exception of the activist lawyer Florynce Kennedy, were absent from the public face of feminism. Their concerns differed markedly from those of white middle- and upper-class women, and it wasn't until 1973, when Margaret Sloan and Flo Kennedy founded the National Black Feminist Organization, that their influence began to be felt more widely and writers like Gloria Anzaldúa and Cherríe Moraga, Alice Walker, bell hooks, and Michele Wallace became well known. Slowly, the debates about feminism in relation to class and race started to take place, and the situation today is better—at least in the United States. But the struggle for civil liberties and equality continues, encompassing race, gender, and sexual preference—it's the same battle, different forms.

Another problem came from the question of power and authority, critical issues for feminists in the sixties and seventies. Years later, I carried Jane Gallop's *Reading Lacan* around like a bible, fascinated with her idea of undoing authority from a position of authority. She wrote, "One can effectively undo authority only from the position of authority, in a way that exposes the illusions of that position without renouncing it." But before you can relinquish authority, you have to have it. The first step in exploring this notion is to understand and acknowledge one's own privilege, to make clear where one is positioned and from what position one speaks.

I was the first woman the Whitney had ever hired as a curator, and by then, the institutional climate had already been set. I did what I could from the inside—I could visit women's studios, I could write critically about their work, I could show their work, I could train interns, recommend qualified women for jobs, and offer opportunities for visibility, even if I didn't feel secure myself. I knew interns and volunteers who helped with an exhibition or a project rarely got their names in lights—if their names even saw the light of day. But I could do it differently. I could give credit on the title wall to the people who volunteered to work with me, or I could invite them to write a chronology or biography for the catalogue under their own names, or I could even give an internship a title that would look good on a résumé, something like "curatorial assistant."

I have always considered it part and parcel of feminist practice that those of us in a position to do so should support other women and serve as role models through internships and mentoring programs. The very first intern I had at the Whitney, Linda Cathcart, remains a close friend. When we met, she seemed much, much younger than I was—twenty-two to my worldly twenty-nine—but now we're the same age. It gives me tremendous pleasure that many of my former interns are now well-known museum directors and curators, critics, editors, writers, professors, and scholars.

On August 26, 1970, I urged my female co-workers at the Whitney to join the first Women's March down Fifth Avenue. We felt a galvanizing sense of solidarity as we set off with the thousands of other marchers.

Those of us who were activist art critics or curators daily encountered sexist attitudes on the part of male bosses and colleagues. Adding to the pressure were a group of women artists who, feeling rightfully powerless, saw us as wielding power from within the system, and they often attacked the Whitney in the press, on panels, and in demonstrations for not doing enough for them.

One night, Elke Solomon, the only other female curator at the Whitney, and I were invited to attend a meeting of feminists, mostly artists, at

Lucy Lippard's loft in SoHo. Thinking that we were going to be talking about common issues, we arrived, potluck contributions in hand, only to find out that the enemy was us. All night, we were on the defensive. Why didn't the Whitney include more women artists? What exactly were we doing to promote their work? Why weren't we visiting more women's studios, doing exhibitions of all-women artists? Elke and I were working hard to change the institutional assumptions at the museum, and being the target of so much anger and disappointment made me feel physically sick. I told them that I was not insensible to the discrimination, that it existed among the staff of the museum, too, and I asked that they let me help them without any active interference, that I felt I could do a better job for them that way.

A few months later, when a group of women artists staged a protest at the Whitney, leaving used tampons and smashed eggs in the stairwells, Elke and I were the ones on cleanup duty, but not for the mess on the floor. If this was feminism, the administration said, they didn't want any part of it. Reason and dialogue were the necessary tools, they said tightly, if any change was to take place; garbage in the stairwell only proved that the women artists' demands were unreasonable and that they were only interested in showing the museum in an unfavorable light. Elke and I spent months arguing with our male colleagues that equity and attention to the work of first-rate women artists was deserving, regardless of how they felt about actions taken against the museum.

The quality of the women artists' work was what won the argument every time. Elke organized the exhibition *Women in the Permanent Collection* in 1970, and I managed to organize solo shows at the Whitney for Ree Morton, Gladys Nilsson, Nancy Graves, Jane Kaufman, Lee Krasner, and Joan Mitchell, among others. I was also able to show artists whose work I found extraordinary but who hadn't had the attention they deserved simply because they weren't white, like Betye Saar, Jack Whitten, Alvin Loving, Joseph Yoakum, Fred Eversley, and Rafael Ferrer.

Today the landscape has changed so much that it's easy to forget how hard we had to fight for women and artists of color to receive their due.

———

In February 1970, I was working on a major solo exhibition of the work of Robert Morris. The retrospective was to include Bob's earliest conceptual

pieces as well as the huge felt swags and minimalist sculpture he was better known for.

I had concluded my essay about his work by writing that it was possible to understand his ideas only through direct experience of the work itself. It wasn't a brilliant observation, but I knew that, although Bob's simple forms were conceptually complex, it was the physical and sensory experience of the work that was truly engaging. I was particularly interested in the spectator's response, because the work seemed to demand active encounter rather than passive viewing. I was interested in art that defied categorization, respected its audience by challenging it in meaningful and complex ways, and spoke to issues in the real world of shared experience—not just those the art world was concerned with at the moment.

I had blithely registered how much I was enjoying the preparations when Bob showed up at my office door. He didn't sit down; he didn't smile. "I don't want a retrospective," he said. Installation was only eight weeks away, and the catalogue was ready to go to the printer.

"Why not?" I asked.

"I only want to show my recent work," he said. I didn't know then that almost all artists believe in the idea of linear progress in their work, and they want to show only the work they've just done because they're sure it's their best work—unless they're old and wise and understand their work as a continuum.

I did my best to convince him to reconsider, but he held his ground. I finally suggested that we have a retrospective catalogue, but an exhibition of all new work. The book would shed light on the new work, and it would be an unusual approach to the solo show. Bob liked the idea. I was relieved—it meant I would not have to scrap the catalogue I'd been working on for months.

The new pieces Bob wanted to show were a log spill (several tons of gargantuan logs, let loose at a dramatic moment to fall where they might— pure process); enormous steel I-beam sculptures (heavy); and a couple of monster felt pieces (relatively easy to exhibit). I switched gears and began to call companies doing heavy construction, rigging, and steelwork, in addition to the Whitney's architectural consultants and operations crew. We weren't sure the elevator cab could hold the logs, or whether the floor would sustain their weight when they fell. We weren't sure the floor could hold the weight of the show as a whole, for that matter.

Instead of having a formal opening, we decided to let the public have access to the museum floor as the installation took place. What was I thinking?

After days of meetings with the museum's insurance broker, lawyer, and public relations team as well as a seismologist, we were ready. The public came. The logs fell. To a giant collective sigh, the exhibition opened and nobody died.

I crawled back to work, trying to catch up on the correspondence and files now towering precariously on my desk. Then Bob showed up at my office door.

"I'm closing the show down," he said. "Tomorrow." It was May 17 and the show wasn't scheduled to close for another two weeks.

His decision was part of a joint political action by nearly a thousand members of the New York art community, who proposed a two-week blackout in galleries and museums to protest the war in Vietnam. As an activist, I agreed with what they were doing—I hadn't earned the nickname Marching Tucker for nothing—but I thought that the role of the museum should be as an active participant and that it was our responsibility to engage the public, not send them away.

I suggested that we drape the entire show in black for two weeks. No go. "I'm closing it down," he said, and so he did.

In 1972, I was asked to help organize the Whitney Annual, which that year was devoted to painting. We curators decided that this was the year for change and that we'd invite lesser-known artists from around the country to introduce new work to the public. It was a breath of fresh air that propelled us forward in search of the challenging, the unknown, and the unexpected. We arrived at the final day of installation exhilarated and exhausted, putting the last touches to what we thought was a great show of new, different, and decidedly avant-garde work.

At this point, who should walk onto the floor unannounced and unexpected, and to the consternation of guards and staff, but a wizened old gentleman, carrying a very large painting. In a thick German accent, he announced, "I am Josef Albers, and I have brought my painting to you." He'd been asked to participate in the Annual every year for a long, long time and had simply assumed that there had been some mistake when he didn't receive his usual invitation. What did we do? We thanked him effusively and made room for the painting!

The Whitney paid the usual not-for-profit low salaries, but vacation time was generous—a full month each year, and I used it to travel, visit artists, and continue my theater studies. One steamy summer, I left New York and went to American University in Washington, D.C., to take courses in voice, storytelling, circus arts, and African drumming.

I also spent time with the artist Anne Truitt, who lived in Washington in a big house with lots of rooms, good smells, cozy places to sit, and her perennially busy children. She stayed amazingly calm and centered, attentive to the needs of her household and at the same time completely focused on her work, and she did it all without a lot of fuss.

Anne's paintings and sculptures were pale and minimal, nuanced studies. They were like atmospheres, temperatures, times of day, or states of mind more than objects. I was used to artists who hung out in bars and argued ferociously about a lozenge or dot shape in a painting—Was it more valid than a rectangular one?—as though only one person's vision was the right one. Anne, in contrast, pretty much kept to herself, trying to find out why she was doing what she was doing rather than comparing it to what anyone else was up to. I took heart from seeing that it was possible to stay modest and low-key and still do the work you wanted to do, that being competitive might actually muddy or even obliterate your own vision because you were so busy comparing, looking over your shoulder.

In my early days at the Whitney, only the tiniest whiff of unease marred what I felt was otherwise the perfect job. Shortly after I started, Lloyd Goodrich, Jack Baur's predecessor as director, had asked Jack for my help with research for his Georgia O'Keeffe show. When Jack relayed the request, I stood still for a moment, knowing that a lot depended on my answer. "Jack," I said, "you hired me as a curator, not a research assistant. My job is to find and to introduce new artists to the public and to organize my own exhibitions. I'll be glad to help find Lloyd a graduate student who can help him, but that's not my job."

"Oh," he said, looking somewhat startled. "Yes, of course, you're quite right. I'll ask personnel to find someone. Thanks."

But the removal of the Arshile Gorky painting that hung on my office wall for the first year or so of my tenure at the museum forced me to see my work environment for what it was. The walls of my office started closing in, looking more beige and drab by the minute. The desk seemed to get bigger, the bookshelves I'd asked for groaned under the weight of hundreds of catalogues that made the room seem even more cramped than it was, and I couldn't have more than one visitor at a time. I had no assistant, a lousy salary, and a windowless basement office the size of a dumpster. I had been so happy to be able to spend my time with artists that I had neglected to look out for myself in the institution or to consider that my youth and gender might have had anything to do with how I was asked to work.

Then one day, my colleague Jim Monte told me that he was earning more money than I was. He and I had become good friends and he thought it was unfair, so he just blurted it out without warning. The minute he told me, my mouth turned to copper. I felt like bludgeoning the messenger, even while I was overcome with gratitude that he'd let me in on the ugly secret. The museum had hired him at the same time that they had hired me, with the same title and job description, but they'd been paying him about two thousand dollars a year more than me. In 1969, two thousand dollars was almost a fifth of my yearly paycheck.

Baur knew I deserved to be paid more. I had done what he had hired me to do, which was to help change the museum's profile from that of a traditional, slightly fussy little brother to the Museum of Modern Art to a dynamic, provocative venue for contemporary art with its own identity. But I knew exactly why there was a salary discrepancy.

I wanted to storm Baur's office that minute, but instead I made an appointment to see him the next day, when I'd cooled down. I started by asking him to move me upstairs to a space, any space, where there was a window. I also asked for a change of title—from Associate Curator to Curator of Painting and Sculpture, eliminating the implication that I still had one last rung of the curatorial ladder to climb. These two were easy; Baur agreed.

I then told him that I was delighted with the move upstairs and my change of title, but that I needed his help with a new problem. Someone once told me that, contrary to assumption, anyone whose advice you ask is beholden to you. Now was the time to test the theory. When Baur cocked his head and asked what the problem was, I explained my dilemma about the discrepancy in pay.

"What do you think I should do?" I asked.

His immediate response was something I've heard many times since, from my own lips as well as those of others. Out came the mantra "the budget," bracketed by a sigh. I tactfully wondered aloud how he'd feel if his daughters—both scientists, I'd discovered—were being paid less for their work than their male counterparts. That stopped him for a second, but then the magic words were back. So, taking a breath, I opted for the tactic of last resort.

"Well," I said, "there's always writing for *Time, Newsweek, Art News, Artforum,* the *Nation* and the *New York Times.*"

My litany seemed to rouse him from his fiscal reverie. "We'll see," he said. I thanked him for his time and left, gently closing the door behind me with the restraint of a Zen master. Two days later, I got a memo from the accounting department. "Salary adjustment in effect as of April 1," it read.

I was now receiving equal pay, but not for equal work. By 1973, I had logged six major exhibitions, two Whitney Annuals, fourteen small solo shows, several permanent-collection installations, hundreds of studio visits, and at least ten trips across the country to see the work of artists in places most New Yorkers didn't seem to know existed, like Rapid City, South Dakota; Fresno, California; Fort Madison, Iowa; and a couple of obscure towns in Louisiana. This frenzy of activity on my part was the beginning of a runaway work ethic, no doubt modeled on my father's idea of a reasonable nineteen-hour-a-day, six-and-a-half-day workweek.

———

One night in 1971, the furnace of the building where I was living on Twenty-sixth Street exploded for the umpteenth time in a year, sending all of us hapless tenants out on the street in our underwear. I swore I'd never rent from anyone ever again.

My friend, the sculptor Ken Snelson, had found a century-old brick building on Sullivan Street in SoHo that had been the E. & A. Fredericks Art Supply factory, and he convinced me to buy a small studio in it, one that I could afford. Once I saw the larger loft spaces in the building, though, I opted to go for broke. Literally. The down payment was ten thousand dollars, which was a fortune to me. To come up with the money, I sold my mother's diamond engagement ring, and every time I gave a lecture, I'd think to myself, "In an hour I'll have the sink, the toilet, and half the bathtub." It was worth it, because I lived there for the next thirty-four years.

To live in the co-op, which was designated as an Artists in Residence (AIR) building, you had to be an artist, but that wasn't a problem because after fleeing the theater commune in the Catskills a few years earlier, I had started another group without too much trouble, this time made up of artists.

We called our band of about a dozen the Mighty Oaks Theater Company, and now we could meet at my place, where I set up an area at one end of the loft for our musical instruments, props, tape recorders, and anything else we needed.

For a short time, I led the workshops. Then we all took turns directing, periodically inviting guests to work with us until we evolved our own, unscripted material. The group lasted ten years, and we performed three finished pieces during that time (our first public foray was at the Kitchen in 1975)—"the longest rehearsals in history," as one friend put it.

I was one of the few feminists who didn't have problems with the man I was living with. I had first met Tim Yohn on the boat to France back in the fall of 1959, because he was part of the Sweet Briar College junior year abroad program, too. He looked like a young Anthony Perkins, only better—tall and thin, with a shock of light brown hair falling over his forehead, a wide grin revealing slightly crooked teeth, and intense gray eyes. He was one of the best-informed people I'd ever met, a hardened news addict and a budding writer, which automatically made him interesting to me. More important, he didn't seem to mind my staying drunk the entire way over to France, passing out and throwing up in clockwork cycles—I was *that* happy to be away from home.

When we got back to the States, we settled into an easy friendship. We both married at about the same time and our divorces were practically synchronized. After Bob left me, I was ready to meet someone who was present and accounted for. I looked around and there was Tim, still as handsome and interesting as ever. We liked the same things—reading, talking, cooking, traveling. He was gregarious. He enjoyed my friends and respected my work. He was now a trade editor at McGraw-Hill, a job he was good at and liked. He was sweet. I perked up. One night, we decided to take the friendship to another level. A few months later, he moved in with me.

Once again, I was in love. Tim was smart, talented, and caring—a deadly combination for someone like me, whose shaky sense of self was camouflaged by a hard crust of cynicism, avoidance, and despair.

We also had an "open" relationship, the kind that the early seventies embraced as "hip." It meant that whenever one of us was out of town, we were free to sleep with whomever we liked, as long as it wasn't under our shared roof. We thought of this arrangement as a way to avoid the inevitable boredom and jealousy of a long-term relationship. It was also a way to avoid intimacy, but I wasn't ready to own up to that yet.

I sought escape in my job. I worked blindly, compulsively, joyously. My father had worked like that, and I saw no reason why I should mess with what he knew best. When there are no spaces between events, when everything you do has the same urgency, when you wake up in the dark with long lists already in your head, when you sit straight up in a panic, planning trips, writing letters, making phone calls before you even know you have to make them, watching yourself negotiate through a meeting that you haven't had yet, you can't stop and ask what it all means, because you're too busy. While being frantically busy is something many of my colleagues in the museum field pride themselves on, I now see it as a chance to make sure you never get to think about, experience, or feel anything deeply at all. At that particular time in my life, that was just fine by me.

Whatever our issues were during the eight years we lived together, Tim was not a sexist. We split everything down the middle—cooking, cleaning, all the costs of shared living. He supported my work enthusiastically, and since he was a professional editor, he volunteered to edit everything I wrote. He understood feminism as a political necessity and tried to live according to his convictions.

Tim was as supportive as anyone could possibly be, even helping to organize a men's group that followed the same consciousness-raising format as my women's group, exposing stereotypes that limited men's lives as well as women's. Most of the men were in relationships, and I assumed they were all straight, although I wouldn't have known one way or the other because what went on in our groups was confidential. If the men were more political in their approach and the women more personal, well, that was our conditioning. In fact, it gave Tim and me a chance to talk to each other more deeply about who we were, what we wanted, the world we lived in, and the world we wanted to live in.

At work, it continued to be another story. The thing that bothered me the most wasn't the lack of respect I received from some of my co-workers who were in a position to make my life miserable. They'd brush me off by not answering my requests, or put perverse obstacles in the way of any reasonable suggestions I made, or comment on me in my presence. It wasn't the sexual innuendoes I had to dodge constantly, being young and normally attractive. It wasn't even the senior co-worker who once slid behind me at my desk when I was working late, creepily massaging my shoulders. Instead of asking him to leave, I had to maneuver out of the situation without hurting his feelings, leaving his pride intact, or I might have found myself without a job. I could handle even that.

But two guys on the installation crew really tormented me, constantly whispering asides about my appearance and qualifications. I couldn't imagine what I looked like to them, but I knew, whatever it was, it wasn't an authority figure. They might have to honor my requests, but it didn't mean they had to respect me.

When I was asked to install the permanent collection galleries for the first time, I got to the floor early, wearing jeans, sneakers, and a big work shirt. I said good morning amiably as the crew filed in with the works I had chosen. Then they stood watching me, waiting to see how I was going to handle the installation, given what they assumed would be a lack of knowledge when it came to tools, measurements, hardware, lighting, and wiring—guy things. I asked them to start placing the works against the walls, indicating where each one should be. They didn't say a word, but they moved more slowly than necessary and gave me challenging looks whenever I asked one of them to move a piece back to its original location.

I pointed to a large Marsden Hartley. Sighing, I said, "Can you hold that one up, please?" Two of the men picked it up and held it lackadaisically against the wall. "Can you move it over just a bit?" I asked, gesturing.

"Move it a cunt's hair to the left!" one of them said loudly. The painting moved imperceptibly. I didn't react.

"A little more, please," I said, pretending that I hadn't heard them. The painting shifted again. "That's fine, thank you. You can put it up." I felt queasy.

I had no idea what I would do if this continued. I also knew that I wasn't going to be driven out of my job by the installation crew. At the end of the day, I asked around and found out that some of the men were artists. They were the ones, it turned out, who had seemed most reluctant to join in the fun.

One by one, over a couple of months, I asked to visit their studios. I spent at least an hour in each, talking about the issues in their work, about the state of the arts in general, about shared interests, about other artists. Once I had established myself in a new relationship with them, things began to change. They must have talked to the rest of the crew, who slowly became helpful, even—on rare occasion—enthusiastic. Installations were starting to be fun, and I began regularly asking the crew's opinion as we worked together. It made for a better show, and ultimately we became colleagues, sometimes even friends. I appreciated their suggestions and learned a lot about how people who weren't artists or art historians looked at art.

Then I had an idea, something that departed radically from normal museum practice. I asked Baur if I might invite the art handlers to choose and install a permanent collection show. They knew the collection best, I argued, and might offer a new perspective. A number of them were artists themselves. It would strengthen the relationship between the curatorial department and the crew, which under the best of circumstances was always tense. It was foolproof, I insisted. To my astonishment, he agreed.

It turned out to be a terrific show, and, as I suspected, they chose unusual works that hadn't been seen often. They gave the public a fresh view, whether deliberately or not, and the staff a new feeling of respect for the crew. And no one ever made it hard for me to install an exhibition again.

Proof that I was finally accepted as "one of the guys" came in 1974 when I arrived at the museum one morning dressed in evening attire—an exhibition by Ray Johnson was opening that night and I knew I wouldn't have time to go home to change clothes. One of the crew saw me coming, glanced at my high heels, black stockings, and miniskirt, and turned to the others. "Hey, guys," he yelled. "Tucker's in drag!"

———————

It took a few years of mentioning Bruce Nauman's name at every other staff meeting to have his exhibition become "the Nauman show that Marcia's been talking about forever."

Finally, in the spring of 1973, I stood in the middle of the fourth floor of the Whitney with Bruce beside me, installing his retrospective, which I co-curated with Jane Livingston at the Los Angeles County Museum of Art.

Bruce and I were testing the video monitor we'd mounted high in a corner. It was running a video he had done that consisted of him walking back

and forth in his studio, playing the notes D, E, A, D, over and over on a violin. No, he didn't know how to play the violin, as the awkward screeches he produced proved. And yes, it was tedious to watch him repeat this effort over and over with the same result—although I must say, I don't mind being bored for twenty minutes if it gives me something to think about for twenty years. That a visual artist was making music—a genre normally outside the realm of visual art making—and that he made no effort to display any kind of musicianship or technical ability beyond making the squealing sounds of each note, made his work utterly fascinating to me.

When I was a little girl, I would daydream about what it would be like if you could be yourself but see the world through someone else's eyes at the same time. I wanted to choose who that someone else was, of course, because otherwise there might not be anything interesting to see. (That's the arrogance of the very young, but a fantasy is a fantasy, for better or worse.) I imagined lowering myself down into someone else's body feet first, lining up my toes inside theirs, fitting my fingers one by one into the other person's hands as though into a glove of flesh, matching our belly buttons, and finally, eyeball inside eyeball, looking out onto the world with pellucid double vision, mind and body, theirs and mine, in perfect harmony.

Suddenly, I realized that the sensation I was having while installing Bruce's show was like my favorite fantasy come true—the feeling of being able to inhabit someone else's body and vision without giving up my own autonomy. I was seeing what Bruce saw, but as myself.

It's one thing to want to create something, another to spend your life interpreting what someone else has made. At that moment, I understood why I had become a curator.

———

Sometimes it's hard to work with artists, not because they're demanding or because the art is complicated and difficult to put up, but simply because they're so vulnerable. I like installing shows with the artist present when the nature of the work demands it, because I have a chance to become engaged more deeply with the work, but if the exhibition consists of discrete objects, I prefer to place the pieces myself. I try to leave at least a day after I've finished hanging the show so that the artist can see what I've done and make any last-minute changes before the show is scheduled to open. When it works for me, it usually works for the artist, too, but it's hard to keep some

artists away from the installation process, especially when they're unhappy or insecure about their work.

In early 1972, I was working with James Rosenquist on his first museum retrospective, scheduled to open in April. To research the show, we hung out together, racing around town on errands, darting in and out of his studios, checking slides, having dinner, looking at billboards, and talking, talking, talking. Jim was fun to be around, consistently witty, entertaining, energetic, and smart. He had an impish grin, a yellow halo of wispy, flyaway hair, and a tall, wiry body that was always in motion. When it came to installing the exhibition, though, Jim became irritable and distant. Granted, he was distraught: he had been the driver in a recent car accident in which his wife and son had been badly injured. It took a lot for him to focus on the exhibition in the midst of so much pain and uncertainty about their recovery, but his distracted state made it hard for me to do my job.

The day before the opening, when everything was laid out and most of it hung, Jim decided that he didn't like the way one room looked. We talked it over and tried a number of his suggestions, but he still wasn't happy.

Finally, Jim decided to ask his dealer, Leo Castelli, to come by and help. I was dismayed by his lack of confidence but told him to do as he liked. I took Polaroids before taking the paintings down, though, just in case I needed to put them back the way they originally were.

Leo arrived, kissed me, and set about reinstalling the gallery. When he finished placing the works, he looked at me apologetically. But I was delighted: his placement and mine turned out to be virtually identical. Poor Leo; he was the only man I've ever met who could look embarrassed and dapper at the same time. "*Cara,*" he murmured into my ear. "You are so right. But we must always humor the artist, no?"

Even though Lee Krasner had a reputation as a tough old bird, we got along well. Things went smoothly while we were planning an exhibition of her large paintings, but when I told her she couldn't watch while I installed her work, she reacted as though I'd stabbed her with a pitchfork. I'd learned the hard way that if I didn't do it by myself, the show would never open in time.

Besides, hanging the work was my favorite part of the process. This time, it was also a reward for spending endless weekends alone with Lee in East

Hampton, never leaving the house, while she reviewed every single aspect of her life, obsessively cataloguing the ideas that she said her husband, Jackson Pollock, had borrowed from her. I admired her work enormously and felt that it had been seriously neglected, but her use of the royal "we" to refer to herself got on my nerves, and I was always hungry when we worked: either Lee couldn't cook or she didn't like to eat. More likely, her attention was elsewhere.

When I finished placing the paintings, I called her and told her the show was ready for her to look at. She harrumphed and hung up. Twenty minutes later, there she was, wrapped in a fur coat, looking and acting like Her Majesty the Queen. She sailed by me without saying hello and marched through the fourth floor as though she were reviewing the troops, hoping to find at least one soldier with scuffed boots or bad posture. I trailed her at a distance, not wanting to be in the line of fire if something displeased her, but she didn't say a word. Forty-five minutes later, I caught up with her as she leaned against the wall in one of the small back galleries. "You know," she was murmuring to herself, "I'm a pretty damn good painter."

Joan Mitchell was a really good artist and a really bad drunk. In 1959, she'd moved from New York to Vétheuil, France, near Giverny. I went to her house, where Monet had once lived, in the spring of 1974, to work on a full-scale exhibition of her paintings. It was early afternoon when the taxi let me off at her front door, which was ajar. I pushed it open, stepped inside, and dropped my bags. Joan was sitting in the living room with a group of friends. She peered at me for a moment through her huge, thick glasses. Even the dark hair and bangs that obscured most of her face couldn't conceal her grimace of distaste. "*Alors,* Madame Whitney has arrived," she announced dismissively, without getting up from her chair. She didn't bother to introduce me to the others. That evening at dinner, gesturing toward the jet-lagged remains of my body slumped into an armchair, she announced to her friends, "Madame Whit-neey is doing a show of my work because she needs something to add to her list of feminist credentials." I took my head out of my hands and told her that it was too bad she thought so little of her own work. That shut her up for at least a minute. When she'd had a bit more to drink, she snarled, "And what makes you think you're so smart? What do you know about Abstract

Expressionism—or any kind of painting, for that matter? You're just a baby. I can't imagine why they hired you."

Each day, a variation on this theme would blossom like an evil extraterrestrial plant, sprouting tentacles until it filled the room and crowded me out. It was hard to escape when she went into attack mode, because I was staying with her. No sooner would I walk out in frustration than she'd find some excuse to come after me, all friendly and smiling, and drag me out to the studio behind the house so we could "work." After one particularly grueling session of insult-and-seduce, I went back to the kitchen to get a cup of coffee, and there was Jean-Paul Riopelle, the Canadian painter who was also her lover, even more drunk than she was. He gave me a quick, leering once-over and grabbed my hand to kiss it just as the door opened. Joan had followed me in from the studio. When she saw us together, she turned on him and yelled in French, "She's here for *my* work, asshole, and don't you forget it. I'm a better painter than you'll ever be!" His response was to pick up his *oeufs à la plat* and throw it at her head. I ducked as it went whizzing over me and fled to my room for the third time that afternoon.

Late that night, I heard a terrifying crash and the sound of falling glass, as if someone had thrown a chair or god-knows-what through a window. I desperately wanted the solace of a double bourbon, but after my first day at the house, I'd developed an ulcerlike condition that made it impossible for me to drink alcohol. As I went back to bed, I thought I'd be lucky to survive the night.

In the early morning, I packed up my things and went to a nearby inn, leaving Joan a note that said, "Meet me for lunch at 1:00." She never got up before noon, but I thought that at least this way I had a fighting chance of talking to her early, before she sank, burbling, to the bottom of the scotch pool. To my surprise, she darkened the door right on time, wearing enormous sunglasses and wrapped in a long green scarf. She sat down, beckoning the waiter for a drink. As she looked across the table at me and opened her mouth to speak, I stopped her.

"No, not this time," I said. "You listen to me. I've had enough. I can't work this way, and I won't. If you want the show to happen, then you're going to start behaving, stop insulting me, and get to work. If not, then I'm finished here. I don't need to do this show, and I'm just about at the point where I don't want to." There was a long silence as she stared me down. Then, to my astonishment, she muttered an apology, patted my hand, and asked me if we should include the painting *Wet Orange* in the show. "It's

small, and seems a little incongruous with the other recent work," she said thoughtfully.

The exhibition opened on March 6, 1975, without another murmur from her except to tell me how much she loved it and how happy she was with my catalogue essay. "Of course," she added, "you *would* have to make one really stupid mistake." I had referred to a color as "blue-black" when, she said, it was really a very, *very* dark brown. I gave her a kiss and told her she was a bitch on wheels.

eight: 1974-1976

In 1974, when Jack Baur announced his retirement, I was stunned. "How could you do this to me?" I blurted.

"Oh," he said with a chuckle, "it's time for me to get back to my Burchfield book. I've missed writing."

I wanted to whimper. Instead, I congratulated him and told him how important his scholarly work was and how happy I was for him that he'd be getting back to it.

Then I went into my office, closed the door, and seriously considered teaching kindergarten as a fallback position. I knew that without Jack's support, doing the work I wanted to do would be like trying to cross the Atlantic in a canoe.

When I used to talk about Jack to my friends, I would always say that I would lie down on the yellow line dividing Fifth Avenue for him. (Those were the days when it was a two-way street!) I not only respected him, but I loved him as well. When my father died, I was a secretary at the Museum of Modern Art and I suspected that he was disappointed in me. Jack, who was probably about the same age as my father, believed in me and acted on that belief in every way; it was thanks to him that I started finally to believe in myself as well.

When he welcomed me to the museum that first day and put me—a twenty-eight-year-old neophyte—on a par with Henry Geldzahler, it was

dazzling enough. But then to encourage me to go out into the field—that was truly inspiring, and so I took off. And Jack supported me over and over again, in so many ways.

When I asked him why he read everything that I wrote, he said, "Well, first of all you're writing in an area of expertise that isn't my own, so I look forward to learning something. Secondly, if you're attacked, I'd like to be able to defend you intelligently."

His last year at the Whitney, I did yet another exhibition that was really controversial, and the critic Hilton Kramer demanded that I be shown to the door. There were other harsh reviews, too, but I will always remember Jack standing at the doorway to my office, reviews in hand, looking somber in his dark suit, with a scowl on his face. I thought, "Uh-oh, this is finally it." To my astonishment, he tore the papers into tiny bits and flung them in the air. And then he winked.

Jack valued ideas above all, was never expedient, and was scrupulously ethical, fair, open-minded, and adventurous. He wasn't a management person, he wasn't a money person, and he wasn't a fund-raising person, although he was as good at all of those things as most. I tried to model myself on him, in (alas) a very rough fashion, having no other models to turn to with the kind of admiration that he inspired in me.

Years later, Gertrude Vanderbilt Whitney's granddaughter Flora Biddle wrote a book about the museum and, to my astonishment, said that I'd been considered as Jack's successor. It's hard to imagine that my candidacy would have been given anything other than a cursory glance. There hadn't been a woman director at the Whitney since Gertrude had founded it, and there was the minor problem that early on I had been cast in the role of house radical—a useful view for those who needed a scapegoat for anything the public found too far-out.

When I fought for greater diversity in the museum's exhibition program, I thought I was just doing what needed to be done, but it made me a crazed activist to those who thought that all the interesting and important artists had to be white guys living in Manhattan. Perhaps strangest of all, I had the idea that art wasn't just painting and sculpture, which turned out to be a concept so upsetting to some as to threaten the museum's existence.

But that's what really interested me: blocks of ice and leaves; sixteen-foot-high piles of hay; forty-foot-long liquid "pours" of latex paint; films that had no beginning, middle, or end; an empty room whose hidden audiotape whispered, "Get out of the room, get out of my mind."

Fortunately, I wasn't alone in my convictions. There were others in the field, especially in Europe, who found this work compelling, and they weren't all artists. In the United States, dealers like Klaus Kertess, Leo Castelli, and Dick Bellamy were the first to venture out. Articles were being written and published, arguments generated by individual artists, group shows staged, but this new idiom hadn't penetrated the bastions of the museum world yet. I was interested in sharing something radically new with an audience that was much broader than a gallery or alternative space could provide.

But once Jack left, my position as house radical blossomed, not just because I was interested in work that caused most people to say, "That's not art!" It was also because when I was asked my opinion, I gave it. It never occurred to me not to say what I thought, though I did try to be diplomatic.

I hardly kept my politics a secret. I was a civil rights activist, an antiwar demonstrator, a die-hard feminist. At one staff meeting, a curator proposing an exhibition of painters of the American West referred jokingly to the show as "Cowboys and Indians." The museum's administrator said in a stage whisper, "Shh, don't say that in front of Marcia. You have to call it 'Cowpersons and Native Americans'!" Whenever fellow curator Elke Solomon or I would mention the name of a woman artist—*any* woman artist—eyes would roll upward and there'd be an impatient, exaggerated sigh or two around the conference table.

Even so, I was determined to slide gracefully through the transition to a new director because I was in a seriously codependent relationship with a museum that had, after all, nurtured and trained me.

In January 1974, the board named Tom Armstrong director. He came from the Pennsylvania Academy of the Fine Arts, an institution more historical than contemporary, whose mission to exhibit, collect, and preserve American art matched that of the Whitney. Nothing in his background suggested that trawling the outer reaches of the aesthetic lagoon for unrecognized art forms was going to be a priority.

A major exhibition, *200 Years of American Sculpture,* was being planned for 1976 in recognition of the national bicentennial, and each of the Whitney's curators, myself among them, was asked to write an essay on one aspect of it. My essay, "Shared Space: Contemporary Sculpture and Its

Environment," gave me a chance to think through an issue that fascinated me—how sculpture occupies space compared with how space is used in everyday social interactions. In contrast to the permanent, representational three-dimensional objects that had defined sculpture in the past, the new sculpture was ephemeral and interactive. I argued that the work of Robert Morris, Bruce Nauman, Robert Smithson, Richard Tuttle, Barry Le Va, Nancy Graves, and Richard Serra, among others, was responsible for what I saw as a major shift in the way art was being made and experienced. After my fourth revision, I handed the essay to Tom, hoping I'd finally be in his good graces.

It came back scrawled all over. I had described a Carl Andre piece—composed of over fifty twelve-inch-wide, four-foot-long orange Styrofoam blocks laid out end to end—as a "horizontal stack," but Tom had crossed it out and written "vertical!" over the sentence. Overall assessment? "Not acceptable. Needs to be rewritten." Tom gave my essay to Barbara Rose, an art critic whom he was considering, someone later told me, as my replacement. She didn't think much of my writing, Tom said, and he wanted me to rework it. I suggested that he give the essay to Jack Baur, who was happily retired and working on his Burchfield book. Whatever Jack's opinion was, I'd abide by it. Tom reluctantly agreed. Three days later, Jack sent it back with helpful suggestions, including cutting several paragraphs to strengthen the opening. He attached a memo with the following comment: "There will be people who will not understand her text, but they are the people who will not understand this kind of art, no matter what is said about it. I think her essay is a distinguished critical achievement."

Jack's letter smoothed things over with Tom—for a little while, anyway.

A Richard Tuttle show was my swan song—or maybe duck honk is more like it—at the Whitney. Ever since Jim Monte and I had first included his work in the *Anti-Illusion* show in 1969, I'd been haunted by its fragility and its absolute irreducibility. I was drawn to how insubstantial and modest his materials were, how ordinary they seemed. Pieces made with florist's wire, a nail, and a pencil line, completed by the wire's shadow. Tin, plywood, string. Not the stuff of greatness, perhaps, but then, who's to say that the bigger something is and the more expensive and precious the materials used, the more important the work is going to be? I was especially crazy

about the string drawings, titled *Ten Kinds of Memory and Memory Itself,* which he laid out on the carpeted floor of the fourth floor's back galleries. Mysterious, poetic, unfathomable, infinitely compelling. That pretty much describes Richard, too.

"But Richard," I protested, "what happens if someone accidentally destroys one of them?"

"Oh," he said, taking my arm and pulling me gently to the center of the room, "I'll show you how to do it."

It was like an incomprehensible but charming modern dance, only performed without an audience by an ordinary, slightly clumsy person—me. Hold the ball of white string in one hand, just over your head, with the unraveled end touching the floor. Make a half-turn, releasing string as you go. Bend from the waist, lean outward, make a semicircle with the outstretched arm that's holding the string. Continue the turn, stop, and release the rest of the string gently where you stand. The result was a wobbly, vulnerable little hieroglyph, the record of a few tentative, impractical movements whose traces on the floor amounted, improbably, to sheer visual poetry.

There were three different installations of the exhibition, each lasting several weeks. The changes were made after hours, and the touch-up work on the walls was done early in the morning, before the museum opened to the public. Richard would reuse some of the same pieces, changing how and where they were placed, so that they could be experienced in new ways. The carefully executed string drawings in the back galleries disappeared, to be replaced in the next installation by eccentrically shaped dyed cloth paintings laid randomly on the floor. The third time around, soldered metal pieces, about eight inches big and looking like letters from an otherworldly alphabet, were strewn over the floor.

We decided not to use wall labels because they would have been bigger than some of the works, so instead we made handouts consisting of floor plans with the title and location of each piece. The catalogue was published after the show closed, so that on-site photographs of the work could be included, along with all the reviews.

My favorite work was a one-inch piece of rope, about as thick as a clothesline, attached to the wall by a single small nail. We left a lot of space around it, so that the viewer's eye would inevitably focus in on it. When I asked him why he did these pieces, Richard said, "So I won't have to do them again."

The installation changes were the result of an ongoing dialogue I had

with Richard. He wanted me to evolve a catalogue essay about his work based on my direct experience of the changing exhibition. Richard explained the process to the *SoHo Weekly News:* "By changing works within groups or series, Marcia will then be able to have contact over a two or three week period with different works. Marcia and I are children of the sixties. With the seventies turning out to be a period of mellowing, conservatism gaining strength, and life generally getting duller, everyone should have the courage to put one's beliefs on the table. Art offers security for some people, adventure for others."

David Bourdon at the *Village Voice* thought that we'd decided to publish the catalogue after the exhibition because I was unprofessional. He wrote, "The real scandal of the exhibition is not Tuttle's art but the pretentious, unprofessional behavior of Marcia Tucker, the Whitney curator who organized the show. Is it too much to ask that Tucker familiarize herself with an artist's work before mounting a show?" He closed with the thought that if my catalogue was like the others I had put out, it "probably will be as elusive and ephemeral as anything in Tuttle's art" ("Playing Hide and Seek at the Whitney," *Village Voice,* September 29, 1975).

Jack Baur stepped in and wrote a letter to the editor:

> Bourdon's attacks on the personal integrity of Marcia Tucker should not go unchallenged. To suggest that Tucker is unfamiliar with Tuttle's work is nonsense. She was one of the first in New York to recognize his art and included three of his works in an exhibition entitled Anti-Illusion: Procedures/Materials, which she and Jim Monte mounted for the Whitney in 1969. This was Tuttle's first major Museum showing. Since then, Tucker has followed the progress of Tuttle's career as his art has been exhibited in galleries and other museums in New York and elsewhere. (*Village Voice,* October 13, 1975)

I thought Baur should just cut to the chase and legally adopt me.

The day before the show opened, I got a call from Vera List, one of the museum's trustees. She was on the exhibition floor and wanted to talk to me. "Uh-oh," I thought, "here it comes." I was sure that I'd have to defend myself with sword and shield against her bewilderment and disapproval. No anger was as great as that of a trustee who didn't like the show you'd just put up.

Vera was tall, aristocratic, outspoken, and extremely rich, and she looked stern. I braced myself. "I want to tell you," she said emphatically, "that I do

not understand this work at all." She pointed to the piece of rope. "What it is, why it's in a museum, why it's even considered art is a complete mystery to me." I waited for the guillotine to drop. "But I must tell you that I find it utterly poignant and I want to know more about it."

My last cherished prejudices about rich people clattered to the floor. I'd made a friend for life.

When the exhibition opened, though, the public went berserk. People tried to pull the delicate wire pieces off the wall. They scrawled pencil comments of their own next to some of the works when the guards weren't looking. They complained bitterly that it wasn't art—nothing new there. One critic grumbled that Tuttle hadn't given him anything he had any use for. (How on earth would you "use" a painting? As a potholder? Or as a matching wall hanging for your new sofa?) Another was upset because, he said, "Tuttle's work makes you scrutinize the teeny-weeny hairline cracks on the wall." (Odd, but I thought that's what art was supposed to do, make you pay attention to things that you might otherwise take for granted.) Hilton Kramer wrote, "In Mr. Tuttle's work, less is unmistakably less. It is, indeed, remorselessly and irredeemably less. It establishes new standards of lessness. . . . So far as art is concerned, less has never been as less as this" ("Tuttle's Art on Display at Whitney," *New York Times,* September 12, 1975). Another critic complained that the work in the exhibition couldn't have weighed more than ten pounds. I wondered how much a Picasso or a Cézanne weighed.

One day, I got a call from a woman who said she was a sculptor, and although I didn't know her, she thought we should meet. She had been to my panel discussion about the show, she said, and she agreed with everything I'd said, so much so that she absolutely had to talk to me about it. She invited me to meet her uptown for lunch at Les Pleiades.

When I arrived, it took me a minute to realize that the woman sitting in the corner with two enormous paper shopping bags propped like bolsters against her legs, and her feet clad in what looked suspiciously like bedroom slippers, was probably the artist. She was unprepossessing, to say the least, with a broad, flat Russian face, no makeup, and a puffy, ear-length light brown wig that wasn't on quite straight. She was wearing a black dress that looked as though it had come straight from the Salvation Army. And there we were, at one of the fanciest restaurants in New York. We shook hands and she motioned me onto the banquette beside her. "Now then," she said, "your reasons for wanting to organize that show made me think that you understand how absolutely wrong-headed arts education is today. No one

has any confidence in people's ability to look and think for themselves. No one is interested in taking chances anymore. Everything is ridiculously safe." And she was off on a tear.

By the time we'd finished our lunch, the restaurant had emptied out, and I realized that I had to get back to work. Risa, the single name she used professionally (her full name was Blanche Risa Sussman), was smart and eccentric, and I liked her. I had the sense that I had met a kindred spirit. We agreed to meet again, and, leaving her on Madison Avenue, I walked back to the office.

———

Things were happening that I didn't understand. People were whispering as I walked by, others would look at me strangely, then glance away. Someone would see me coming and execute a military maneuver to turn sharply in the opposite direction. Phones were furtively returned to their cradles when I entered a room.

By September 1975, the institutional temperature at the Whitney had turned arctic. I felt like I was working for a cutthroat Fortune 500 company instead of a museum. I started to hear things like, "Museums are businesses and should be run as such." Works of art were becoming increasingly commodified, and taking risks with regards to exhibitions was seen as a threat to the status quo.

Then I had a wild idea. On my next trip to California, I went to see Henry Hopkins, the director of the San Francisco Museum of Modern Art. We liked each other, and I assumed that he wouldn't pat me on the head and say, "There, there," if I presented him with an unconventional idea. So over lunch, I proposed that I open a branch of his museum in New York City. I told him I didn't need much—stationery, a salary, modest start-up funds, and the board's support. He nodded thoughtfully and then questioned me: What were the advantages for the museum? It would benefit from having a presence in New York, and it would have a showcase for the very recent art it wasn't able to show in San Francisco. What kind of art would that be? The kind that raised more questions than it answered. How would I find an appropriate space? Real estate brokers. How would it be run? By me, with a small staff; independently but with lots of feedback from him. What was the competition? The other large museums didn't seem interested in contemporary art, and the alternative spaces,

which were artist-run, didn't have the resources. He tilted his head, looked me in the eye, and promised to talk to his board of trustees about it and let me know.

I had a lot of chutzpah, assuming that they'd let me go ahead on my own and start a branch museum, but I still think it could have worked. It would have been a groovy little upstart museum under the auspices of an older, more established institution that had the reputation, the funds, and—if the trustees agreed—the nerve. But they never got back to Henry, or, more likely, Henry never got back to me.

Late that fall, Robert Irwin, for whom I was organizing a retrospective exhibition at the Whitney, called and asked me if I'd help him with a project. A Pasadena redevelopment agency wanted to study the feasibility of creating a museum on top of a shopping center they were building, and they'd called Bob for advice. He in turn had called me, and I called my three closest museum friends, Jack Boulton, Brenda Richardson, and Linda Cathcart. We convened for a weekend at my loft to work it out. Would people laugh at a museum built on top of a parking garage? Would the museum's program be changed or compromised by the involvement of the development agency that had put up the money? How would it look to have purely commercial interests support a radical new museum? Weren't there enough contemporary art venues in Southern California to make another one unnecessary? What kind of art could this museum show that would distinguish it from others?

After three days, we were slumped on the couches like boxers after the thirteenth round. In my journal, I summed up the hours and hours of planning and debate: "Some urban redevelopers in Pasadena want to make a museum, but a difficult weekend meeting indicated that the plan is patently unfeasible. Alas."

It was the "alas" that showed where *my* head was. By early December, I'd made a pact with myself, signed, witnessed, and notarized by my journal: "If I don't get the S.F. idea to work, I'll try to start a museum of my own— if I have the courage."

Then, in the spring of 1976, the California Institute of the Arts contacted me. There was an opening for the position of dean of the School of Art and Design, and they wanted to interview me. They would possibly provide start-up funds for a new museum on campus as well. I went out to LA to visit and loved the school, the people, the whole package. It was a haven for supersmart, ambitious, multitalented young artists. The faculty consisted of successful working artists, some of whom were already

friends of mine; the school had state-of-the-art facilities; and, unlike most art schools at the time, this one believed in reading as an essential part of an artist's education.

The only problem was that it was in California. I was a Brooklyn girl whose body was likely to reject the transplant. I turned lobster red after three minutes in the sun. I got lost if the streets weren't in a grid. Trees scared me. I hadn't driven in fifteen years. But it was a reasonable alternative to the misery I felt at not being able to work, really work. And after several visits and lots of negotiation, they offered me the job.

———

I went to see Tom Armstrong. I told him about the offer, the salary, the chance to start a university museum there. And, taking a big breath, I asked him to level with me. "What would you like me to do?" I asked. "Do I have a future here? Or should I leave?"

He thought for a minute, and then said, "I'd like you to stay. But I want to change your title from Curator of Painting and Sculpture to Curator of Contemporary Art."

Since contemporary art encompassed sculpture and painting, this sounded fair enough, and the new title reflected more accurately my area of concern. I thanked him, we shook hands, and I left with a sense of relief, even optimism, that perhaps he was warming to the importance of contemporary art at the Whitney.

Less than four months later, on a Monday morning, Tom called me into his office and told me that he wanted me to resign. When I asked why, he said, "I want to emphasize the permanent collection, and there's no longer any need for a curator who specializes in contemporary art and changing exhibitions." I reminded him that altering my title had been his idea in the first place, but it was like trying to reason with a traffic light.

"I'm not going to resign," I told Tom. "I'd rather that people know the truth."

I was given two months' notice, enough time to finish several of the projects Tom wanted completed. When I left his office, I felt calm and reasonably centered, except for being unable to breathe. Actually, I knew that Tom was entirely within his rights to do what he did, but I didn't understand why he had prevented me from taking the CalArts job by asking me to stay on. I wanted to call in the forces of justice to have him seized and dragged

away to a dungeon to live out his life on a diet of fried worms and liquid Maalox.

I gathered my composure and wrote a letter to the museum's trustees:

As you know, I have been relieved of my responsibilities as Curator at the Whitney Museum of Art effective December 31, 1976. I will leave with a deep sense of loss and regret. I have been told by Tom Armstrong that the reason for the termination of my services is a shift in the emphasis on contemporary art toward its acquisition and preservation, and away from scholarly evaluation. I have also been led to understand by him that my continual involvement with artists outside the museum is no longer viable in term of the museum's present and future direction.

When the Whitney was founded in 1930 by Gertrude Vanderbilt Whitney, its purpose was to encourage, support, and preserve the best art being made by living American artists. I have, since my appointment as curator here in 1969, done my best to maintain and enhance the tradition for which the Museum has achieved prominence. As a scholar, it has always been my conviction that it is the museum's responsibility not only to reflect the consensus of educated opinion by which art history is made, but also to seek out the best work at its source, rather than only after it has achieved commercial exposure. It is my belief that among the unknown and lesser-known people presently working are those who will ultimately establish themselves as major American artists of the future. I feel that my record of exhibitions and activities throughout my eight years here supports this conviction.

The Whitney Museum is an institution whose past, present, and future are of profound concern to me, and I hope that it will continue to be a place that nurtures and affirms the best art being made in our country. I am consistently committed to this ideal and it is with the greatest reluctance that I am leaving.

Getting fired was like developing a huge rotting sore on my nose. When my colleagues got the news, several of them were generous enough to share their opinion that I'd never be able to find another job as good as the one I'd just been relieved of. Most of them, though, simply lost their tongues. They not only stopped saying hello, but refused to even look at me. I'd become the invisible woman. Fear was like a vapor in the offices, filtering through the vents, seeping into desk drawers, clouding the elevator, and causing people to speak in whispers.

Not everyone, of course, was overcome by paranoia, and I even managed to have a good time at my goodbye lunch. Jack Baur came, and my assistant,

Katherine Sokolnikoff, and guys from the installation crew and a handful of fearless friends. They made fun of Tom's published statement by having it printed on enormous white T-shirts: "Any changes in the staff of the museum are judgments by the director toward the attainment of objectives based upon priorities established at a particular time in the history of the museum."

We put the shirts over our work clothes, so that we looked like a bizarre sports team on a lunch break. I could have fallen apart weeping in the face of their affection and concern, but I held together, because by that time I had a road map for the immediate future. Never mind that it had been drawn on a paper napkin.

nine: 1977-1980

The basis of optimism is sheer terror.

OSCAR WILDE

In 1977, people to whom I described my plans for a new museum inevitably said something encouraging, like "You can't do that!" There were also some clever variations on the theme: "You'll never be able to get enough money together to start anything, much less a museum." "Why on earth don't you just look for another job?" "Who do you think you are, Peggy Guggenheim?" And even more succinct and helpful: "Are you out of your mind?"

Marga was one of the few people who didn't laugh when I announced my plans. Instead, she told me about the problems that Alfred had had in the early years at the Museum of Modern Art, making me feel both larger and smaller than life. Her point was that if Alfred could do it, so could I, but this didn't cheer me up. After all, he was Alfred H. Barr, Jr., King of the Art World, and I was a nobody misfit female curator in her late thirties who'd just been fired. But Marga seemed to think that it made complete sense for me to just go ahead and do it, and who was I to argue with her? I would have lost, anyhow.

As a lawyer's daughter, I'd always known that if you want to do something, no matter how far-fetched it may seem to others, you should seek legal advice. A good lawyer will tell you *how* to do something without making judgments about its feasibility. One of my interns at the Whitney had been Allan Schwartzman, a budding art historian from Vassar. Allan's father, Herman, was a lawyer, and within minutes of my calling him, he was

explaining to me what had to be done in order to start a 501(c)(3) organization. "You need one trustee," he said, "and you need to incorporate. The filing forms are fairly simple. First, you should . . ." After about ten minutes of this, I noticed that the pronouns had changed from "you" to "we." That's how Herman became the New Museum's first counsel. People look at me strangely when I say that I find lawyers to be some of the kindest, most generous, helpful, and knowledgeable people in the world, but it's true, and he's just one of the many reasons why. Without Herman's practical, no-nonsense, "let's just do it" attitude, starting up a museum never would have happened.

All I had to my name was twelve hundred dollars in severance pay, the knowledge that I was acting on what I believed in, and all those endless hours of discussion over the Pasadena proposal as a basis for my new museum prospectus. I wanted to redefine the concept of the museum altogether, to turn it upside down and do all the risky things I had wanted to do but couldn't at the Whitney—and wouldn't be able to do at any other museum in the country, either. The academic model on which museums were based was slowly being replaced by a corporate one. Budgets and fundraising had become predominant in a nonprofit world that hitherto had been about connoisseurship and quality, often at the expense of the bottom line. My own thinking was to get an audience so excited about what they were seeing that they would always want to come back for more.

When I was asked why it had to be an art museum and not an alternative art space, I responded by saying that I was an art historian who had always worked in museums and that if I was going to challenge a paradigm, it needed to be the paradigm I knew best.

My plan was for the museum to present retrospective exhibitions for lesser-known mid-career artists; group exhibitions that showed work being done outside the artistic mainstream and/or elsewhere in the country; performances, concerts, screenings, and events that were inter- and multidisciplinary; community-based projects; and publications with original scholarship. There would also be an information-services component that would facilitate loft and studio exchanges. One staff member would be on the road for six months at a time, looking at work and establishing contact between the museum and its constituents. Most important of all would be involving artists in shaping the future of the museum. I wanted to have a direct relationship with living artists. I wanted that to be primary.

I'd taken to calling my project "The Museum in the Sky," because it had just gotten off the ground. The thought that I could just start somewhere

and see what happened made my ears twitch. What I needed first was to find someone who might be both sane and crazy enough to agree to become the museum's founding trustee.

———

I'd met Allen Goldring at a Young Presidents' Organization meeting in Acapulco, where I was one of the speakers. The YPO was composed of men (and one or two women) who had been made CEOs of multimillion-dollar businesses before they were forty-five. They met yearly at different locales outside the United States, convening to learn about world issues, new ideas in technology and science, and unconventional approaches to business.

It was the first time the YPO had held any sessions on art, the usual subjects being politics, economics, and history. But there I was, along with Adelle Davis (in a wheelchair, lecturing on better living through nutrition), H. R. Haldeman (teaching a course in crisis management), and Jesse Jackson (whose remarks about "where women belonged" irritated me into a sparring match with him after his speech).

Each guest speaker was assigned to a host, whose job was to ease our transition from the real world into the YPO ether and to act as a guide and facilitator. Allen and his wife, Lola, were assigned to me because they were interested in art, which meant that by YPO standards they were offbeat enough to be suitable escorts for the arty, eccentric types. Allen was handsome in a distinguished, businesslike way, and he had a warm, direct smile and a reassuring number of crinkles around his blue eyes. Lola was slim and blonde, with the kind of energy that slapped you playfully on the arm and said, "Wake up, sleepyhead, let's go!" You could hear her distinctive, raspy laugh across the room, drawing people like a magnet. By the time the YPO weekend ended, the three of us were becoming fast friends and we vowed to stay in touch.

Allen was someone I liked and trusted, and he was a highly successful businessman, traits that up until then I had thought were mutually exclusive. When I called to ask him if he'd become the museum's first trustee, there was a long enough silence on the other end of the phone for me to know that he was actually considering it, and when he said he'd look at my prospectus, I immediately wrote one up. It was simple—a straightforward mission based on showing the work of living artists, for which I needed a start-up fund of seventeen thousand dollars. We met several days later, he

read through it, and agreed. He also gave me the money. I found out later that financially he thought it was an ill-conceived project, but he didn't say anything of the kind at the time. He later told *Newsday*, "If Marcia said to me, I'm going to walk through that wall, I wouldn't ask her how, but I'd meet her on the other side" (March 12, 1986).

I invited my former Whitney interns Susan Logan and Allan Schwartzman to join me, used all my severance money to rent an office for a year at 105 Hudson Street, and got an artist friend to design a logo, stationery, and T-shirts, across which "The New Museum" was deployed in black-and-white letters that looked like art deco on acid. (The museum's name would be changed to the New Museum of Contemporary Art in 1998.) I went to Exxon's corporate contributions department and convinced them to give us some used office furniture, and on the first business day of January 1977, we sat down at our slightly battered desks and got to work.

At first, it felt as if we were using plastic spoons to build a castle. The Fine Arts Building, as 105 Hudson came to be known, had no heat, no air-conditioning, and bathrooms that emitted an alarming death rattle every four and a half minutes. The other tenants in the building were Artists Space, Printed Matter, and the Julian Pretto Gallery. Joe Lewis, a young artist with dreadlocks, a gold tooth, and a temper that flared up sporadically, had a studio on the wasteland that was our floor, and if it was tough for us to put in a regular eight-hour day in the place, it must have been hell for him to live in it full-time. Illegal, too. But Joe smiled and schmoozed and lent a hand when the boiler blew or the plumbing erupted—true grace under pressure.

Surprisingly, there was more than enough for the three of us to do. Artists began stopping by to show us their work, especially those who couldn't get anyone else to look at it. Reporters asked for interviews: Why would someone want to start a museum in New York City when the Whitney and the Modern were already there? The answer was that the bigger museums were ill-equipped to respond quickly to radical or sudden changes in the arts, in part because exhibitions had to be scheduled years ahead of time to allow for securing loans, preparing a catalogue, and, most important of all, obtaining funding. Even if institutions did have a contemporary department, they weren't interested in anything that wasn't being shown in the galleries.

We, on the other hand, were intrepid, willing to go where no curator had ever gone before—even to Queens and Brooklyn, which back then were thought of as no-man's-lands. Our tiny staff spent the days brainstorming ways to raise money, looking for trustees, going to artists' studios, and searching for venues in which to put up exhibitions.

Even though we operated on a shoestring budget, I believed very strongly in scholarship and in the importance of documentation. I knew how vulnerable it made the artists feel to put their work out there, and I wanted the rest of us at the museum to take an equivalent risk. During the first six months of operation, we organized three exhibitions at off-site venues, and we produced catalogues for every show. We didn't have the funding to print the first two catalogues, so we Xeroxed and stapled them together by hand. They may have been handmade, but I gave them the same attention and scholarship that I had given to all of my publications at the Whitney.

One day, I got a call and heard a lilting Japanese voice speaking rapidly and insistently on the other end: "Yes, I want to come to meet you today at three o'clock, *arigato*, bye-bye." The phone clicked. That afternoon, the door opened on a diminutive, smiling young woman in pigtails, wearing a creamy pink and yellow wraparound top and tight black pants, the whole balanced on enormous platform shoes. Michiko Miyamoto had come to the States with her mother, husband, and small daughter to learn English and find work as a curator. The artist Jonathan Santlofer, a mutual friend, had told her to come and see me, and here she was. She insisted that the New Museum was exactly, and exclusively, where she wanted to work. It didn't matter that we were a would-be museum rather than the real thing; it didn't matter that our temporary office was less than ideal; it didn't matter that I couldn't pay her. She liked our ideas, she said. She wanted to work with unknown artists. She understood collaboration, because that's what they did in Japan. She knew that she could be useful, she said.

And she was. Michiko settled down at the corner of a desk and began a series of rapid-fire phone conversations in Japanese. Within a month, she had organized the New Museum's first exhibition abroad, at the Institute of Contemporary Art in Tokyo. She went over for the opening, a perfect emissary, seeing that she was the only one of us who spoke the language. We even managed to have a slim Japanese catalogue published, thanks to Allen's efforts. After working with us for a year and a half, Michiko moved back to Japan and became a well-known writer; her first book, a critical success, was a humorous and ironic account of her years in America and her work as a curator at The Little Museum That Could.

At the end of our first year of operation, the San Francisco art critic Alfred Frankenstein, on a New Year's trip to the East Coast, dropped by. He reported back to his readers in California: "It [the Museum of Modern Art] is certainly no longer the explosive, challenging institution it used to be, and it is not surprising that during the past year another museum of modern art has arisen on Manhattan Island. It is called The New Museum. You will be hearing a lot about it as time goes on" (*San Francisco Sunday Examiner and Chronicle,* January 15, 1978).

———

I didn't want to repeat the flaws of the Whitney's management structure, which by the time I was fired, in 1976, felt more like a government office than a museum, with cocktail parties instead of summit meetings. In an ideal work environment, I thought, there'd be no top-down decision making, no palace intrigue, no favoritism, no quid pro quo, no secret negotiations.

The two standard models of museum management, the corporate and the academic, seemed inappropriate for an organization devoted to challenging the status quo. Just thinking about the corporate model, the one that already seemed to be taking over the museum field, gave me a rash, and the academic one, in the few places it still survived, was as full of petty politics as any college or university. There had to be another way, one that matched the museum's internal structure to its purpose, which was to show new and radical art in a new and radical way.

I longed to shake things up, my own thinking most of all. But the possibility of new ideas, fresh voices, uncommon ways of doing things couldn't come just from me; it had to come from working with others who could take an idea and challenge it, morph it, transport it to someplace exotic and unexplored.

I looked for ways to redistribute authority and privilege in the museum context; to share power and decision making; to create alternative management structures that stressed collaboration, openness, mutual respect, exchange, and dialogue. In the process, I had to learn to accept contradictions, inconsistencies, and mistakes. Now I had the chance to share decision-making power from the perspective of power. Of course, my friends wanted to know why on earth, now that I finally had just a little itty bit of power, I'd want to give it up.

When we began, there were only a few of us, so everyone on staff did everything together and there was a shared sense of the importance of what we were doing. I thought that work hierarchies in the museum could be subverted by rotating jobs, so that eventually everyone would know what everyone else's job entailed and would appreciate the skills involved. Once again, I could hear people saying, "That won't work." Well, in some ways they were right, but it was worth a try. Putting unconventional ideas into practice was stimulating. We learned to write complex budgets, use a dolly to transport heavy objects, paint ceilings with a potato chip bag inverted on our heads, and stand guard for hours in the exhibition space, alert for art lovers carrying spray cans of paint.

Museum work was an enormous responsibility for young people with no curatorial training or background other than the art history classes they'd taken at school. And some of them didn't have even that. But they brought whatever they could to the table and worked hard to make things happen.

Everything, from what file folders to use to what exhibitions to organize, we hashed out as a group. After the first year, we grew slightly, adding an office assistant, an administrator, a preparator, and an educator. When the staff was still relatively small, there was little real disagreement about the important things, like which artists' work to show or how we should spend our meager resources. An unknown artist's work had priority over someone with an extensive exhibition history. But when it came to the small things, our goodwill absconded. Deciding whether the catalogue cover should be fuchsia or purple, or who should take notes at staff meetings, or whether we should serve chicken or fish at the annual benefit dinner turned the conference room into a madhouse. At first, all that butting of heads was fun. Decision making meant talking, arguing, pleading, voting, voting again, talking some more, and finally agreeing on something when at last the few grudging dissenters gave up, as much from fatigue as anything else.

"Oh, all right," the last holdout would say, pouting. "Do it your way. But don't say I didn't warn you. And don't come running to me to fix it, either." Which was more prophesy than threat.

I thought about the things I'd hated at the Whitney and how the institutional climate might be improved. For one thing, I was sure that the arbitrary salary differences that had caused me so much grief could be eliminated by simply paying everyone the same thing. We started out by paying everyone twelve thousand dollars a year, which in 1977 was a halfway decent wage in the not-for-profit world. I didn't get paid, because there wasn't enough to go around and because I was the only one who was able to earn money

by lecturing or doing an outside curatorial job now and then. I supported myself this way for about three years, until the staff began to complain. How could I raise money if I was working on other projects? I could see their point. I was trying to do too much. It was time to become a full-time, paid director—not to mention curator, which was what I loved to do most of all.

After I'd been fired by the Whitney, Risa and I had continued to meet at Les Pleiades almost every week. She loved that particular restaurant, and she always paid, which was a good thing since I was broke. I was worried that it was too fancy, and I mentioned nervously several times that we could easily go to a less expensive place, but she insisted that we eat there. Then one afternoon, over coffee, she surprised me. "I have a present for you," she said. Her wig was tilted precariously, and I was debating whether or not to say something. She pushed an envelope across the table at me.

"What's this?" I asked. "What's the occasion?"

"Oh, she said, "I thought you could use a little cheering up."

I tore the envelope open. Inside was a check for five thousand dollars. It was a huge sum for a struggling little museum. "Risa," I said, dumbfounded, "I don't understand. Is this really from you? You can't afford this!" It did have her name on the check, but I still wasn't convinced.

"Who else?" she replied. "I have a little something set aside, and I want to give some of it to you."

What I soon discovered was that the "little something" was her late husband's fortune. He'd been a dentist who had played the stock market exceptionally well, and although she hadn't paid much attention to her money and the bank that she'd entrusted it to hadn't done the greatest job of investing it, it was still considerable. The reason she liked to meet at Seventy-eighth and Madison, it turned out, was that she lived right around the corner, on Eightieth and Park, in a gorgeous apartment crammed with African and Oceanic art.

When Risa died twelve years later in Paris, she left half her estate to Parsons School for Design and the other half to the New Museum. I sometimes wonder if the museum would have made it without her.

In July 1977, the building where we had our office was sold, and we were forced to move. Thanks to Vera List, our newest trustee, the New School for Social Research gave us space in its graduate center to use until we relocated to a permanent facility. The building was called the Albert and Vera List Center, which explained why our new trustee had so much pull. We were given 2,500 square feet on the ground floor, plus a small operating budget and an assurance of autonomy. With the help of a few brawny artists, we U-Hauled our few possessions and the oversized Exxon desks to the center and crammed them into the tiny office adjoining the exhibition space.

Our first show in the new space was called *Early Works by Five Contemporary Artists,* and it consisted of early, unseen pieces by five well-known artists: Ron Gorchov, Elizabeth Murray, Dennis Oppenheim, Dorothea Rockburne, and Joel Shapiro. Our intention was to examine these works in light of the artists' subsequent careers.

This exhibition helped to define us, small as we were, as a "real" museum. In our first museum newsletter, we reported that more than three thousand people had attended the opening: "What we learned—besides how to make such an evening operable, was that our audience was uniquely heterogeneous in a way that had not occurred in many years. Artists, collectors, art dealers, students, museum people, and scholars of all kinds came that evening and continued to attend" (*New Museum News,* Spring 1978).

I had been wanting to do a show called *Bad Painting* for several years, but at the Whitney eyes had rolled upward around the big conference table every time I'd suggested that the issue of quality was important enough to address in the public forum of an exhibition.

I was intrigued by a new tendency in painting that I'd been seeing in studios across the country. Notions of beauty and classical good taste (both of utmost importance at the Whitney) were being thrown out the window. The figure, personal narrative, and an avoidance of the conventions of high art characterized this new work. As someone schooled in the East Coast minimalist tradition, I'd initially been put off by what I was seeing—but I soon came to realize that "quality" simply didn't exist according to the old rules. This work reminded me, when I first saw it, of everything that we had learned not to do in high school drawing class.

It eventually occurred to me, however, that narration and so-called personal art might not be "alternatives" to minimalism, but an alternative structure altogether, a circular, self-referential one like that found in Terry Allen's work. A "strange loop," as Douglas Hofstadter called it in his book *Gödel, Escher, Bach.*

When I visited the painter Joan Brown in her studio, she said she felt as though she had deliberately placed herself on the edge of a precipice, looking into the abyss; she was trying to live dangerously in her work. She meant that she was keeping figuration but abandoning its conventions and exploring a more autobiographical approach.

What I wanted to do was to raise questions about the quality of works of art—to find a way to engage the public and encourage them to decide for themselves what was good or bad. Most museums validate work—they tell the public what's good by virtue of inclusion and what isn't by virtue of exclusion. Was there really such a thing as "bad" art, I wondered, and if so, who set the standards? The artists? The public? The critics? Or, God forbid, my relatives?

In 1977, I gave a lecture at the Nelson-Atkins Museum of Art in Kansas City, showing the work of artists who challenged classical notions of good taste. I showed slides of the painters I would eventually include in my 1978 *Bad Painting* exhibition at the New Museum. Among them were Joan Brown; Charles Garabedian, who interested me because he refused to be consistent in any way at all; Earl Staley; and Neil Jenney, whose sprawling work I had included in the 1969 *Anti-Illusion* show. I ended my lecture by quoting Marcel Duchamp, who said, "Have fun. If not, you'll bore us."

After the lecture, my Uncle Harold invited me over for a serious talk. Hands clenching and unclenching the fabric of his pants in agitation, he sat forward on the worn beige recliner. "And just how do you think you're going to make a success of yourself," he asked, "when you show the kind of crap you just showed?" My aunt, smoking furiously on the tufted gold sofa across the room, nodded her head in agreement.

Most people, if they don't understand a work of art right away, say, "That's it, goodbye." But taking the time to ask why and to find out more usually leads to something interesting. The burden shouldn't be on the artist to make things the public understands, nor should it be on the museum to show only things that are understandable.

"Unfortunately, most of it is really bad," Mark Stevens would write in his review of the exhibition in *Newsweek* (March 18, 1978).

The night the *Bad Painting* show opened, I tried not to look as though I'd been hit in the forehead with a rock. We'd been working straight through for days, getting the paintings uncrated, doing condition reports for the insurance company, adjusting the lighting so that the fuses didn't blow. This business of "rotating" jobs was getting to me.

People were crowding around to offer congratulations, most of which sounded suspiciously like condolences. I'd been air-kissed until my hair looked as if a hurricane had flattened it, and I was so preoccupied that I hadn't noticed a tall young man in a dark suit, one of the dozens of people whose names I'd immediately forgotten, waving frantically at me from the edge of the crowd. "I want to introduce you to Henry Luce," he said. "He's Alfred Jensen's biggest collector, and he wants to see the museum that Alfred chose over the Whitney." Alfred Jensen had never had a museum retrospective in the United States, even though he had had a whole series of dealers. He had left Pace Gallery in New York, because, he complained, they were selling his work. He said an artist should always have twenty years of work surrounding him.

I had wanted to do a show of his work when I was at the Whitney, but I couldn't get them to agree. After I left, the Whitney changed its mind and offered him a show. But he'd said he was a young artist (he was seventy-four!) and he wanted to do a show at a young museum, so he chose to have his retrospective at the New Museum instead.

Henry Luce, whom his friends called Hank, was tall and big-bellied, with gray hair slicked back from a high forehead and thick glasses covering his extra-sharp eyes and runaway eyebrows. He had a whole lot of history behind him—the entire *Time* magazine empire. He'd once been *Time*'s London bureau chief and then its publisher, had traveled virtually everywhere in the world, and was an expert on China. Hank's father, Harry, was a larger-than-life entrepreneur, known for being temperamental, even tyrannical, and his stepmother, Clare Boothe Luce, was Dorothy Parker's direct spiritual descendent and could kill a half-dozen lesser women with one well-placed comment. (Several years later, when I was formally introduced to her at one of Hank's cocktail parties, she gave me a sweeping, head-to-toe appraisal and asked, eyebrow arched, "And just what qualifies *you* to run a museum?" I answered before I had a chance to think, "The same thing that qualifies *you* to think I can't." She laughed. We were going to get along just fine.)

It must have been hell for Hank, growing up under their combined tutelage, but my empathy for his plight was shoved aside by my terror at meeting someone with that much fame and money. He shook my hand and smiled. "I hate just about everything in this show," he rumbled, by way of introduction. Not so friendly. "There's one piece I do like, though," he said, pointing to Cham Hendon's huge *Mallard with Friend*. The painting depicted two ducks, rampant in a marsh, their wings flapping, crudely deployed against a lurid paint-by-numbers sky.

Like impoverished royalty, I drew my meager resources around me with dignity. "Well, you certainly can't say something like that and not let me take you to lunch so we can fight it out," I replied. He smiled again.

"I'll have my secretary call next week," he said and disappeared into the crowd. I had never met anyone like Hank before, and perhaps he could say the same for me.

At our first lunch together, by the time he had finished his pasta and I'd picked at my salad, anxious not to dribble dressing on my blouse, we were laughing. The main course—sweetbreads for him, poached salmon for me—ended in a discussion of wealth. He told me that a "millionaire" didn't necessarily mean a rich person these days. Okay, maybe Hank was a poor millionaire, but money wasn't the only object of my intentions. I thought he was one of the most fascinating people I'd ever met, and he was only slightly less well connected than God. His range of friends and acquaintances was astonishing, from Douglas Dillon to Philip Glass to Brooke Astor to James Michener, and on and on. There was no subject he couldn't talk about knowledgeably, very few places in the world he hadn't visited, and not a whole lot of books he hadn't read.

While we finished our coffee, I asked Hank to join the New Museum board. The next year, he became the museum's first president, and the only one I ever worked with. What I loved most about Hank was that he never promised something he couldn't deliver. When I retired twenty-two years later, so did he.

At a meeting of the Association of Art Museum Directors one year, we decided to invite our board presidents. At a private session, they were asked, "What do you think is your most important responsibility?" Hank's answer, I later heard, was, "To support the director." Heresy, considering that most board presidents seemed to think—and still do—that their job is to harass and ultimately get rid of the director. Word spread fast. For the first and probably last time, I was the envy of my more distinguished colleagues, those who ran the country's big, important museums.

I thought Hank was a perfect leader. Well, nearly perfect. His long silences were legendary, excruciatingly uncomfortable for most people to endure. I used to joke that it always took me a while to realize on the rare occasions when Hank called me at home that it wasn't an anonymous heavy breather on the other end.

He also had a volatile temper, and on rare occasions he directed it at me. Maybe as a way of letting me know I shouldn't take it personally, he told me a story about a woman who had worked for him. The two of them were embroiled in ferocious battle, day after day. He'd yell at her constantly, but she was obstinate, refusing to change her work habits or her demeanor. "Finally," he said, "I just had to marry her."

It was helpful that at least he had a sense of humor. Since he could lash out at me unpredictably at board meetings, I needed to find a strategy that would save me from responding to his anger by bowing formally to the trustees and knifing myself in the belly. I decided on the aikido method, which is to move in the direction of the blow. That meant saying something to make everyone laugh. It usually worked.

Sometimes, Hank would be annoyed with me for just being myself. When he told me that his mother had been diagnosed with cancer, tears welled up in my eyes. "I'm so sorry, Hank," I said. "How awful for you."

"Oh, for God's sake, get a grip," Hank growled. I stopped mid-sob.

"Oh, Hank, you don't understand. I'm Jewish."

He laughed, and we went back to the business at hand.

I mostly got to experience Hank's anger when I couldn't answer a question about the budget. That was because, for me, numbers look like colors, a serious problem if you're directing a museum.

I may forget a person's name, but I never forget a work of art. I can remember an artist's studio that I visited twenty years ago and see each color clearly—where it was placed, exactly how it looked, the pattern the light made coming in the window. In my mind, numbers and individual letters have colors, too. For example, one equals silver, two equals red, three equals yellow, four equals aqua. Multiplying a silver and a yellow by a red results in a red and a green. This is fine for very basic stuff, but it gets really complicated if you've got to multiply a green, an aqua, and a pink by an orange and an aqua.

Recently, I learned that this is called synesthesia, and scientists have begun detailed clinical studies of it. Synesthesia means the capacity to hear colors, taste shapes, or experience other startling sensory mix-ups. It's too late to tell Mrs. Kelley, who kept me from skipping a grade because she

wouldn't let me retake the math test that I'd failed, or the principal of my high school, where my SAT math scores were the lowest they had ever seen. Or Hank, for that matter. When he would ask me about a specific line item that failed to match the same item elsewhere in the budget, I couldn't find it, because yellow, teal, fuchsia, and orange were running together on the page.

We'd barely had time to breathe in again after the *Bad Painting* show, when we had to face the next big issue: salaries. By 1981, the staff had grown to fifteen, and there were still only two salary levels, $13,500 for part time and $15,000 for full time. "That way there's no jockeying for position," I said at the time in an interview, and I suppose there wasn't. My reasoning, I explained, was that we wouldn't have to put energy into defending the judgments that a traditional salary structure required. I thought we should put that energy *toward* something, namely, art.

Once we began to really grow, though, it became clear that we couldn't continue to pay everyone the same amount or we'd have to hang an "Equal pay for unequal work" banner over the door. We just couldn't hire new people without offering competitive salaries. We needed to devise salary levels. Yet staff members who'd been at the museum for any length of time were on the warpath, justifiably unhappy that they might end up making less than someone who was just starting. We realized we had to consider both seniority and skill and adopt a more conventional approach to salaries. That meant the "flat" organizational structure had to go the way of the Styracosaurus. Eventually the staff would decide to restructure itself, opting to appoint department heads—even though in some instances there were only two people in a "department."

One of the things that made the New Museum different from galleries or alternative spaces was our collection, which began in 1978. Traditional museum collections struck me as problematic, because they created a system of hierarchies and judgments that I thought was inappropriate for works that had been made very recently. Institutional collecting generally assumes

a linear art history so that not only the artworks are preserved, but also the narrative systems and ideologies in which they were created. Collecting is also the act of preserving vanishing cultures, which the cultural critic James Clifford calls the "salvage paradigm." But culture is living and changing, not static. And I saw that as museums focused increasingly on acquiring works and showing them and on looking for collectors to donate or will their collections to the museum, they increasingly lost touch with what was actually happening today. The resources taken up by the collection expanded at the expense of contemporary, experimental programs and exhibitions. Contemporary art is always fluid and changing, its value is contingent, and it calls for research and scholarship very different from those required by historical art. The collection at the New Museum was premised on the acknowledgment that artistic value is not absolute, and a determination to make transparent the critical and historical judgments that created the collection.

We assumed that if the New Museum could keep a work of art in the collection for no less than ten years and no more than twenty, and then either sell it or trade it for another work, that process would help to create a more challenging collection. It would be a contemporary collection that stayed contemporary. We called it a semipermanent collection. When the museum first began, we acquired work in two ways. We had a small acquisitions fund from the trustees, and we received gifts from artists who were glad to have their work in the collection and to have it sold eventually to support other young artists' work. I assumed that after ten or twenty years, some pieces would have no commercial value at all and thus could not be sold or exchanged.

We tried to acquire at least one work from every exhibition, and as a result the collection grew steadily. But it was 1995 before we organized an exhibition of the entire collection, *Temporarily Possessed: The Semi-Permanent Collection.* The team that organized the show consisted of staff members—curator Laura Trippi, registrar John Hatfield, exhibition coordinator Mimi Young, and education curator Brian Goldfarb. This diverse group of curators raised fresh questions and came up with exciting new ideas and approaches. In the catalogue for the show, they described the collection as a "constantly changing body of work, an anti-collection of sorts that continually renews its status as a resource of contemporary work, rather than a monument to the past."

The concept of the collection was met with criticism. Some artists were upset that their works would be sold again, even though our policy was

clear from the start. But dealers were the loudest in vocalizing their dissent. Our concept threatened the traditional system of connoisseurship and museum collecting, whereby works of art are considered to be timeless and unchanging.

But we were interested in igniting a living dialogue and resource of new ideas and in finding out if it was possible to reduce the physical bulk of our holdings and augment the dialogical potential of a work of art.

Now I think it would be exciting to find another paradigm altogether—one that allows the possibility, for instance, of collections in transit, collections that move and circulate, and collections that are entirely ephemeral.

By early 1980, catastrophe was scratching furiously at the door, wanting in. We were running out of money again. I was wondering what could have led me to the folly of starting a museum when Vera List called. "I've been thinking," she said in her gravelly Bostonian voice. "I know things are difficult right now, so I have a proposition for you." Vera's "propositions" always involved her giving away large sums of money or handing over works of art that could bring large sums of money at auction. As far as I was concerned, she was a Jewish mother with no downside. "I want to give the museum a matching grant," she continued. "Fifty thousand. But it's a three-to-one match, with a two-year time period. Do you think you can handle that?"

Raising one hundred and fifty thousand dollars in two years was going to be difficult, but I told Vera that I was sure I could do it. "Well, then, very good," she said. "Give me a report. You'll get my part as soon as you've raised the rest."

When I told Hank about Vera's offer, I thought he would be thrilled. Instead, he responded with one of his extenuated silences. "I don't think this is really feasible," he said. "Our entire year's budget is a third of what you have to raise. We would have a very hard time meeting that match. In fact, it's close to impossible. I just don't understand what Vera thinks she's doing." I sighed and hung up the phone.

Fifteen minutes later, Vera was back on the line. "Hank called," she said, "and accused me of putting the museum in a compromising position, promising something that we would never be able to achieve. I would never do that."

Before my mouth had a chance to close, there was Hank again. I told him what Vera had just said. "I don't understand," he bellowed. "A match is a match. You don't come up with the funds, it's no go. Why is she fooling around with this?"

Then Vera was back for the final round. "So what did he think I was going to do if you couldn't meet the match?" Vera said. "*Not* give you the money?"

I decided that I was the go-between in a contest between old money and new, between what I jokingly referred to as the Master Race and the Chosen People. It wasn't a job I'd applied for.

We didn't make the match, although we came close, but Vera gave us the money anyway. Soon afterward, I saw her and Hank chatting away amiably at lunch, as though nothing had ever happened.

———

If there's something I want to do and no existing group will take me in, I start one myself. It's easier than you might think. In 1979, I asked around and found nine nonprofessional singers, mostly working in the arts, who wanted to be part of an informal a cappella group. New York is great, because all you have to do is want to make something happen and you can invariably find others to join you.

We called ourselves "The Art Mob" after the song "The Collector (and the Art Mob)," by the artist and musician Terry Allen. We performed a cappella songs we'd cull from old hymnals, vintage nineteenth-century songbooks, radio gospel pamphlets, and assorted sheet music found in the collective family attic.

I saw the singing group as critical to my museum work. That's because being part of the Art Mob made me understand what it meant to make something out of nothing, to experience the anxiety and vulnerability of sharing work with the public and not knowing how it would be received until it was too late. I could put myself in an artist's shoes because, in some small way, I was one too, even if I wasn't a very good one.

Music was one of the greatest joys of my life, and I knew that if I sang with others consistently I was bound to improve. Everyone in the Art Mob had periods of frustration with me, as we had to repeat everything umpteen times until I learned it. But I had started the group and we met at my loft, so I couldn't very well be kicked out. Besides, we always had a great time

after rehearsal drinking wine and schmoozing. After about a year, we began performing for our friends.

Two years after I started the museum, Tim and I broke up. We'd lived together for eight years, but for much of the time our minds and hearts, as well as our bodies, had been busy with other people. The "open" relationship wasn't working. When I'd first started seeing my therapist, Patrizia, she'd asked me gently why I had so many boyfriends in so many parts of the country. I answered, mystified, "Why *not?*" Now I knew why not. You couldn't be intimate with the one if you were constantly distracted by the many.

It was Tim who called it off, and although I briefly hated him for it, he was right. We'd tried damage control, mostly by seeing Patrizia, but my problems were old and deep, and even though I'd been excavating my psyche for years, I was still terrified of being close to anyone, terrified of what I stood to lose. When I told Patrizia that I just didn't want to put all my eggs in one basket, she said, "You know, don't you, that the pain of keeping yourself from being close to someone is much greater than the pain you'd feel if you did trust them and they eventually hurt you?" Either way, it sounded painful. So I decided not to have any relationships at all.

ten: 1980–1983

She's forty
An lonely
An raw
An raunchy
An has a good heart
Yeah
An has a good heart

TERRY ALLEN

I had decided to give up men for a while—specifically, for the rest of my life. It was April 1980, and I had just turned forty. Since Tim and I had broken up, guys had been picking me up and throwing me away with stunning regularity, and I was doing the same thing to them. Some relationships were more satisfying and complex than others, but they were always the ones that had absolutely no future.

Like the one with the sensitive, affectionate opera singer with the sexy mustache. I had just begun to feel as though we really had something going, when he woke up one morning, looked me in the eye, and told me it was over.

He couldn't be serious. "Why?" I asked, trying to nuzzle him. "Did I do something wrong? Is there someone else?"

"No," he replied, "but you're white."

"You just figured that out?" I asked.

"Black power, baby," he replied. "I've got to be with my own kind." Ten seconds later, he was dressed.

"Good luck," I muttered to his departing back "I hope you find a wonderful six-foot-tall, black female opera singer with a mustache and live happily ever after."

My life had turned into one frantic, harried, blundering search for . . . love? Was that what it was? Romance had dwindled to a series of one-night stands, some of which lasted for months, and I was fed up with the aimlessness of it and with my own bad judgment. That's why I decided to try celibacy. That's when I met Dean.

You never know when you're going to run smack into the love of your life. It's haphazard, a chance occurrence, a single dumb moment that changes everything, forever. If you'd made a different decision—if you'd showed up a day earlier or an hour later, taken another route, or decided not to go at all—then the life you're living now would be completely different. It's so arbitrary, and so ordinary.

In my case, luck arrived disguised as a party. I'd made plans with Bruce Nauman to have dinner at my loft. He was living in New Mexico and was in the city for a short visit. Because the Art Mob didn't finish rehearsal until 9:00, I wasn't planning to cook, thinking we could order takeout when the singers left. Then Bruce called to say that there was a party going on over at Frank Owen's loft, where he was staying. Why didn't I come over there, instead?

"I'll be too tired," I insisted. "And too hungry. By the time I get there, it'll be so late that I might as well turn around and go home to bed."

"Don't be silly," Bruce said. "I'll come get you."

Before I could protest again, he'd hung up. A few minutes later, the bell rang down on the street. Bruce bounded up the stairs. "Let's go," he said. "They're waiting."

I looked dubious. Kent Hines, my best friend and singing partner, was still perched on a stool at the kitchen counter, trying to come up with a harmony for a duet that we wanted to do together.

"Come on," Bruce said. "Dinnertime. Frank's ordered pizza."

As we walked down a deserted West Broadway together, Kent began to hum a Rosalie Sorrels tune—"Starlight on the Rails"—from an album that Bruce had given me. "Now if you live out on the highway / You're like a clock that can't tell time / And if you spend your life just ramblin' / You're like a song without a rhyme."

Bruce began to harmonize with Kent, and when I tentatively took over the melody line and Kent wove in a second harmony, I had one of those moments when I thought that I had really, truly, chosen the wrong line of work—I *knew* I could have been a professional singer, if only I'd had the right backup!

Frank's loft, on Broadway between Grand and Howard, was a light-filled floor-through that he'd been renting since the early seventies from the owner of a textile business. The neighborhood was just beginning to change from a desolate, uninhabitable stretch of sweatshops into a place where artists lived and worked. A few years earlier, when I'd first moved to Sullivan Street, I'd run into Dick Serra on the corner of West Broadway and Spring. After a muttered hello, he fixed me with a fierce scowl, flung his arm out, and snarled, "Some day all this will be fucking *boutiques!*" I laughed. It was true that the neighborhood was becoming a little bit safer at night. But designer stores? Specialty foods? Never!

Bruce opened the heavy metal doors to Frank's building and fumbled in the dark for the hall light. A caged overhead bulb went on, revealing an apartment-sized freight elevator before us in the gloom. Bruce pushed open the iron gates with a clang, and we stepped inside. Just then, the front door opened again and a muffled voice called out from behind a precarious stack of pizza boxes to hold the elevator. I got a brief glimpse of the person carrying them as the aroma of oregano, tomato, and garlic filled the elevator. My first thought was that delivery guys were a lot cuter than I remembered.

"Hey, Dean," Bruce said. "Good work. You must be the only sober one left. They're starving up there." The elevator stopped, and we clambered out, blinking at the light and noise. There was a party going on, for sure. Some of the guys were playing a horn duet—I couldn't tell an oboe from a trumpet from a frog, so I wasn't sure exactly what instruments they were using, but they sounded like enemy herds of elephants preparing for battle.

Dean set out the plates and food. "So who's *he,* and what's he doing here?" I whispered to Bruce.

"He's from Antioch. He spent his work-study period as Frank's studio assistant," he answered. "He just moved to the city, and Frank invited him to stay till he finds his own place."

The horns grew louder and more raucous. When Dean picked up an instrument and joined them, I thought the sound improved, probably because by then I'd had a few drinks in an attempt to catch up with everyone else.

When I looked at Dean more closely, I saw that he was definitely not your ordinary, run-of-the-mill young artist, although I couldn't put my finger on what made him stand out. He had long dark hair, dark brown eyes with unreasonably long lashes, and a tall, thin frame that he carried with ease. He wore a tank top, a pair of dark jeans, and work boots, and—uh-oh, there it was—an earring in his left ear and a bunch of keys hanging from the back belt loop of his jeans. "Too bad," I sighed to myself. "All the attractive men really *are* gay."

Making the best of a disappointing scenario, I grabbed Kent and walked him over to Dean. At the appropriate moment, I slipped away to the kitchen to get some pizza.

A few minutes later, someone tapped me on the shoulder.

It was Dean. "I think you've made a mistake," he whispered.

I looked up, startled. "A mistake?"

"I'm not gay," he said.

"Oh." I was at a loss for words, but not for long. It suddenly seemed like the perfect time to leave the party. "Well, why don't you walk me home then?" I suggested. I carefully ignored the fact that I was old enough to be his mother. Or that he was an artist, and I'd sworn that I'd never go out with an artist again.

I remember being startled at one of our consciousness-raising sessions to find out that a few of us had the same kind of taste in men: all young, all poor, all sloppy, all artists, and all interesting, smart, and fun to be around. Hooray for us, and fuck the doctors, lawyers, dentists, and accountants our parents wanted for us!

Outside, it was raining. I got out my umbrella and Dean opened it over our heads, taking my arm as we careened slowly down the street toward my place. We had only gotten about a half a block when he stopped, turned toward me, and leaned down to give me a long, gentle kiss. My heart skidded sideways, then straightened and bumped into my rib cage, where it gave two thumps and stopped altogether.

There I was, at a railroad crossing with the gates coming down, signals wildly flashing, whistles blowing, and bells clanging. The train was roaring toward me at two hundred miles an hour as I stepped out onto the tracks with my head up, smiling calmly. "Come on up for a drink," I said as I got out my keys.

———

I managed to restrain my animal instincts for exactly one week. I had made a pledge of abstinence and was proud of myself for keeping it, but I only succeeded because I was thousands of miles away from Dean— in Nacogdoches, Texas, to be exact. The morning after he walked me home from Frank's party, I'd left town to begin a week as a visiting art critic at the local college. I'd sent him packing at 5:00 A.M. with a sigh of simultaneous regret and relief at not having slept with him. But once I

returned to New York, my inner adult left to go trekking in the Himalayas.

Dean and I had a date planned for my first evening home. We were going to an opening for James Surls, a Paul Bunyanesque Texas artist whose trademark twin braids, dangling earrings, and colorful snakeskin cowboy boots caused New Yorkers who passed him in the street to come to a halt, mouths agape. After the opening, there was a dinner at Un Deux Trois, where we met some of Surls's pals, all of them spectacular Texas storytellers and comedians—James Hill, Dan Rizzie, and John Alexander and his girlfriend Rosie Shuster, a writer for *Saturday Night Live.* The restaurant was cavernous, noisy, and pretentious. We were crammed together at a long, paper-covered table, where cups of crayons awaited us. Were they expecting hordes of young children at 10:00 P.M.? Or did they know that artists were going to be sitting there? The menu was in French, unsullied by translation, and the waiters had accents so thick they sounded like cartoon caricatures. Getting one to take our order for more drinks required cunning. Rizzie, frustrated, finally yelled at the top of his lungs, in a god-awful Gallic accent, "Breeeng me your verreee worst wine!," making us all choke on our food and leaving our otherwise inattentive waiter looking baffled.

Jokes and tall stories, each funnier than the last, kept pace with the flow of house wine from huge pitchers. People were collapsing against each other, screaming with laughter. It may have become a wildly memorable night in Texas folklore, but what I recall is the feel of Dean's shirt touching my bare shoulder, Dean's muscled arm around my waist, Dean's warm hand on my knee under the table. Halfway through our coq au vin, we excused ourselves and fled.

————

When we weren't dancing prone, we boogied around the living room, Ry Cooder's *Chicken Skin Music* playing at full volume. We ate Chinese take-out. Curled up on either end of the couch, toes touching, we talked as though speech had just been invented and we were the first people ever to try it out.

On Monday morning, I had to go back to work. I expected him to say the magic words, "I'll call you," and then to disappear from my life, but instead, he looked devastated. He walked me to work and we kissed goodbye without a word about when we'd see each other again.

It was hard to concentrate. A fist was squeezing me just below the breastbone, producing accordion-like waves of dread. Would he want to see me again? This was a relationship with no future, if ever there was one. I should never have started it in the first place, because I was bound to get hurt again. In fact, I was hurt just thinking about how I would feel as the minutes, hours, days, weeks passed with no call. Why did I do this to myself? My vow of celibacy meant nothing as soon as a cute guy paid me a bit of attention. It was more than a bit; it was a whole glorious weekend's worth. And it was more than attention; it was total immersion. Still . . .

At 6:30, I packed up my briefcase for the night, sighed, and got ready to visit an artist whose work I'd promised to see. From there, I planned to go home to an empty loft. But then I had to look twice—there was Dean at my office door, carrying a big bouquet of flowers. "What are you doing next?" he wanted to know. I explained that I still had work to do. "But what are you doing *after* the studio visit?" he asked. Within four days, his toothbrush had found a home in my bathroom, and by the third week the rest of his personal effects had found a permanent place in my loft.

A few months later, I wrote in my journal: "Dean is very young, but seems centered and is much more in control of things than anyone I've ever met before. I am starting to feel really happy, and even thinking about marriage again. This is a totally private thought, since the likelihood of marrying someone where the difference in age is so phenomenal—seventeen years—is negligible. On the other hand, trust me to do something out of society's norms. Occasionally, I feel a deep and abiding hatred for everything proper, and everything you're supposed to do."

The work of gay and lesbian artists at this time was becoming politicized in fresh and unexpected ways that had little to do with political propaganda. In October 1982, guest curator Dan Cameron organized the exhibition *Extended Sensibilities: Homosexual Presence in Contemporary Art.* (We would hire Dan as senior curator in 1995.) It was an important and timely show for the museum to present.

Almost nothing in the exhibition could be taken literally as "gay" imagery or imagery overtly promoting homosexuality. This caused arguments on both sides. In *Artforum,* Richard Flood found that the show was "first

and foremost a vehicle for social and sexual confrontation, an act of bravado" (March 1983). James Saslow, however, reviewing the exhibition in the *Advocate* complained, "This show is surprisingly short on images that deal directly with two staples of gay subject matter: sex and politics. . . . What matters to The New Museum is not gay people themselves, but High Art, and whatever notice this exhibit takes of us is on its terms not ours" (December 9, 1982).

There was also an ongoing debate about whether an artist's sexual orientation had anything at all to do with the kind of work he or she made. After all, there were many artists whose proclivities weren't known to the public and so weren't a factor in the critical commentary on their work. In the catalogue, Dan argued: "Art does not generally rely on the artist's private life directly, but indicates identity through sensitivity, reasoning and intuition. To assume that gay content cannot be present without a strong and clear indication that someone involved has sex with members of the same gender is to underestimate both the flexibility of the idea of content and the gay imagination."

Another consideration, from an institutional point of view, was that for years gay and lesbian influence on contemporary aesthetics had been acknowledged in the fields of design and theater, and certainly among visual artists themselves. But museums were still in the closet, never having recognized sexual orientation as an issue—at least not openly.

At a panel discussion held in conjunction with the exhibition, "What Is the Impact of Homosexual Sensibility on Contemporary Culture?," the writer Bertha Harris told the audience, "There's nothing that America is more afraid of than a bull dyke." The audience cracked up, but some of the museum's supporters were offended.

One trustee told me that she thought the show was inappropriate. "Why do we have to even talk about these things?" she asked. "I just can't see giving money to an organization that supports *homos*." I told her that while I appreciated her honesty, I knew that she was far more open-minded than she herself realized, and that I was counting on her support. We breathed a collective sigh of relief when she resigned, never to be heard from again.

—————

By late 1982, the New Museum had become a ravenous infant, needing constant attention. I loved it, but I chafed at the loss of my freedom to be able

to go off whenever I had a chance to attend a theater workshop. I needed to concentrate on activities that would bring the museum money or recognition. I was traveling as much as I ever had, but only on museum business. Because at least ten of us were crammed into an office the size of a small fish tank, and several staff members were about to morph into piranhas, I knew I was doing my fellow workers a favor by being out of the office regularly.

The modest exhibition space was still serviceable, but access to it was limited to New School hours and subject to New School security measures, and it wasn't easy to hold social events in the lobby, which we shared with clumps of milling students. We needed a new space. We had been working for several months on the possibility of buying the landmark Astor Building at 583 Broadway in SoHo, but it didn't look like we'd be able to afford it. Just when I'd given up hope, Hank and the board worked a miracle.

It was a cold winter night two days before Christmas, and I was still at my desk working when the phone rang—it was Hank, of the never-promise-what-you-can't-deliver department, calling to announce that the building deal was going to go through after all.

On my way home, I went to look at the building looming in the dark. Standing there alone, I felt frightened, sentimental, fierce. I wanted this to happen very much, but I didn't know whether I was prepared for the kind of thinking that would have to be brought to bear on a drastically new situation. I decided to wait to have a more formal announcement before trying to understand what it all actually *meant.*

That night, I dreamed that I was working in a new office.

It's like a living room, with dishes scattered around, couches, shelves, lamps, and a bed. The place is a total mess. There are clothes, books, towels, bedding, everything piled up or thrown helter-skelter. My colleagues are relaxed, nice, and seem to accept me, but they don't stop what they're doing to help me find my way about.

I hear that my father has arrived. I go to greet him and show him around. Somehow, although I know he is dead and I am dreaming, I believe in his presence, and I am happy. He smiles sadly and says something in Yiddish, which I don't understand. He says he will wait for me to finish work and we will go to dinner together. Because it's my first day at this new job, I'm very busy and pressured. He says he'll wait outside till I'm ready.

I immediately begin to clean up. I put everything away, until the entire room starts to look good. People comment casually on my activity and I explain that I am terribly neat and that I actually like to straighten up and have things in order. I'm bemused by the fact that at the New Museum it is infinitely

more crowded and horrendously messy and yet I can work there without a problem.

The cleanup takes longer than I think. I suddenly realize it's very late and everyone has gone. I put away my things and leave the office, only to find, when I'm outside, that there's no trace of my father.

———

January 1983 was an extraordinary beginning to the new year. On December 31, we received a letter from the New School formally asking us to vacate our space, and, on the same day, we were given the deed to the building at 583 Broadway. We were promised that the part of the building we would occupy would be finished to our specifications: ready-to-use offices, enormous new exhibition space, two-hundred-seat auditorium, lobby with gift shop and bookstore, interior staircase, lighting, new flooring, and bathrooms.

The museum was scheduled to open in the new building eleven months later, but the contractor abandoned ship in the middle of the project; the developers turned out to be dishonest and mostly absent; huge debts were run up without our knowledge; and almost nothing we'd been promised came to pass. By the time we moved in, the building had consumed all our resources, and then some. Everyone was tired from the move, stunned that so much still had to be done and that there was so little left to do it with. We were hunkered in the basement while our offices were being built, over two dozen of us working in the sunken area that would become the library's reading room. There was no privacy, not enough desks or light, tangles of wire and phone cord snaking across the floor.

On my way out to get a sandwich, the development director and the administrator grabbed me. "We have to speak to you," they whispered. "Now. In private."

They led me to the back of the basement. "We have to cut two positions, now," they told me.

"Why?" I asked. "What's going on today that I didn't know about yesterday?"

"Well, we looked at the numbers again. We're headed toward a deficit of around seventy thousand dollars. The donors who committed money to the building are stretched thin, and it doesn't look as though any of these sources are going to come through."

The administrator handed me a stack of papers, budget figures arrayed in neat rows and columns. "See?" she said, pointing to a bottom line. The development director handed me another sheaf of papers with the names of several important donation defectors highlighted in yellow. My heart was taking a nosedive.

"Which positions?" I asked.

"Education and library assistant," they said in unison. "We've looked at it every which way, and those are the only ones we can do without right now."

These were employees who had trusted the museum, and they had trusted me, as its director, to make good on my assurance that we wouldn't pull their jobs out from under them. I was about to let them down.

I took the budgets away with me to study, hoping that they were wrong. I made phone calls to the trustees with the softest hearts, but no one thought we should use what they called "stopgap measures." If we were anticipating such a huge shortfall, who's to say the economy would improve any time soon? Better to be prudent now, and add the positions back when we were more secure financially.

When it came time to give the education director notice, I started to cry. "I'm so sorry," I said. "I'll do anything I can to help you find another job. If there were any way at all that I could have saved the situation, I would have. Believe me, I tried." He was incredibly gracious.

"I know you did," he said, "and I appreciate it. If you can give me some leads, and a good letter of recommendation, I'm sure I'll be fine." He didn't look as confident as he sounded. I hugged him, then flew out of the building to cry on the street.

The next day, the administrator and the development officer were back at my paper-strewn desk. "We need to talk to you in private," they said. "Now." Again, they led me to the back of the basement. "How could you have upset the staff like that?" they asked. "Your behavior was totally unprofessional."

I had no idea what they were talking about. "You were right about cutting back," I said. "I followed your advice. I laid off both people. That's what you asked me to do, and that's what I did."

"It's not what you did, it's how you did it," they shot back. "You cried. Everyone saw you. You were *crying*, for chrissake!"

Struggling to keep my voice calm, I said, "What's the worst that's happened here? The staff saw how upset I was at having to let people go? That's a bad message to send them? If you think that being stone-faced at a moment like that is 'professional,' you need to revise your definition."

My friend, the curator and art historian Susana Torruella Leval, once said, "Can you imagine anywhere other than the United States where they would congratulate a woman, as they did Jacqueline Kennedy, for not crying at her husband's funeral?"

My job was becoming increasingly difficult. The challenge was to maintain a very clear vision for the museum in terms of inquiry and scholarship while also attending to the real necessity of balancing the budget and raising money—and to create an organizational climate that was highly productive and efficient but was also fair, compassionate, and *human.*

eleven: 1983–1984

We were a couple. We were living together. And we were about to go on vacation together. Through an act of God disguised as a mileage promotion, I got two free tickets to Hawaii. I booked the flights, and, feet up, champagne in hand, Dean and I flew off to Maui and the Big Island. I kept waiting for the tropical breezes, the smell of jasmine and plumeria, the warm, clear turquoise ocean to work their spell on Dean and seduce him into proposing to me, but on that particular subject he was silent.

On the flight back to New York, I developed horrible shooting pains in my hands. When I told a friend about my strange ailment, she joked, "I guess he slipped through your fingers!"

It made me terribly sad that after all the years of bad relationships, when I had finally found the right person and marriage to him was something that I wanted with all my heart, he didn't want to marry me. I kept hoping he would propose, but two years had already sped by and I was forty-two years old. I was ready to get married and have a baby, but I couldn't work up the nerve to consult Dean about my plans. I hoped he would read my mind and agree enthusiastically, but he seemed as oblivious to them as to my age.

I needed to make him understand how critical this was, so I decided to enlist the help of a couple of dry martinis and a wine-soaked candlelit dinner of *pasta fagiole,* his favorite. When I finally broached the subject,

cushioning it in postdinner warmth, he seemed taken aback. "I'm too young to start a family," he said sensibly. "I'm only twenty-five, and I'm just beginning my life as an artist."

It was hard to argue with reason, but that had never stopped me before. The more he resisted, the more I persisted. Finally, one night at a bar, when I was whining away for the tenth time that week, Dean interrupted me.

"Okay," he said. "I know that if we don't resolve this, I'll lose you, and I don't want that to happen. Why don't we compromise? What if we just put the decision in the hands of nature?"

"You mean, no birth control?" I asked.

He nodded. "It's a deal," I said, and we went home to try it out.

April 11, 1983, was my birthday, so I took the day off from the museum. I went to the bank; to the bookstore to look for May Sarton's *Journal of a Solitude,* which my reading group would be discussing; and to the gym. I got two prescriptions filled, went grocery shopping, ran home to wait for the plumber, ate lunch, made supper ahead, wrote a catalogue preface, finalized the artists for a section of our opening show in the new space, wrote a letter and rewrote a proposal for the Venice Biennale, organized my slides for a lecture in Iowa the following week, typed up a program for that night's Art Mob performance, designed the flyer, and mimeographed everything on Eighth Street. (This was a relaxed day!) Then I rushed home to get dressed for the evening.

Climbing the stairs to the loft, I opened the door, kicked off my shoes on our Dan Quayle doormat, and yelled, "Anybody home?" I had secretly hoped Dean would greet me at the door with his arms full of flowers and presents, ready with kisses and a marriage proposal. Silence. I called out again. His studio, catty-corner to the entryway, was soundproofed, with a heavy wooden door that locked. Lightning could have taken out the rest of the loft and everyone in it, and Dean would have stayed bent over his drafting table until the need to pee forced him out. "Huh?" he would ask in surprise, staring at the gaping hole that had been our home. I pounded on the door. A long minute later, it opened. Dean, dressed in worn jeans and a stained T-shirt, his glasses spattered with ink, peered out. He looked puzzled.

"What's up?" he asked.

I tried to hide my disappointment.

"We are going to be late for the sing, and it's my birthday," I said, pretending to be cavalier about the whole thing.

His eyebrows furrowing, he looked down at the floor. I could see that he'd completely forgotten. I also knew that he was not going to propose just to make up for the oversight.

I took off my jacket and carefully hung it in the closet before I started to cry. "I'm sorry," he said. "You know me, I'm not very good at that stuff. I should have remembered, but it's only a birthday. Anyhow, that's not why you're so upset. You're upset because what this birthday really means is you're forty-three and you're still not pregnant."

I wanted to pick up my fifty-pound briefcase and lob it at his head. Instead, I ran to the bedroom, slammed the door, and spent the latter part of the evening in tears. I was never going to speak to the son-of-a-bitch again, much less have a baby with him.

———

May 4, 1983
I'm pregnant! I can't believe it—I'm in shock. The doctors called at 2:00 to tell me. I'm so frightened and confused and wildly happy and just devastated. I was up almost all night last night thinking about this and one of my thoughts was that if I am pregnant it might mean that God is giving me back everything that was taken away in all those nightmare early years. The idea of being a family, a real family—is overwhelming.

I was terrified, elated, joyous, in shock. I was afraid to tell Dean, afraid that he'd say that it was all a big mistake, that he didn't want to make the commitment after all, that it was time for him to leave and for me to have an abortion. I was afraid that even if he did decide to stay, and even if he wanted to have a kid, I wouldn't be able to work and have a baby at the same time; I'd be a bad mother; I would have difficulty giving birth because I was too old; or the baby would be born with some terrible problem; or it would be a boy, and I wouldn't know how to raise a boy, and even if I did figure it out, the kid would grow up to hate me and I'd make all the same mistakes my parents did. Even more important, I was worried that Hank and the board might think I was incapable of running the museum once I had a baby. Most of the trustees had been with me from the beginning. They'd had over five years of seeing me as an independent, professional,

workaholic person whose entire being was devoted to building the museum. I didn't want them to revise their view—I just wanted them to expand it.

What cheered me up was that Allen Goldring, my first trustee and guardian angel, had been wildly enthusiastic about the prospect. At lunch the year before, I'd timidly mentioned that I wanted to have a family. Allen had beamed, patting me on the hand. "Go ahead," he said. "It'll be wonderful. Dean is a terrific guy, and he'll make a great father. You can do it, and in fact, you should!"

Remembering that conversation, I took heart and called Hank to make a date for lunch. Although he was a perfect board president, I wasn't sure how he'd take the news. We arranged to meet at one of his favorite restaurants, one with more class than culinary savvy. I was always surprised at how bad the food could be at some of those fancy places! Hank's own gastronomic preferences seemed to run to mystery meat, but this time I didn't notice the food—his or mine.

Seated side by side on a plush, uncomfortable banquette, I ignored his quizzical frown when I didn't order a drink. I took a deep breath. "I have some big news, Hank," I said, "and I want you to be the first to hear about it." Hank took a gulp of vodka while I took a gulp of air. "I'm pregnant. The baby is due in December, six months from now."

Hank glanced up. After a long pause—actually, a very, very long pause—he turned to me. "Somehow," he said slowly, "I never thought of you quite that way before."

I thought it was the greatest compliment he could possibly have paid me.

———

Being pregnant made me feel outrageously fat, but then again, had I ever *not* felt fat? I had intimations that I'd been brainwashed, but I couldn't stop acting as if the body I'd been given was an inferior model. Several years earlier, I was lying in bed with a part-time boyfriend who'd told me that he usually preferred to date models. He was lying on his back after an uninspiring round of pin the tail on the donkey, his exhausted parts collapsed under the pale, hairy mound of his paunch. He reached out and put his hand on my stomach. "You could stand to lose ten," he said thoughtfully. I looked at him, smiled agreeably, and got out of bed, gathering his clothes up as I headed toward the front of the loft. I let a few minutes elapse.

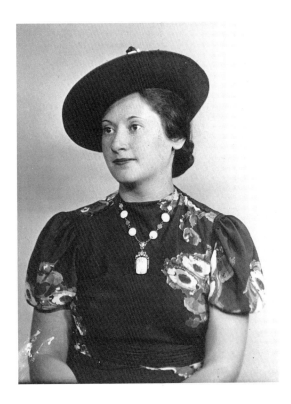

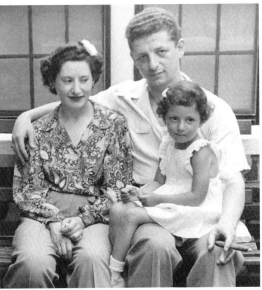

1. Dora Silverman, ca. 1938

2. Marcia with her mother and father, ca. 1943

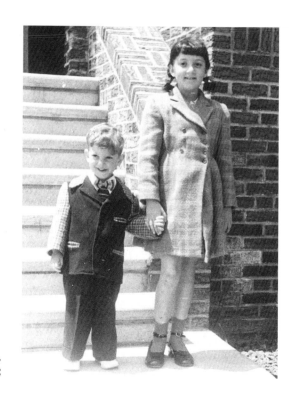

3. Marcia and her brother,
Warren, 1948

4. The Silverman family,
1957

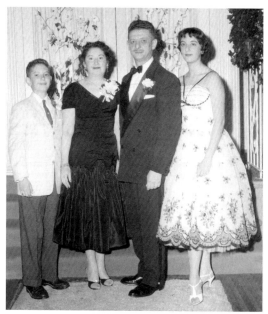

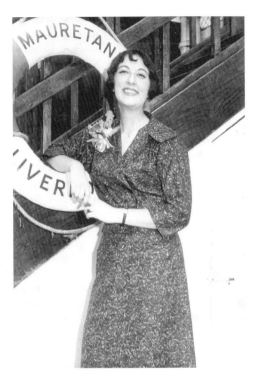

5. Marcia en route to France, 1959

6. Marcia at a picnic in Bad Vilbel, Germany, 1960

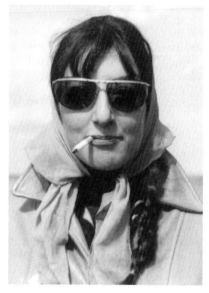

7. Henri, Bois de Boulogne, 1960

8. Marcia on the West Coast, 1962

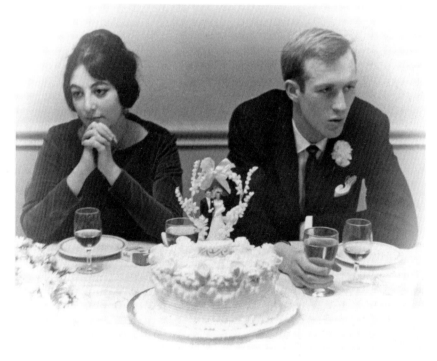

9. Marcia and Michael Tucker on their wedding day, December 15, 1962

10. Marcia's world: after the motorcycle accident in Spring Valley, New York, 1963

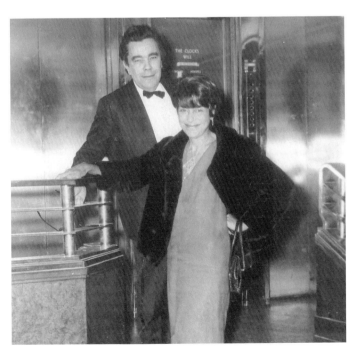

11. Bill and Noma Copley on board the *Queen Mary,* ca. 1965

12. The women's group, 1973—top row, left to right: Nancy Azara, Nancy English, Jane Kaufman, Joan Thorn, Pat Brennan; bottom row, left to right: Pat Steir, Elke Solomon, Marcia Tucker, Harriet Lyons, Victoria Barr

13. Margaret and Alfred Barr at the Venice Biennale, 1948

14. Installing the Robert Morris exhibition at the Whitney Museum of American Art, 1970

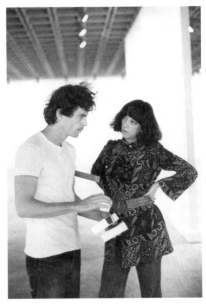

(clockwise from top left:)

15. Bruce Nauman in one of his *Corridor* pieces, 1970

16. Richard Tuttle and Marcia during the installation of his show at the Whitney, 1975

17. Marcia in her loft on Sullivan Street, 1973

18. Mighty Oaks
Theater Company,
1976—top row,
left to right:
Kent Hines, Tim
Yohn; bottom row,
left to right: Elke
Solomon, Nancy
English, Marcia
Tucker, Michael
Kwartler, Arlene
Slavin, David Troy,
Mannie Lioni

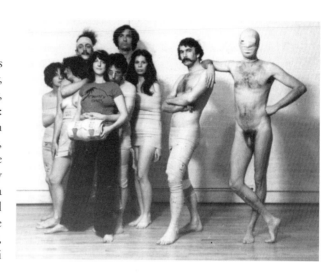

19. New Museum
staff, 1977—left to
right: Michiko
Miyamoto, Susan
Logan, A.C.
Bryson, Allan
Schwartzman, and
Marcia Tucker

20. Displaying the
deed to the New
Museum's home
at 583 Broadway:
Jonathan
Edelstein, Marcia
Tucker, Herman
Schwartzman, and
Elliot Leonard,
1982

21. The New Museum, located in the Astor Building at 583 Broadway from 1983 to 2003

22. Marcia and Dean's wedding day, 1983

23. Marcia in the
loft, photographed
by Arnold
Newman, 1983

24. Marcia with the
New Museum's
founding trustee,
Allen Goldring

25. Tehching Hsieh
and Linda
Montano in
*Art/Life: One Year
Performance,*
1983–84

26. Holding Ruby at
Beth Israel
Hospital, 1984

27. Hank Luce and
Vera List at an artist's
studio visit in
Spain, 1992

28. The New Museum celebrates its fifteenth anniversary, 1992

29. Marcia, Dean, and Ruby in Paris, 1992

30. Bob Flanagan during "Visiting Hours" at the New Museum, 1994

31. Dean, Hillary Clinton, and Marcia at a White House reception celebrating the completion of the Sculpture Garden installation Marcia curated, July 22, 1996

32. Marcia and Liza Lou in Santa Barbara, 1997

33. Marcia with
Lisa Phillips at the
New Museum gala
benefit, 1999

34. At the New Museum benefit after announcing her departure, Marcia with brother, Warren Silverman, best friend, Lynne Darcy, trustees Lola and Allen Goldring, and board president, Saul Dennison, 1999

35. Marcia as Miss
Mannerist, 1999

36. The Art Mob, 2005—left to right: Connie Beckley, Aldo Ceresa, Kirsten
Skrinde, Dean Rainey, Noel McGrath, Terry Ward, Nancy Simpson, Dean
McNeil, Gaynor Coté, Mark Wolff, Martha Giardina, Frank Donno, Betty
Harris, Marcia Tucker, and choir director Frank Lindquist

37. Dean, Ruby, and Marcia at Ruby's high school graduation, 2002

38. The New
Museum building
at 235 Bowery,
designed by
Sejima + Nishizawa,
in 2008

"Hey, you've got to see this!" I exclaimed. Curious, he padded over to where I was standing.

"What is it?" he asked.

"Unbelievable!" I said, pulling him toward me by the hand as I opened the heavy door. With one graceful movement, I threw his clothes out onto the landing and shoved his naked, pot-bellied, hairy body out after them. I slammed the door, threw the bolt, and listened with deep contentment to his bellowing as I put on my black silk bathrobe and poured myself a glass of wine. I waited. After a while, the noise stopped. Glancing around the loft with pleasure, my eyes came to rest on his shoes lying in the middle of the floor. I'd neglected to throw them out the door with the rest of his stuff. I picked them up with the tips of my fingers, stuffed them in the garbage pail, and closed the lid with a satisfying ping.

I didn't need anybody's help finding my own physical shortcomings. I'd already spent a lifetime hating my body, with the unshakable conviction that I should be ten pounds thinner. My crowning achievement had been staying on a strict macrobiotic diet for a month in the summer of 1969 while I was living in the theater commune. I wondered why I didn't just stay that way all the time—except that once I lost the weight, I immediately wolfed down a cheeseburger and loved every second of it.

Being pregnant meant that I could eat without having to be distraught first. It seemed like a good time to develop a new, improved relationship to my body, which I mostly thought of as a prisoner of war, captured by my head after a long battle and held for a ransom that no one was willing to pay. Even in captivity, I could never get it to obey. Maybe it was time for amnesty. I could let it go and beg forgiveness for having tortured it all these years.

———

I was four months pregnant when Dean and I got married on July 17, 1983. We had the ceremony in the huge dining room of his parents' rambling bed-and-breakfast, The Hillside, in Ephraim, Wisconsin, an area that is often referred to as the Cape Cod of the Midwest.

My girlfriend Max, always an enthusiast when it came to dressing up, had agreed to undertake the challenge of finding me a wedding gown. She'd taken me to a boutique on Madison Avenue that specialized in glamorous plus-size fashions. When she explained the "problem" to the delighted

owners, they proudly produced a diaphanous beige chiffon number that was amply cut where it needed to be. But my stomach blossomed like it was in a time-lapse film. By the time I wore the dress, along with my mother's garnet necklace and earrings, it barely fit. The wedding party was small, seventeen in all, made up of a handful of our close friends, my brother, Warren, and some of my relatives, and Dean's family.

It was a very short ceremony, but perfect—everybody cried, including Dean. Warren, Dean's sister, Diane, and my new mother-in-law, Evadne, and our friend Stuart sang "May the Good Lord Bless and Keep You," and Dean and I joined in and cried some more. Then we ate all the food we had cooked the day before, which was delicious, and drank champagne and had wedding cake (carrot cake with sour cream icing). Then we all went swimming in the bay.

For our honeymoon, we went up the road to the lakeside resort Gordon Lodge, on North Bay, for a few days, where we had a relaxing time reading murder mysteries and drinking champagne. I wrote in my journal:

I know that no one can predict the future, and none of us know what hardships or joys lie ahead, but I do know that I'm as happy as I've ever been in my life, and that I feel full of optimism and hope, and life. I never thought this would actually come true—I don't know if the love we have for each other is different, or "better," or more intense than what other people feel—I sometimes wonder, because it seems so positive and so joyous, and so secure, comparatively. And I wonder why I never experienced anything like this before. . . . I think about my parents, especially, and wonder if they ever felt like this about each other, and what they felt when mother was pregnant with me and Warren. Did they want me as much as I want this baby? Did they comfort and console each other the way we do? Did they ever have fun the way we do? Here I am, more than halfway through my life, and I'm having fun—who would have thought?

———

Two days later, we were back at Dean's parents' bed-and-breakfast, where I got back to work. I was writing the catalogue essay for an Earl Staley retrospective that Linda Cathcart, by then at the Contemporary Arts Museum in Houston, and I were organizing for our respective museums. It was hell trying to write when I could barely breathe. I hated sitting down, I hated standing up, I couldn't bear walking, I couldn't lie down or sleep.

I had included Earl's work in the 1975 Whitney Biennial, and in 1978 I had included a group of his paintings in the *Bad Painting* show at the New Museum. I was drawn to his work by his iconoclastic, off-the-wall approach to the great images and traditions of art history and mythology, his acute observation of nature, physiognomy, ordinary objects, and the phenomenal world—and the fact that the work was largely misunderstood, ignored, or dismissed by the art world. He said that the most important event in his career, and the one that had had the most profound effect on his work and his attitude toward it, was his decision in 1974 to "stop making art." Of course, he continued to paint after that, but he had freed himself from aesthetic rules and boundaries.

I loved his work, but what I remember most about that summer is the heat, the slow pulsing of my bloated and recalcitrant body, and the fact that I had a writing deadline when what I most wanted was to spend my days floating belly-up in the warm waters of the little bay in front of The Hillside.

———

July 30, 1983, we found out that the amnio was okay, and the baby was a girl. Dean and I danced around the living room, or at least he did. I lumbered from foot to foot like a beach ball on stilts, waving my arms and laughing. I really wanted a girl, and so did Dean. I thought of all those years in the women's movement, all the confusion and struggle and anger, all the relationships that had snapped apart like twigs under the weight of the growing awareness of the inequities of our lives. I felt an incredible joy in thinking that now my very own daughter would be able to take advantage of the world that I had helped, even in a small way, to change.

———

Ruby was born January 3, 1984. Labor started on Sunday night, stopped Monday afternoon, and resumed during singing rehearsal that evening. At midnight on Monday, my water broke. The feeling was extraordinary— water all over me, puddles of it on the floor. Dean mopped up, got me to the shower, and I spent the night and morning in what felt like hard labor, except that the contractions were eight minutes apart. We got to the hospital at 1:00 in the afternoon Tuesday, and the doctor said there was too

much pain, so they gave me an epidural. The contractions got closer, but there was no dilation. After hours of this, they decided at 10:00 that night to do a cesarean. Dean was there the whole time, and I was wide awake. When the baby was lifted out, she was so beautiful, even all covered with blood. She was pink and long and thin, and when she started to cry, I was overwhelmed. All I could do was yell, "Baby! Baby! Baby!"

———

When I went back to work, less than six weeks after Ruby was born, Dean quit his day job to become a full-time dad. His job, the one that had supported his work as an artist, was contracting and construction work. "You can't leave your work," he said, "but I can leave mine. I can always go back when I want to. I'll be able to be with Ruby and also have more time in the studio." It made sense to me. What I didn't expect was that I might have feelings, strong ones, about leaving her with anyone else, even him.

Every morning, I'd tear off to work, half-eaten bagel in one hand and my overstuffed briefcase in the other, leaving a greasy smear on Dean's cheek and a dollop of jam on Ruby's forehead. No sooner was I at work than I missed them. I imagined the two of them enjoying their day while I cradled the phone uncomfortably between my shoulder and ear and tried to convince a wealthy stranger to give the museum half a million dollars. Or one hundred thousand. Or one thousand, anything at all. I could picture Dean reading his paper and drinking a leisurely cup of coffee while Ruby gurgled happily in her bouncy swing. I saw Dean sitting on a park bench while Ruby slept peacefully in her carriage, the spring breezes blowing gently across her smiling little face. I could hear Ruby making those cute little sucking noises while Dean fed her a bottle and watched the news on TV.

My role as the feeding machine was necessary, but it felt more like a walk-on than a lead. Twice a day, Dean brought her to the office so I could nurse her on schedule, which meant that I did it while I read budgets, wrote a grant proposal, had a serious phone conversation with a trustee, or—the worst—ran a staff meeting. The baby couldn't wait, and neither could the meeting, so in I went with Ruby and a shawl, prepared to flesh out my infant and the next year's exhibition schedule simultaneously. Dean, sitting patiently in a corner with a book, picked her up when she was done, burped her, and cheerfully waved goodbye as they departed for the joys of the outside world.

Dean worked in the studio, shopped, cooked, cleaned, and took care of Ruby. He had supper waiting when I got home. The house was clean. There was always a supply of paper towels, toilet paper, detergent, milk, juice, eggs, and breakfast cereal. Little containers of baby food were lined up in the cupboard like miniature jars of pastel pigment, awaiting the painter's craft. Their life was perfect. Mine wasn't.

I tried to get my share of mothering in at night and on the weekends—that is, whenever I didn't have to go to a dinner, a cocktail party, an opening, or a panel. I wanted to be with her so much that whenever I did get a chance, the rest of the world disappeared. I felt as though I'd won the lottery when I was able to just sit with her, cuddling on a park bench for an hour. Watching her was like going to the theater where she was the star—and only performer—for a rapt audience of one. I sang to her, talked to her, kissed her so much I thought for sure that she'd have bruises on her little pink cheeks.

Before getting pregnant, I'd made a commitment to lecture at several places around the country, and I wanted to fulfill my obligations. I was uncertain how motherhood might affect my professional life, and I worried that people might not see me as a competent curator and museum director now that I had an infant latched onto the buttons of my business suit. There weren't many role models out there, at least none that I knew personally, and I was nervous about showing the two sides of my life simultaneously, especially outside the museum. One way to solve the problem, particularly while Ruby was still nursing, was to make sure that Dean could come with me.

My first lecture tour took me to several universities in the South, where we were mostly able to stay with friends. Ruby was angelic, sleeping through the night in a pulled-out dresser drawer lined with blankets, or in a shallow laundry basket, or in a variety of makeshift bassinets. The only glitch was that Dean liked to hold her at the back of the auditorium so he could listen in, and every time she made a little sound, whether a whimper or a gurgle of pleasure, I leaked. My nursing bra wasn't up to doing double time as a milk dike, and my blouses all had big round stains in the obvious places.

———

The forty-first Venice Biennale was coming up, and the New Museum was organizing the exhibition for the United States Pavilion. I had been named United States Commissioner, and I was working with New Museum curators

Lynn Gumpert and Ned Rifkin to select the artists and refine the theme, *Paradise Lost/Paradise Regained: American Visions of the New Decade*. We felt it was no coincidence that in 1984, the year made famous by George Orwell's novel, artists were making paintings that were tinged with nostalgia or a desire for Utopia.

We decided to include the then little-known artists April Gornik, Eric Fischl, Charles Garabedian, Earl Staley, and the Reverend Howard Finster in the exhibition, and we hung the paintings Salon-style, from floor to ceiling. It was a packed, exuberant show that featured every kind of imagery, from traditional scenic depictions to intense, otherworldly vistas.

The critics hated it. *Paradise Lost/Paradise Regained* didn't hold much promise for an art world accustomed to the kind of star system that permeated the 1980s. They wanted Julian Schnabel, it seemed, or the next best thing. A group show that featured a majority of unknown artists whose work was critical of the American Dream just didn't have much panache.

I took the criticism in stride, mostly because Dean and I had taken Ruby with us to the opening, and I was struggling to nurse her in a variety of handy closets, toilets, and dressing rooms so that my serious-museum-director image wouldn't be marred by the sight of a bare nipple urgently applied to a squawking, overheated, incontinent infant. When we had to go out to eat, we decided to throw ourselves on the mercy of the Italians, who were reputed to love babies. It was true. Waiters, waitresses, bartenders, and cooks whisked Ruby away to their redolent lairs while Dean and I gulped down our food, barely tasting it in our anxiety to be out of the restaurant before she started screaming or pooped on someone's apron. But she was impossibly, deliciously, irresistibly cute.

When Ruby was still in diapers, her godmothers, Lynne and Cheryl, spirited her off to Vermont on a camping expedition. Lynne and I had met when I was eleven and she was ten, because our fathers were best friends. One drunken Irish poet, self-proclaimed, one sober Jewish lawyer who loved to read. Our families were dragged along for the ride. No one ever understood it, but by some miracle the rest of us all got along. Our mothers immediately bonded, although they were as different from each other as our fathers were. Lynne's mom wore denim work shirts and a huge apron and could cut firewood, run a tractor, pick apples, and pitch hay. My mother had exquisite taste in clothes. Hats, in particular.

Although Lynne's parents, who saw me as spunky and outgoing, wanted Lynne to be more like me, and mine wanted me to be more like her, the

diligent, straight-A science and math genius, we dismissed their warped views of us and became lifelong friends.

Lynne met Cheryl the same year I met Dean, and they've been together ever since. They were the most stable couple we knew, so shortly after Ruby was born, we amended our wills to make sure that if anything happened to us, they would become her legal guardians. They lived a few blocks away, so if Ruby ever had to run away from home, she wouldn't have far to go.

twelve: 1984-1993

I wonder if great inventions are not the invention of problems rather than the invention of solutions.

JEAN HYPPOLYTE

Just about every exhibition I organized taught me something important. I learned from the research I did in art historical sources, but my real education came from reading the books that the artists I worked with loved, or from reading in areas outside the arts—science, math, religion, philosophy, even murder mysteries—because a foray into those fields led me to think about an artist's work in a way that art historical research could not offer.

I read Hans Reichenbach on the relational concepts of time and space when I worked on a four-part show with Barry Le Va in which not only the installations changed, but so did the component parts of his floor pieces as the public moved through them. I pored over Abraham Moles's book on information theory and Jean Piaget's writing on early childhood development, particularly his book on the child's perception of space, when writing about Al Held's enormous abstract paintings, and I plunged into the philosophy of Ernst Cassirer when I began thinking about why Alfred Jensen's work had no discernable linear development.

Looking at art historical antecedents has always struck me as circular. You can certainly find out something about recent art by thinking about older art, but the process is self-referential. I wanted to learn about the world, and I've always believed that if you look to a work of art to see what it can teach you about living right here, right now, it'll open up like Pandora's box.

In 1984, we invited five guests, Benjamin Buchloch, Donald Kuspit, Lucy Lippard, Nilda Peraza, and Lowery Sims, to curate the show *Art and Ideology*. They selected the artists' work and examined how and why each piece was informed by underlying ideology. The assumption was that all art is political, because it reflects the power relations of the polis, or citizenry, whether deliberately or not. In the catalogue, Lucy Lippard wrote, "All art is used politically by the right or the left, with the conscious and unconscious assent of the artist. There is no neutral zone." Art always has a deeper story to tell, a meaning other than the one that is immediately obvious.

In April 1984, Hilton Kramer, no longer at the *New York Times,* devoted the lead article of his fledgling magazine, the *New Criterion,* to a diatribe against the exhibition: "In *Art and Ideology* we were offered a[n] explicitly Marxist account of American society together with arguments (in the catalog) calling for the political criticism of all cultural activity. . . . [O]pen political commitment . . . is now standard policy . . . at the New Museum of Contemporary Art."

I've been criticized for preferring ideas to art, but I never did understand how to separate the two. The Enlightenment dualism of mind and body is a concept that we can't shake. Try to tell me about the mind/body dichotomy when you have stubbed your toe. Karl Marx may have been right when he said that there is only one antidote to mental suffering, and that is physical pain, but pain slows down the mind for only a short time. (Chocolate, I've found, works a whole lot better.) Or maybe the two *are* different, and it's actually your mind screaming at your body, "You idiot, you've stubbed your toe, and now you won't be able to take me to the bookstore!"

Nevertheless, that particular criticism had some basis. It's true that I'd rather talk about concepts, contexts, the how, where, and why of a thing, than analyze the formal properties of a work of art. If you lay off the "parallel lines on the canvas," the "balance of light and dark," and other art history shibboleths, if you really look at the painting or sculpture or photograph or installation work or video and pay close attention to the ways the images resonate with your own life, then the world of your experience and the world of the artist's experience have a chance to connect.

———

People sometimes ask me who my favorite artist is. The idea of having a "favorite" artist presents an impossible conundrum—how can anyone possibly

choose? But because people really want an answer to the question (as though it may explain the professional decisions I've made over the past thirty years), I give them one. My favorite artist is Tehching Hsieh. Of course, the next thing people immediately ask is, "Who is he?"

Tehching's life's work consists of paintings he did as a young art student in Taiwan between 1970 and 1973; a handful of never-realized film and photo projects; five "one-year performances"; and a final piece entitled *Earth,* which he completed in 1999.

For his first performance (1978–79), Tehching locked himself in a cell in his loft and lived there for a year without reading, writing, or speaking and without entertainment of any kind. Twice a day, someone silently brought him food and removed waste. In his second performance (1980–81), he punched a time clock every hour on the hour, day and night, for one year, a witness confirming each day that he had done so. The third piece (1981–82) consisted of living outdoors for a year, never entering an inside space except once, when an altercation led him inside a police station. For his next one-year performance (1983–84), he tied himself to the artist Linda Montano with an eight-foot length of rope. They lived together, slept in the same room, and were in each other's immediate space at all times. The condition of the work was that they not touch each other for its duration. The rope piece was followed by a year (1985–86) during which Tehching didn't make, look at, read about, or, presumably, think about art at all. I mailed him a check for his participation in the New Museum exhibition *Choices* (a group exhibition I curated in 1986 that focused on artists who drastically altered their lives as a way of making art), in which we had included several posters marking the beginning, middle, and end of each of Tehching's one-year performances—and he didn't open the envelope until his non-art year was over.

Tehching told me that this last one-year performance had brought him to a turning point in his thinking and that his next piece, *Earth,* would be a thirteen-year project in which he would make art with all of the concentration and intensity that he had always brought to bear on his output, but that he would not show it to anyone publicly. He emphasized to me that absolutely no one would see the work. By not showing it, he would be able to attain a certain degree of freedom—no grants, no shows, no "success." It meant that he would be able to work entirely on his own terms and not feel that the art world owed him something.

Earth lasted from December 31, 1986, through December 31, 1999—from his thirty-sixth birthday to his forty-ninth. Though each of Tehching's

"performances" was a lived metaphor, a sustained act of attention to a basic facet of life—isolation, work, otherness, intimacy—*Earth* strikes me as a unique act of artistic honesty and courage because it involved taking the measure of himself intrinsically rather than extrinsically during his mature years, when people usually look for validation from the outside world. There's real power in privacy, and in removing the idea of the "best" artist and the idea of acclaim being the measure of the value of one's work.

Thinking about Tehching's work provided a doorway for me to think about my own work as a curator and writer, and the risks I had been willing or had not been willing to take. For twenty-five years, I had tried to understand others—in the case of artists, to interpret through their eyes—and suddenly it struck me that that made twenty-five years of avoiding the painful process of looking into myself, and calling that avoidance "work."

The struggle from there on was to understand who I was, and to bring this to bear on my work. I hoped the personal voice, the entirely subjective (female) one, would allow room for others to enter the dialogue and to voice their own opinions. In the museum and in my writing, I wanted to create a space from which everyone equally could raise questions, debate issues, think. I would not try to resolve contradictions, and I would use my own experience as the best source—no footnotes necessary!

———

In the fall of 1985, the New Museum was being picketed by animal rights activists because of an installation in our Broadway window called *Plato's Cave,* by Remo Campopiano. It involved an ant farm, and the animal lovers were upset because we were mistreating the ants by providing them with food, water, company, climate control, and a view. We were planning to release them in Central Park when the show was over, but the protesters were convinced that we were unrepentant ant torturers. One day, just as Marga was leaving after our lunch, one of the PETA people became completely unhinged and padlocked the front doors with a resounding metallic snap, locking us all inside. We called the police, who called the fire department, who used the Jaws of Life to get us out, which took about an hour and a half. Instead of being irritated at the delay, Marga was vastly amused, watching the brouhaha avidly from the sidelines. Once we were released from bondage and Marga sallied forth to continue her errands, one of the staff members turned to me and asked, "Is that your grandmother?"

"No," I replied, "she's my girlfriend. She just looks a lot older than she actually is."

———

That year, Rock Hudson became the first famous person known to die of AIDS. It was only the beginning. By the fall, several of my friends were dying or had died of AIDS. Dennis Florio, whom I'd first met because he was a framer for the Whitney, lived his entire life as though he were onstage. He was a loyal member of the Theme Luncheon of the Month Club, an extrovert, a rake, and an outrageous wit. It took a while for his friends to realize that he was suffering from AIDS-related dementia, because causing a scene was something he did regularly, just for fun. Only when the police had to carry him out of his apartment and lock him up for disturbing the peace did we know that something was seriously wrong. His mind was clear, though, when with his last breath he whispered to the crying friends gathered around his bed, "Whatever you do, make sure I'm cremated. *Nothing* can get me to go back to New Jersey!"

My best friend, Kent Hines, who'd accompanied me to the party where I first met Dean, had lost his boyfriend Jack to AIDS before anyone knew what to call the disease, and a few years later, he was dying of it himself. His hair had become completely straight from the drugs he'd been taking. His beautiful body had become impossibly thin, his blue eyes clouded and worn. Resigned and wise, he took my hand in his and said softly, "The only difference between us, sweetie, is that I'm catching the 10:40 and you're getting the 11:25."

In February 1986, Reagan requested that Congress cut 12.5 percent from the budget of the National Endowment for the Arts, which constituted a loss of $20.7 million to the agency. Like most other nonprofit art organizations, the New Museum depended on NEA funding for our survival. NEA grants meant credibility for a start-up organization like ourselves, helping to attract private foundation, individual, and corporate support. They had allowed us to create a model for arts education that had changed the lives of high school students for the better. It had helped us to fund multicultural internships and to present important bodies of work to the public that wouldn't otherwise have had a venue at that time.

Just when we were getting scared about what the new cuts would mean to us, Hank announced that he would be awarding the museum a grant of $1.5 million through the Henry Luce Foundation in order to spearhead an endowment fund to complete renovations to the museum, to purchase a computer system, and for exhibitions and other programs.

By our ten-year anniversary, we had already organized more than thirty exhibitions, each accompanied by a catalogue; we had shown the work of over four hundred artists; and we had presented countless lectures, panels, and symposia, as well as running an education program for elementary and high school students. We had received three previous grants from the Luce Fund for Scholarship in American Art, for the publication of anthologies documenting significant thought, writing, and criticism in contemporary art. *Art After Modernism: Rethinking Representation* was the first of these anthologies, published in 1985.

The catch was that the museum was growing so quickly, and we were always so busy catching up to the demands, that we hadn't had the time to work on an organizational structure suited to the drastically bigger situation. By 1988, we had grown to a staff of thirty-five, and still everyone was overworked. Even if I could have eliminated the resentment and anxiety and the burnout that turned some staff members into human embers, a fundamental problem still remained: I loved the museum, but I was starting to hate my job.

I thought about hiring some management consultants to look at our organization and help us. But were there any consultants who didn't come from a corporate environment?

Then I heard about Don Adams and Arlene Goldbard, an unconventional couple who had been successful in their work with public arts agencies and community-based arts organizations.

We paid to fly them in from the West Coast for an initial meeting. Don was tall and lean, with pale glasses and a gentle demeanor. Arlene was an attractive, dark-haired, intense bundle of energy and goodwill, with a quick laugh that could offset even the most devastating critique. Within minutes of talking to them, I felt a sense of relief.

Don and Arlene did their job with the care and concentration of lion tamers. They spent months interviewing, writing, creating time charts, and rethinking the organization on every level. It occurred to me as I watched them go about their assessment that if the staff was going to be evaluated, it made sense for me to be evaluated, too. I could learn a lot, improve my working style, and become a better director.

When the report came back from Adams and Goldbard, I learned that the staff thought that there was a lack of leadership on my part. Apparently, I was not perceived as a "boss"—they saw me as receptive and supportive, but the downside was that I refused to resolve an issue when they were deadlocked. They perceived favoritism on my part, and there were complaints about my traveling to lecture—I wasn't around enough, I wasn't available as a mentor, I wasn't accessible enough.

I felt mowed down. On the bright side, Don and Arlene said, the willingness to be self-critical was what separated us from other institutions. It was true that I thought consensus resulted in better decisions, or at least ones that couldn't be blamed on single individuals if they didn't work out. And I believed that what people could do together was always greater than what any individual could do alone—the collaborative process encouraged amazing contributions and helped people to learn management and leadership skills.

My friend Carol Becker, an art historian and dean of faculty at the School of the Art Institute of Chicago, wrote an essay called "The Institution as Dysfunctional Family," in which she offered a startling view of the parallel psychodynamics of institutions and traditional nuclear families (*Zones of Contention: Essays on Art, Institutions, Gender, and Anxiety* [Albany: State University of New York, 1996]). As she describes it, there's usually a patriarch at the top (the father); a second-in-command (the mother), who works as confidant, advisor, mediator, and interceptor; and a staff (the children), who support the father and relate to the institutional structure as siblings and as kids. The children try to please the father and earn his praise, but if the mother assumes leadership, the result is trouble. Becker writes:

> A woman who rises to the top of an institution is in a difficult situation. Most members of the institution, as players in the psychosocial drama, will position her in the role of mother. However much she resists, they will see her either as the nurturing, supportive figure from whom they will ask unconditional acceptance—the "good mother"—or as the withholding ice queen, the stepmother, or the female sibling who has won the father's favors and has now become, inappropriately, the head of the household—the bad mother. . . . Another aspect of this discomfort is that women often relate to power in new, and thus disconcerting ways. For example, women are often more egalitarian managers. They frequently encourage others to take more initiative, to assume more control of the institution and their own place within it. In other words, they are willing to share authority as well as recognition. This seriously challenges the traditional infantilizing of

the institution, creating the possibility that everyone can become an adult. The result is that those who cannot cope with this expectation of freedom and accompanying responsibility become nervous and begin to act out against the one whose presence undermines the ancient status quo.

I was so relieved when I finished reading her essay that I had to lie down. What was happening at the museum wasn't just my fault; some of it was a conditioned response that other women had experienced, too.

Adams and Goldbard's report, with its dozens of pages of problems—"no systems for evaluation; no clear decision-making processes; inadequate flow of information; not enough advance planning; crisis management; un-workable hierarchies caused by the departmental structure"—made me feel worse than I had before they had arrived. I wasn't sure we could ever get out of the mess, even though, as they pointed out, many of the problems were a result of the museum's success. Still, the report gave us a blueprint, clear instructions, a plan. And buried in the midst of all those pages were several sentences that gave me hope: "The last, conservative decade has been a period of great financial difficulty for arts organizations focused on work that is critical, oppositional, or experimental. But during this time the New Museum grew into a world-famous institution, established in its own building with a sizeable staff. . . . What people liked best about working for the New Museum was its flexibility, openness to new ideas, and the creative freedom and independence many have been offered in their own areas."

As a result of Adams and Goldbard's recommendations, we created a new position, managing director, and hired Ellen Holtzman, who had worked at the Brooklyn Museum, to fill it. Ellen was just what the management doctors ordered. She was calm, fair-minded, evenhanded, skilled. She read budgets. She wasn't power-hungry. She listened.

Thanks to Ellen's reassuring presence, by 1988 I felt I could finally take a sabbatical. The one thing that made me uneasy about going was leaving our curator, William Olander.

Bill had recently told me that he had AIDS and that his health situation was precarious. Although he said he wanted to go on working, he didn't know how much time he had left. When I told the museum's trustees, they agreed immediately to provide him with a full salary whether or not he was able to work.

Bill made a lasting contribution during the three years he was at the mu-seum. He was one of the most knowledgeable curators in the country,

speaking readily and clearly about even the most complex art issues. Bill had an analytic mind that made connections between works of art and ideas that opened out onto the bigger world. What I loved most about Bill was that he was an arts activist in the best sense of the word.

Bill went to a meeting of ACT UP, the AIDS activist group, and asked them to do a visual demonstration in the Broadway window at the New Museum. It was considered, at the time, a radical act for a museum to team up with a political organization, but we all felt strongly that it was something the museum should do. The resulting installation, a neon sign reading "Silence = Death," targeted the pervasive indifference of political leaders to the AIDS epidemic.

Later, several ACT UP members got together and formed a group called Gran Fury, after the New York Police Department patrol car, the Plymouth Gran Fury. Gran Fury went on to create more political art action, using different media strategies, from bus posters to mass mailings, to create public awareness about AIDS. Posters like *Kissing Doesn't Kill: Greed and Indifference Do* went a long way toward changing the American public's homophobic perception of AIDS and fear of the "other."

As for the Olander years, working with Bill was one of the best things to happen to me. He was beloved by artists; he saw absolutely everything; he was open in a way that no other curator I've ever met has been; and he had a curious, sharp, truly unconventional mind. We talked at length about my taking a sabbatical, and he insisted that I go; I had the disturbing feeling that if I didn't, he'd assume that I thought his time was up.

Dean and I traded houses with our friends Richard and Cissy Ross and their two kids. We went to live in Santa Barbara, while they roughed it during Manhattan's sizzling summer and frigid winter. They sold us their car for a dollar and made arrangements for Ruby to enroll at the Montessori school their daughter, Leela, went to. They fearlessly put their own kids into New York City's public schools.

Although I spoke to Ellen back at the museum on the rare occasion when she needed to ask me something, I didn't work, and I tried not to worry while I was gone. There were long, lazy days spent with Ruby and Dean; morning walks on the broad expanse of beach beneath the cliffs; time to think, read, and reflect. Santa Barbara had a diverse community, a couple of terrific independent bookstores, parks that people had written books about, lots of movie theaters with no lines, two museums and a contemporary art center, and a farmer's market loaded with locally grown fruits and vegetables.

We loved Santa Barbara so much that a year later we spent our summer holiday there. We managed it by putting an ad in the local paper and found a house in trade for our loft in New York. The minute we arrived, I became intensely happy.

Even though I had several work projects with me, it felt great to be there. The study overlooked the ocean, I was able to take singing lessons, and Ruby was enrolled in zoo camp, which she loved.

In actual fact, the world looked like shit. On July 3, the Supreme Court made its infamous move to curtail abortion rights. Back to the barricades. I actually cried over my coffee when I saw the paper. How stupid we are to assume that minor gains in the endless battle for women's rights are permanent advances.

———

I thought of myself as deeply political, and even though the heyday of the women's movement had been over by the time I'd incorporated the museum as a tiny, barely-there not-for-profit in 1977, what it stood for had seeped into my bones. I still believed that the personal was the political, and I wanted to live and work according to my principles.

From the beginning, the New Museum aspired to be a multiracial and multicultural organization in terms of its exhibition programming, staff, and governing body. The programming part was the easiest because of the number, variety, and excellence of the artists from which to choose. But when it came to the staff, it was harder than I imagined to escape the status quo.

The people who came to work with me at the outset were young, energetic, and optimistic enough to devote themselves to the museum simply because they could learn from it. But they were also the ones who were willing to work for nothing because they had families who could afford to support them while they pursued interests that were personally enriching but may not have led to future financial stability. And with the exception of Michiko, we were all white.

As the museum grew, I became more determined to match the makeup of the staff to the city's demographics. I also wanted the board to be racially integrated.

Inclusion was critical, because, as the feminist scholar Gayatri Spivak pointed out, art and artists from Asian, Latin, and African cultures have

historically been subject to a system of art apartheid, with their own museum wings, their own shows, their own analyses, mostly designed, built, curated, and reviewed by people from outside the cultures being studied.

But were we big enough to make a difference, and was the New Museum only appropriating the work of culturally specific museums, ignoring what they were already doing, and doing well? Would we always have to ask them for the names of the artists they had already discovered and supported?

We knew that in order to make a change, we needed to work with people whose knowledge was broader than, or at least different from, our own. Artists typically had not played an active role in conceptualizing the presentation of their own work, and that went especially for artists of color, whose work was typically selected and subsequently classed together according to ethnicity or ideas about exoticism, in situations that often marginalized the artists' work or presented it in contexts with which they did not agree. To counter that tendency, in 1980 we started Minority Dialogues, a series of meetings that focused on the concerns of emerging artists of color and resulted in a long-lasting allegiance among the curators, critics, and artists who participated. In 1981, we invited Fashion Moda, Taller Boriqua, and En Foco, collectives of artists from the South Bronx and the barrio, to organize exhibitions in our space.

To diversify the administrators of the museum was another story. Even if our director of education was African American, the only other people of color at the New Museum, as at most museums, were the guards. I was frightened and ashamed that this could have happened to us, too. The way to rectify the situation, I finally saw, was to keep each new position open until we found a qualified candidate of color to fill it—at least until the staff was completely integrated on every level. It took a while, but eventually we had a staff that was as racially diverse as the street outside.

By 1989, the Association of Art Museum Directors' External Affairs Committee, of which I was the chair, had begun to address the question of racism, and I thought our discussion could be expanded into a series of formal programs. I wrote up a proposal for the Programming Committee, which, to my surprise, was accepted. I'm sure that there were several people on the committee who thought that my involvement in programming meant trouble, but there were obviously also others who were happy to have things stirred up. They decided that the Chicago and Honolulu meetings in June of 1990 and January of 1991 would center on racism and sexism, under the rubric "Different Voices." The members of the External Affairs Committee and I would plan, organize, and run the meetings.

I invited two extraordinary facilitators, whom I'd met at an academic conference, to run a breakout session on racism at one of the conferences. Their session would have been hard enough, seeing as how it tackled a controversial issue in a group that was almost all male and all white and made up of people who were the unchallenged authorities in their own fiefdoms. But when the workshop leaders announced that they were also a lesbian couple, the last vestiges of politeness flew out the door and chaos ensued. Many of the museum directors became defensive. Others questioned the workshop leaders' qualifications. Some just left the room.

When the postmeeting evaluations came in, I could have burned my hands on the papers. But Mimi Gaudieri, the executive director of the organization, was unflappable. She found the money for a publication and someone to help produce it, and a year and a half later, a classy little book came out, with introductory essays by me and Arnold Lehman, the president of the organization that year (*Different Voices* [New York: Association of Art Museum Directors, 1992]). There were transcripts of the main lectures by some of the great names in the field of theory and criticism, and a listing of all the programs and participants. It looks kind of normal now, hardly incendiary, hardly groundbreaking.

Even if the meeting changed just a few people's minds, it was worth it. I was a pariah only for a while, and then everything went back to normal. Or almost.

When the Program Committee, to which I'd been rotated from External Affairs, decided to do a conference session titled "Why Art Museums Matter" a few years later, we invited the Australian art critic and historian Robert Hughes to be the keynote speaker. I'd known Bob since the late sixties, when we'd met at an artist's studio in California and discovered that we had a shared passion for motorcycles. We'd always been on good terms, and I liked him. But when he spoke at the conference, I was shocked. His lecture, brilliantly worded and impeccably delivered, was a paean to the exclusivity of museums, a plea for the return of "connoisseurship" and the creation of a pure, religious experience in the presentation and viewing of art. Inclusiveness was of no interest to him. In fact, he saw it as a detriment to the field.

"Nowadays," he complained, "every one-legged Chicana lesbian who demands a show gets one." He was telling us that it was a waste of time and effort to organize exhibitions of the work of African American, Hispanic, Asian, or women artists because the only reason for doing so was to be "politically correct."

At the question-and-answer session, I got up from my seat in the audience to take the mike. "Speaking as a one-legged Chicana lesbian," I began,

"issues of race, gender, and class are still relevant. Those who question the relevance of such things are still locked up in the ivory tower. They're very happy to have a token somebody here or there. It's an easy out to say it's not relevant." I saw a number of people turn toward me and look down at my trousers. I had to laugh. Maybe they found it hard to tell the difference between a Chicana and a Jew. Or maybe they thought they now had the answer to why I always wore pants.

In 1990, the New Museum collaborated with the Museum of Contemporary Hispanic Art and the Studio Museum in Harlem to present *The Decade Show*. Mainstream institutions were looking back on the eighties and framing the decade in group shows that tended to be centered around all-white, all-male celebrity artists like David Salle, Eric Fischl, Julian Schnabel, and Jeff Koons. We wanted to show what the important work of the previous ten years had looked like from *our* perspective. Between the three of us, we selected ninety-four artists and divided the show among our respective museums. Works by David Hammons, David Wojnarowicz, Adrian Piper, Jimmie Durham, Lorna Simpson, Betye Saar, Martin Puryear, Amalia Mesa-Bains, James Luna, and Barbara Kruger, among others, represented *our* version of what the art world of the eighties had looked like.

In the *San Francisco Chronicle,* Kenneth Baker described the show as "Art for the sake of persuasion, recrimination and the dignity of lives that have been marginalized by mainstream culture" (July 19, 1990).

Not everybody got it. "Multiculturalism is the buzzword among arts groups trying to position themselves for the day when whites of European derivation become a minority in America" (Kay Larson, "Art: Three's Company," *New York Magazine,* June 11, 1990).

Oh, so *that* was the reason we did the show!

———

By 1993, controversy over government funding of the arts had led to further cuts in the NEA's budget for 1994, and the New Museum was having a tough time of it. Our exhibition program was seriously underfunded. Government art support was so competitive that it almost seemed not worth the effort to write the grant applications because the chances of getting one were so slim, no matter how good the project. There had also been stock losses, and the private sector wasn't contributing generously enough for us to make ends meet. We'd had to cut back our budget by one fifth,

and rather than lose positions, we were trying to reduce the number and cost of our exhibits.

Early in the new year, Hank told me that the board wanted me to write a formal defense of the New Museum's mission, goals, and programs and present it at our next board meeting. They wanted me to explain each of the curatorial decisions we'd made; why and how we had chosen the exhibitions over the past few years; how they accorded with the museum's overall philosophy; and how they fit our public image and differed from the programs of the other museums in the city.

True, we were in a big budget crunch, but that shouldn't have prompted a complete reevaluation of our work. What we had been doing was no different than the risk taking and experimentation we'd always engaged in. I wondered if we'd lost support among the trustees.

During an earlier board meeting, I had been asked to wait outside the conference room while the trustees held an executive session. As I waited to be called back to the meeting, I hoped that they were discussing an overdue pay raise for me. It turned out that they were discussing a letter a dealer had addressed to the board, complaining that there had been too much theory involved in our shows and not enough work that was of interest to them or their constituents. "Dealers feel that most shows at the New Museum lack any visual content. If a show has to be explained to be interesting, there is something missing in that exhibition," the dealer wrote. The underlying problem was that our exhibitions were not addressing the art market. In a period marked by an obsession with career advancement, materialistic attitudes, and blatant commercialism, the New Museum, by intention or default, had presented work that challenged those values, critiqued them, or bypassed them entirely.

Contemporary art is often criticized as not being "visual" or "aesthetic" enough. One reason is that what is visible in a work of art is often only part of its meaning or significance. I didn't think the New Museum should retreat from the challenges such artworks posed, but should continue to develop new exhibition strategies for displaying those works in the most compelling and engaging ways possible.

There had been a lot to look at and a lot to read in some of the exhibitions we'd presented in recent years—maybe too much at times. Many of the co-curators had been academics, so some of the language used in the wall texts and brochures may have been dense. The energetic look of some of our exhibitions reflected a sensibility opposite to that of the time-honored approach to museum exhibitions, which sought to create an aura of exclusivity and veneration.

But I was concerned with creating a genuine "laboratory" organization, where curators could experiment with exhibition formats, could write serious texts on contemporary art and issues, could mix video, photography, installation, and yet-unheard-of forms of visual art with more traditional media, and where the museum's own management structure could reflect the adventurousness of the programs we presented to the public.

We had always tried to create a curatorial balance between thematic shows (issue- rather than subject-oriented, so that there was actually something to debate) and important solo exhibitions.

When I had finished writing the defense of the museum for Hank to present to the board, I felt more than ever that the museum should become more radical in its approach, rather than less radical, and that we should continue to do shows that pushed buttons, challenged the status quo, and threatened the ivory tower. Institutional thinking tells us to look very, very carefully before leaping—and such thinking virtually guarantees that we'll never leap at all. As an antidote to this, my motto has been "Act first, think later—that way you might have something to think about."

thirteen: 1994-1995

She who laughs, lasts.

KATE CLINTON

The idea for the exhibition *Bad Girls* made me happy from the minute it crept, giggling, into my mind. By 1994, I'd seen so much witty, seductive, even hilarious work on feminist issues—by women and men—that all I could think of was wanting to exhibit it and put it out there. I couldn't wait to give people an idea of how much the battleground, artillery, and troops in the gender wars had changed since the late sixties. In the early days of feminist art, the attitude toward men had been "shoot to kill, take no prisoners." We'd drawn a battle line between men and women, but we didn't have the distance or the experience to ask what kind of system had created inequities between us in the first place. Now it was clear that we needed to think not about substituting women's power for men's, but about how to examine, critique, and unsettle the very concept of power, and much of this was being done with the use of humor. I'd always been fascinated by the way artists like Robert Colescott and William Wegman were able to be incredibly funny while addressing serious issues. And women like Reno, Penny Arcade, and Carmelita Tropicana could be hilarious and tragic and profound at the same time.

To my delight, the New Museum received an NEA grant for the exhibition. I was elated but started to worry when I realized that a lot of the work I wanted to include was going to challenge the law passed in 1990 that required the government agency to fund only "works that meet general

standards of decency and respect for the diverse beliefs and values of the American public." How could you have a work that respected all the beliefs of everyone who was part of the American public? Did every individual work have to meet those standards? Or did the law require that the exhibition as a whole, rather than the individual pieces in it, address most people's beliefs and values? I wasn't sure. I didn't want to do anything that might endanger the arts program, so I did the honorable thing, which was to send slides of all the works in the exhibition to the NEA.

The NEA's program officer showed up faster than the return receipt I'd requested when I sent the slides. But not faster than the letter from Jane Alexander, the head of the NEA, whom I'd been thinking of as an ally. In terse, official language, she told the museum to remove the NEA's name from the show.

I met the NEA's representative at the entrance to the museum, dressed in my best tailored black business suit and discrete silver earrings instead of the usual gypsy danglers. I didn't quite pull off the impression that if only my suit were beige, I could be working for the government, but I tried.

I knew Ben from the old days, and he was one of the good guys. I felt bad for him, having to come on an errand like this. But he needed to see the exhibition in person. I took him into the galleries as the work was being installed, pointing out the most controversial pieces, those I thought more likely to raise eyebrows than body parts: Sue Williams's cartoonlike painting of a woman's head with penises stuffed in her mouth, nose, and ears, with the scrawled caption "This won't hurt a bit"; Chuck Nanny's portraits of himself in some lovely 1950s housedresses; Elaine Tin Nyo's photographs of mutant radishes, which might easily have been mistaken by addled Buchananites for pictures of naked children. Then we rounded a corner and ran smack into Keith Boadwee's gigantic, brightly cheerful photographs of popular children's icons, Elmo and Barbie among them, each toy figure nestled beneath the artist's penis and testicles, which in the cropped photos became festive headgear for the dolls. Ben let out an odd, clotted cough. I was certain it was a stifled laugh.

I wondered if the contributions of inner-city schoolkids to the exhibition—I'd invited them to create what proved to be wise, funny, and sometimes tragic drawings based on what they thought a "bad girl" was— might make a difference to Ben. If kids could deal with the show, surely the NEA could. I'd asked Ruby, who was ten, if she'd write a children's guide to the exhibition. It was a task to which she responded happily, choosing Yasumasa Morimura's version of Manet's *Olympia* as her first piece. Morimura had made himself up and digitally substituted his own image for that of both

Olympia and the African maid at her side in Manet's painting, causing viewers to do a double take when they realized that a cleverly disguised Japanese man was playing both roles. Ruby loved the sly reversal. "In all the museums of seventeenth-century art," she wrote, "all the women are nude but the men are not. This way, the men are nude too." She may have gotten the century wrong, but she was right on target with the rationale. The Boadwee photos were among her favorites in the show: "You never thought you could put stuffed animals and a Barbie in this kind of a situation," she solemnly pointed out. "You always thought you were just going to play with them."

Ben seemed embarrassed, but he had a job to do. "I'm so sorry," he said, "but we really do need you to take our name off all the exhibition materials. You don't have to return the money, but the NEA can't allow itself to be listed as a sponsor."

Jan Avgikos, a critic for *Artforum,* wrote a review of the exhibition, one of several that insisted that feminism was something other than whatever we had presented in the show. "The only thing the New Museum challenges," she said, "is our already thinly worn patience with their namby-pamby response, otherwise known as 'death by committee,' whenever they manage to get too close to issues that count." She concluded the review with a sigh of relief. "We can thank God the catalog doesn't have a pink-and-black cover, or rubber parts, or strings hanging out of it" (May 1994). I felt bad— she must have missed the tampon string we'd designed as a bookmark.

Ruby got it, though. The introduction to her kids' guide read: "Some of these things in *Bad Girls* might be kind of disturbing to you, but think of them as funny. All we're trying to explain is just how to express ourself, how women today should be treated and how to explain what a bad girl is . . . *all* kinds of bad girls, not just one kind."

———————

One of my favorite shows the museum ever presented was *Visiting Hours: An Installation by Bob Flanagan in Collaboration with Sheree Rose,* which originated at the Santa Monica Museum of Art and traveled to the New Museum, where it remained from September 23 through December 31, 1994.

During public hours at the museum, Bob was in residence, in a fully equipped hospital room that we built for him in the middle of the main gallery. Periodically, he would remove his hospital gown and Sheree would attach leather straps to his ankles and, using a pulley, hoist him up until he

was hanging upside down, for hours at a time. Bob later told Deborah Drier, in an interview for *Artforum* in 1996, that a woman came in while he was suspended and stood watching him. Then he breathed in and coughed, and she said, "How do they do that?" She thought he was a hanging sculpture!

The story behind Bob's work, what made it so poignant, was that he had cystic fibrosis and, at forty-one, had already lived much longer than his siblings or anyone who'd had the disease. When he was young, he realized that he couldn't do anything about the suffering he'd have to endure, but the one thing he *could* control was his own attitude toward it. So he eroticized his pain by becoming a masochist, using his sexual predilection as a catalyst for the extraordinary installations, performances, photographs, and videos he made in his short lifetime.

The response of museum visitors was totally unexpected: They identified with Bob, so that the extreme practices, which they might normally have considered perverted, became comprehensible to them.

One of Bob's theories of sadomasochism was that those who get into it want to experience death, without the permanence of death. The roots of his practice didn't seem to lie in self-hatred. Rather, he linked himself to shamanistic practice: the ritual enactment of little deaths in preparation for the big one.

In December 1994, we hosted Bob's forty-second birthday party at the museum. Bob lay naked on a bed of nails, with an enormous marzipan cake in the shape of a penis lying on his stomach. His partner, Sheree Rose, the "S" to his "M," did the honors and cut the cake. She scared the partygoers by standing poised over Bob with her big knife while everyone wondered exactly how deep she'd cut.

It was Bob's last birthday.

That same year, we mourned the loss of Felix Gonzalez-Torres and so many others in the art community who had been an inspiration to us. A year after Bob died, *Sick,* a galvanizing, heartrending, terrifying film about his life and work, was shown to a packed house at the Museum of Modern Art. It made the people in the audience gasp, and they gave the film a standing ovation at the end.

I had been aware of the lush, formal beauty of Andres Serrano's photography for several years before I nominated his work to a juried panel for an

NEA grant through the Southeastern Center for Contemporary Art in 1988. The award culminated in a group show with eight other artists, called *Awards in the Visual Arts 7*, which traveled quietly to a few museums. It wasn't until the show closed in January 1989 that all hell broke loose.

It was the catalogue reproduction of Serrano's photograph depicting a crucifix submerged in crimson-colored liquid that did it. If the photograph had been untitled, it is doubtful there would have been any controversy, because the formal beauty of the image was undeniable. But the work was titled *Piss Christ*, and the crimson-colored liquid was the artist's own urine. It might as well have been gasoline, because the image ignited a controversy that threatened to blow the NEA up in smoke.

Serrano's photograph raised the ire of Donald Wildmon, head of the American Family Association, who heard about the work and wrote in a newsletter to his constituents that the tax dollars of the American people were being spent to support pornographic, anti-Christian works of art. He wrote that the officials responsible for permitting tax money to subsidize the work should be fired, and he urged his supporters to join him in his campaign against the degradation of American values. His newsletter included the names and addresses of politicians and senators, which set off a full-fledged attack against contemporary art by the Far Right.

Congressional hearings were held, calling for a review of NEA procedures in allocating grants to artists. Clenching a copy of the exhibition catalogue, New York Senator Alfonse D'Amato called Serrano's work "a deplorable, despicable display of vulgarity." He was infuriated by the fact that Andres had received a fifteen-thousand-dollar grant from the NEA through the show's organizers. "If this is what contemporary art has sunk to, this level, this outrage, this indignity—some may want to sanction that, and that is fine. But not with the use of taxpayers' money. This is not a question of free speech," he added, and with that he tore Andres's image in shreds.

North Carolina Senator Jesse Helms joined in: "What this Serrano fellow did, he filled a bottle with his own urine and then stuck a crucifix down there—Jesus Christ on a cross. He set it up on a table and took a picture of it. . . . He is not an artist. He is a jerk." Other senators agreed, joining Helms in the crusade to save America from the chicaneries of contemporary art.

A few months later, a storm was brewing over Robert Mapplethorpe's scheduled exhibition of photographs at the Corcoran Gallery of Art in Washington, D.C. In response to pressure by her board of trustees, the museum's director, Christina Orr-Cahall, canceled the show.

Museums around the country were talking tactics and strategies, not principles. By default or silence, they let the government define what art should be. The first thing that a repressive government tries to get rid of is any art that doesn't support its agenda or ideology. A flourishing of the arts, on the other hand—especially controversial art—is a vital sign of effective leadership. It signals that critical, independent thinking is encouraged and supported, both politically and economically.

A solo exhibition of Serrano's work was coming to the New Museum six years after the initial assault on his work, and the nerves of museum directors were still raw, even after all that time. I suspected that New York audiences were more sophisticated than those in Philadelphia, but we were prepared for the worst.

We needed a strategy to offset whatever controversy arose, so we spent weeks in preparation for the onslaught. We met with the religious communities that might object to the work on the grounds of sacrilege, we consulted with educators and American Civil Liberties Union lawyers, we worked and reworked the labels of the works to find appropriate language. After days and nights of anguish about how it would be received, the show finally opened. To our astonishment, it got great reviews and even better attendance, and there wasn't a single protester in sight, at least none that we were aware of.

In 1995, we were able to successfully negotiate for the second floor of our building in exchange for easing some contractual restrictions that had been put in place when we first acquired our space. That "we" was a team that included Hank, our president and head visionary, and Saul Dennison, the museum's vice president and our organizational North Star, guiding us unwaveringly through the dense fog of building negotiations. They were joined by a group of dedicated and loyal trustees, staff members, and our pro bono real estate lawyer, Vicki Watson.

It was a perfect time to redesign the space and fix the dozens of building problems we'd lived with since the original developers had defaulted and fled, leaving the rest of our building empty. It was also a good time for a conceptual change. We needed to assess what we'd accomplished, see where we wanted to go, and revise our mission statement accordingly.

We invited our trusted consultants, Don Adams and Arlene Goldbard, back yet again. This time, they found divisiveness among board members, some of whom saw the museum as a business and insisted on cost cutting as a way to balance the budget, while others optimistically believed that growth was the best way to increase our base of support. There were trustees who thought our shows in recent years had been too political. There were the usual staff complaints that the museum was too nonhierarchical or too hierarchical, depending on who was complaining; there was no accountability in job performance; many of the staff were suffering from burnout; money was always in short supply; and the budget process was tortuous. Don and Arlene recommended replacing the unwieldy Programming Division, which had been instituted in 1993 when department heads were reinstated following Don and Arlene's first report, with an artistic leadership team. It would be better, they said, to replace a large body with a smaller one.

I thought maybe the body wasn't the problem, but the head. I was interested in the farthest reaches of museum practice, in art as a catalyst for new ideas and ways of thinking about the world. I had never thought of myself as a specialist in management and fund-raising. Or as a camp counselor or psychotherapist, for that matter. I also hated being the target of resentment for every problem the museum encountered. And although meetings were running more smoothly than before, there were more of them than ever.

I felt as if I were suffocating, my heart squeezed into a knot in my chest, my teeth rattling. My body was telling me what my brain had been hiding in the freezer: I wanted out. I had lost the ability to laugh at myself, to distance myself from the problems of my co-workers, to find relief from the endless pressure to raise money. I had stopped having fun. The boundaries between work and the rest of my life hadn't just blurred, they had evaporated altogether. What I carried home at night and back to the office every morning had become far too big to fit in a briefcase. It was time to plan for retirement.

I had given a great deal of thought to providing the museum with a beneficial and smooth transition to the next and future phases of its history, and I felt that there was a very real need for the museum to distance itself from my name and presence as founder. I didn't want to be like Lloyd Goodrich at the Whitney or Cornell Capa at the International Center for Photography, roaming the corridors of the museum long after my punch card had

expired. And I wanted to be young enough when I retired to be able to explore other options and take new risks.

I spent time with Arlene Goldbard planning programmatic and organizational changes and discussing how I could retire by my sixtieth birthday. I met with the board of trustees, we drafted and agreed upon a retirement plan for me, and we hired a publicist to strategize how to announce my forthcoming retirement to the public. I was looking forward to my new life, even though I hadn't quite figured out what I would be doing next.

fourteen: 1997

To be an atheist, my God, is a very difficult thing.

SLAVOJ ŽIŽEK

I had a bad mammogram. Not that there's ever really a good one when it comes to a fear-filled, "uncomfortable" procedure (think round breast/flat pancake) in which no news is cause for champagne and fireworks. Afterward, they kept me shivering in my pink wraparound gown while I watched the cheerful video on breast self-examination four times. A young blonde technician, hair in a tight bun, eyes severe behind her glasses, called me back in.

"We just need to check and make sure," she told me in an icy Russian accent. Off came the top, back went my boob into the iron-and-glass mashing machine. "Just relax," she told me. I asked her if maybe they had a meditation teacher hiding in the closet, but she didn't even smile.

Next, I had to stay for a sonogram, not so bad since all it involved was ironing my breast with a metal disk and cold jelly. I liked seeing the indecipherable images on the screen out of the corner of my eye, and I paid close attention to the little beeps coming from it to see if they were random, evenly spaced, or just had a mind of their own. Could I make up a song to the beat?

This time, it was busy out there in the waiting room, and I was reduced to *Travel and Leisure*. If they kept me much longer, I'd be reading *Golf Digest*. Back in again. Now the doctor herself was in the cubicle with me and the technician.

"We're not sure what we're seeing," she said, pointing to a minuscule spot on one side of the sonogram screen, "but better safe than sorry. I'd like to do a core biopsy." This time, the procedure involved a very long, thick needle. I distracted myself by pretending they were drilling for oil in my boob. Four hours later, start to finish, they sent me home to apply an ice pack and keep my fingers crossed.

My doctor Beth, who had delivered Ruby thirteen years earlier, called my office as soon as she got the report. I leaned forward in my chair and picked up the phone, hoping that I was going to hear her tell me that it was nothing. Less than nothing. A glitch in their radar, a mix-up, a floater in the eye of the person reading the sonogram, a big mistake. She was going to tell me to go home and enjoy the weekend. Beth had a sweet, lilting Southern drawl that I loved to listen to. This time, she sounded different. "I'm sorry," she said, without any preliminaries. "It came back positive."

"Positive?" I asked. "Are you sure?"

"Yes," she said, "they're sure. The biopsy was definitive. But we still don't know what kind or how extensive it is. I've made an appointment with a surgeon who I think is wonderful. He'll see you right away, but you have to pick up the paperwork here first. Take a deep breath, and try not to think too far ahead. Let's just take this one step at a time."

I liked the surgeon. He was young, balding, and slightly rumpled, and I was thankful that he didn't look like much of an authority figure. He spoke softly and listened without staring at the ceiling. I felt that I could talk to him without my defenses behaving like a pack of Doberman pinschers. He didn't shake his index finger at me, either, a habit that some doctors seem to acquire along with their medical degrees. When he explained what kind of breast cancer I had, it was like learning a foreign language. "Invasive ductal carcinoma, tubular, nuclear grade I/III, histological grade I/III, estrogen- and progesterone-receptor positive." He told me what he thought should be done: "Surgery, radiation, possibly chemo." Then he sent me home to think about it till our next scheduled appointment—as though I would be able to think about anything else.

I was lying on the operating table and Saint Surgeon was smiling down at me, telling me that the tumor was small and contained, and that it hadn't spread. I'd had a lumpectomy, which sounded more like a method

of getting crabmeat out of the shell than a medical procedure. "Of course," he said, "we'll have to wait till the sentinel node biopsy comes back to see what kind of treatment is needed, but it's looking good." I imagined the sentinel node as a trained lookout perched on an outcropping on the side of my mountainous breast, scanning the horizon to alert the doctors to any unusual activity out there. Fine by me, I thought, maybe I won't have to have chemo if that sentinel node does a good job. I promised it a medal for bravery if it brought back the news that all was quiet on the mammary front.

Four days after the surgery, I was sore and shaky, but I desperately wanted to go to the Association of Art Museum Directors meeting in Los Angeles, and especially to the pre-meeting in Santa Barbara. Ever since I'd taken my sabbatical there in 1988, we'd been regular summer house-sitters. I considered it my second home.

I thought of the Santa Barbara airport, with its low-lying hacienda-like buildings surrounded by palm trees and flowering plants, as the gate to Paradise. Warm, scented breezes, blue skies, that special limpid light that makes ordinary colors seem more vivid than a Bollywood movie. Whenever I stepped off the commuter plane there, I could feel my body relax and my heart go giddy. It was the best place on earth, I knew it was, and I had no desire to check out the rest of the planet to make absolutely sure.

The minute I checked in to the hotel for the meeting, though, I realized that the last thing I wanted was to see any of my museum colleagues. I was waiting for the call that would tell me if I had to have chemo or just radiation, and I was not in the mood for sharing. I slipped out a side door and went for a short stroll on the promenade in front of the hotel, had a sandwich at a nearby café, and went back to my room just as the sun went down.

The blinking red light on the phone looked large enough to fit on top of an ambulance. The message said the doctor had called and that he'd call back at 8:30, which meant 11:30 New York time. I thought it was odd that a doctor would be phoning patients that late on a Friday night, but after all, he was in New York, the city that never sleeps. I waited in bed with my feet propped up, trying to read the paper. When the phone rang, it was so loud I jumped. His voice was tired but gentle.

"I have good news and bad news. The good news is that your breast is fine. We took out the sentinel node, and the cancer hasn't spread. You'll need radiation, but no chemo."

I released my shoulders from their locked position around my ears. "And the bad news?" There was a long pause.

"The bad news is that you have lymphoma. The sentinel node lit up like a neon tube."

My mind did its best imitation of a Möbius strip. "What kind of lymphoma?" I asked weakly.

"It's either mantle cell lymphoma or chronic lymphocytic leukemia," he said. "There's some confusion about the markers, although they're pretty sure it's mantle cell. Let's hope that it's the other kind. You need to make an appointment with a specialist as soon as you get back." I had no idea what he was talking about, but I scrawled both terms on the pad by the hotel phone.

Needing a medical library in a hurry, I settled for Barnes & Noble. They stayed open late, giving me plenty of time to scare myself shitless. I became an iron filing on the giant magnets entitled *The Patient's Comprehensive Guide to Cancer* and *The Chemotherapy and Radiation Therapy Survival Guide.* Seated on the floor, surrounded by stacks of medical encyclopedias, the Merck Manual, books on living with cancer, surviving cancer, cancer as a turning point, nutrition and cancer, and cancer miracles, I speed-read descriptions of what mantle cell lymphoma does to the body and the "side effects" of the treatments they use to fight it. Anemia. Leukopenia. Neutropenia. Cytopenia. Immune disorders. Nausea, fever, rashes. Loss of hearing, loss of taste. Loss of hair was hardly worth mentioning. These are called "side effects"? Why not just plain "effects," especially since some of them are permanent? I leaned back weakly against the dark bookshelves and felt hopelessness course through my body. When a disembodied voice announced that it was closing time, I made my way back to the hotel and sank into a sweaty, nightmare-filled sleep.

I have a dream: I am at a beautiful wooded camp with Dean and Ruby and all our friends. Every individual, couple, or family is housed in a cozy pine cabin. Ours is sparsely but comfortably furnished. There's a bed with a red coverlet, a reading chair and lamp, bright curtains on the windows. Outside, the woods smell of pine; dappled light shines through the trees, a fragrant wind ruffles my hair, and the ground is crisp with leaves. I am walking down a path between Dean and Ruby, each holding one of my hands, when I see someone running toward us. I squint, trying to figure out if it's someone I know, but I can't make out the person's face. In the space of a heartbeat, the stranger is right there, next to us, breathless, pulling me aside. He grabs my shoulder and tells me that I've been sentenced to death, and that they're coming to get me in an hour. He turns his back and disappears into the woods.

Life doesn't stop and wait for you to catch up with it just because you're having a medical meltdown. I was ping-ponging back and forth between doctors, hospitals, and treatment centers. There were CT, PET, and gallium scans, blood tests, X-rays, and bone marrow biopsies, I was curating an exhibition of public sculpture at the White House, and I was still overseeing the capital campaign (I'd raised over four million dollars of the six that was needed) and the renovation of the museum, which was scheduled to reopen in two months.

We decided to approach a private collector to see if he'd fund our senior curator Dan Cameron's position. This collector had made other anonymous gifts to the New Museum, so we felt especially optimistic about the outcome.

A small team—Dan, myself, and James McClennen, our board treasurer—was dispatched to Santa Monica in February 1998 to do the "ask," which we'd written out and rehearsed till we had it down like veteran actors. I hadn't disclosed my health situation to anyone at the museum yet. Other than the Grim Reaper perched on my shoulder with his scythe bumping me at every step, I felt up to the job.

Once we were settled and the requisite mineral water had been served, I introduced our pitch. Dan talked about the programs, I talked about the renovation and showed the collector the pictures, Jamie talked about the campaign and finances, and we led into the subject of long-range planning by my saying that he was the first outsider to know that I was going to announce my retirement plans at our next benefit. I told him how happy I was that the plans were underway and how long I'd been working on them. Then I asked him to consider endowing the senior curator position.

There was a long pause. The collector looked up at the ceiling, then over his desk at me.

"You've been here a long time," he said. "I want to consider something else, something that reaches to four factors: celebration, motivation, incentive, and looking forward to the future."

He further explained: "I will offer a challenge grant of up to two hundred and fifty thousand dollars, in the following form: I will give the museum ten thousand dollars for every month that a new director is in place and fully empowered, starting now and ending at the date of your planned retirement."

He said that we had the program, the building, and the finances in good

shape and that the remaining area was the future. He reiterated that the money was in honor of the new director and intended to help empower them. "It joins the enthusiasm."

I said that it might be counterproductive to hire a new director in haste, without going through the processes that would ensure that the choice would be the very best one we could make. He said that he agreed, but that it wasn't his business. He also said that ten thousand dollars a month wasn't enough money to change our plans or influence us in any way, but that it was an incentive. He then grinned. "Out with the old, in with the new!"

As I walked out of the meeting, I felt something shift, like the earth's plates inside my body. But when I delved deeper, all I felt was sadness.

I had first heard Yvonne Rand speak when she addressed the Women's Caucus of the Association of Art Museum Directors in 1997. She'd been invited by Jacquelynn Baas, the director of the Berkeley Art Museum, to do some mind altering for several dozen harried, overworked, guilt-ridden women directors. When I first saw her, in a long black robe of some kind, with what looked like space shoes on her feet—enormous black clodhoppers—her gray hair cropped short, and no makeup or jewelry, I thought she looked like a visitor from another, not-quite-parallel world. Once she started to speak, though, I stopped thinking, because she pried open the top of my skull with a crowbar, a move from which I never recovered. She was a Buddhist priest, although I had no idea what that meant, and the way she saw things was so different from anything I'd ever experienced that when the session was over I left the room in a state of shock. I was also in love. I considered cutting my hair really short (so attractive), buying a long black *schmatta* (so practical), and getting rid of my high heels forever (so comfortable). I wished I had a gap in my front teeth, just like hers.

Just after I was diagnosed with lymphoma, I called her. After seeing countless doctors and pathologists and radiologists and cancer therapists, all with conflicting ideas about treatment, I was desperate. Hunched over the phone in my office, I talked in a whisper, explaining to Yvonne that she didn't know me, but that I had heard her speak, and that I'd called her because I was at a total loss. The truth was that I had gotten out the copy of *Final Exit* that had been hiding at the back of my bedroom bookcase for years and was working my way through the smorgasbord of grisly suicide

options, when her name had come up on my mental screen in flashing red lights. I was on the edge of hysteria, but she was calm (a state endemic to Buddhists, but what did I know?) and invited me to come and spend a weekend with her.

Which is how I came to be standing in Yvonne's kitchen in Stinson Beach, California, on a Sunday morning, trying to boil an egg after two days and nights of nonstop crying. My grief had erupted from the center of my body like a multifanged space invader, but no one else seemed to realize that it was trying to take over the planet and destroy human life. Yvonne took me aside periodically and listened carefully to my garbled story, offering counsel that actually made sense—for example, remember to breathe; listen to your own body; don't believe everything you think— and afterward, her husband, Bill, would calmly offer me food, wine, and his own chair in front of the fireplace. I had to stop bawling occasionally, because there were other people in the house and my pride didn't allow me to collapse in front of total strangers. Or rather, relative strangers, since I was spending the weekend with them. Peering at me with round black eyes was a three-year-old boy whom everyone addressed as "Rinpoche." He was, they explained, the incarnation of Yvonne's former teacher, the Venerable Tara Tulku, and he had come from India to stay with them for a while. Kungala, a Buddhist monk who was Rinpoche's caretaker and teacher, was at his side constantly, never saying much but watching the boy with a stern and unwavering eye, ready to pounce whenever the child tried to do something without his help. Betty, a gentle and attentive senior student of Yvonne's, was also there for the weekend, ignoring the periodic hiccups that kept me from completing a sentence.

I don't remember who took the egg out of my hands, but I stopped suddenly, blindsided by a moment of clarity. I turned to Yvonne, who was leaning against the counter with her mouth curved in a little smile.

"Uh-oh," I said, glancing over at her, "this is a lesson, isn't it?"

The smile broadened. "Yes, it is," she said.

"A lesson in how to accept help, right?" I said.

As she nodded, I felt something deep inside me give way. I was in the presence of someone who knew a whole lot more about helping people, really helping them, than I ever had. And she'd done it for me. I'd arrived on Friday certain that the only way out of my dilemma was to take my own life, and I left on Sunday thinking that death was probably the last great adventure and I wanted to be present for it, whenever and however it came.

Some of us learn our best lessons late.

Back in New York, I disclosed my medical situation to Hank and the board of trustees and presented them with the collector's proposition.

The board felt that I should not leave sooner than we had been planning, but I knew it would be good for me, and good for the museum. I wanted to transition out of the museum in a way that would ensure the museum's future success. If I couldn't do that, it would undermine everything that I had worked so hard to create.

I would assume the title of founding director, which would enable me to complete an exhibition I was working on, while at the same time relieving me of day-to-day directorial duties, which had become an impossible burden. After I set an official date for my departure, Hank announced that he would be leaving, too. The New Museum, he wrote in his resignation letter, "has taught me everything I know about contemporary art. And it has made me contend with problems ranging from construction frustrations to lawsuits to deficits to deadbeats. As I have told Marcia, if twenty-two years is long enough for her, it certainly should be long enough for me."

The New Museum's 22nd Annual Benefit Auction in the summer of 1998 honored myself and Hank and welcomed the new director, Lisa Phillips. When it was my turn to address the audience, I thanked everyone for their love and support, and for believing in me and my crackpot idea of starting a museum of contemporary art in New York. I joked that now that it was clear that it simply couldn't be done, it was time for me to move on. Since the New Museum had been my life for twenty-two years, I said that I hoped that Dean and Ruby would be happy to have me back—that is, if they still recognized me. I told the audience how pleased I was to be able to hand my job over to an imaginative, skilled, clearheaded, and talented person, Lisa Phillips, and, with that, I bequeathed her the classic crown and scepter of museum directors everywhere—I gave her my cell phone.

fifteen: 1998–2004

First you are young; then you are middle-aged; then you are old; then you are wonderful.

LADY DIANA COOPER

For my last show at the New Museum, I wanted to explore a subject that wasn't usually associated with contemporary art—age and aging. It wasn't just personal, although I *was* getting older—fifty-nine, to be exact. I'd been seeing the work of dozens of artists—not only old ones, either—who were preoccupied with the issue and exploring it in unusual ways.

Young people think about age, too, even obsess about it. When I was twenty-seven, I complained to my journal that there were moments when I was acutely aware of growing older. I thought of my preoccupation as "the usual feminine narcissism—seeing all the lines and flab is probably a manifestation of self-hatred in its most elementary form." I wrote that I wanted to change my fear of aging into curiosity and resolved to record the transformation of my features by taking pictures of myself in a photo booth every year of my life from then on ("like a movie of a plant blossoming, ripening and dying"). My resolution lasted only a few years. Remembering to get to a photo booth every birthday and in the same pose was more than I could handle. One birthday, I wrote in my journal, "My body betrays me. It ages, I don't."

My partner-in-crime on the exhibition was curator Anne Ellegood, who had started at the museum as an intern and was now thirty-two years old. People were perplexed when they found that someone as young as herself

was co-curating the project. When she was asked, "Why on earth are you working on a show about age and aging?" she'd reply, "Why not?" Why not, indeed. After all, age is something that we all have in common—unless we're safely packed away in a cryogenic tank. I decided to call the exhibition *The Time of Our Lives,* because, like so many of my peers, I actually thought life got better and better as I aged.

At the museum, we organized shows by beginning with the seed of an idea and inviting small groups—mostly staff members, but also people from other fields—to bat it around. At a series of two-hour meetings, we'd look at the exhibition from every angle: What questions did it raise? How did it raise them? What were the different ways that age could be addressed? Scientific. Social. Medical. The image of the body, its genetic makeup, society's attitudes toward it. Which societies? Whose attitudes? Gender differences. Racial and ethnic differences. What did children think was "old"? What about literature, poetry, music, comedy?

Age and aging was both a subject and an issue, but I was adamant about not including literal depictions, pieces that defined age narrowly or one-sidedly with no breathing room for multiple, complex interpretations—that is to say, no close-ups of aged nude bodies pretending to be tree trunks.

I also didn't want to present age negatively. Rejecting the TV series *The Golden Girls* as too saccharine and unrealistic, we instead showed two episodes from the 1970s series *Maude,* where Bea Arthur gets pregnant in her late forties and has to contend with the shock and horror of those around her. We ended up with some wonderful and provocative works, like Consuelo Castañeda's tender photographs of herself and her mother naked, curled together, spoon fashion; Nancy Burson's images of prematurely aged children with the rare genetic disorder progeria; hysterically funny audiotapes of Moms Mabley, the African American comic; and three installations by high school students in collaboration with their history, chemistry, and environmental studies teachers.

In the catalogue essay, I wrote that for most of our adult lives, we're valued for what we do; with age, we can move toward being valued (and valuing ourselves) for who we are. We can come to know the place that Betty Friedan describes in *The Fountain of Age* as a "state of becoming and being, not merely as ending."

Dean hasn't always been good at presents, but for my sixtieth birthday he made up for all the previous omissions and errors by enrolling me in a stand-up comedy class at New York University. For years, I'd been saying that I really should do stand-up, that it would probably be a lot easier than running the museum. He'd even checked my calendar to make sure that I was free on the eight Monday nights when the class met. The course was run by D.F. Schwedler, a comic who worked and booked acts at the Comic Strip on Eighty-second Street and Second Avenue. As we took our seats the first evening, the other students stared at me. I was old enough to be their mother, maybe even their grandmother. I didn't care. I was excited.

D.F. was a strict taskmaster. My first time up in front of the class, I produced a five-minute spiel that I'd worked harder on than my hour-long public lectures. I stood up and read a description of Dean doing a remodeling job on our place, showing how the weeks stretched into months, then years.

When I finished, there was an uncomfortable silence. I looked out at all those smooth young faces staring at me, puzzled.

"I didn't ask for Erma Bombeck," D.F. said coolly from the back of the room. "I asked for stand-up. If you want to be a writer, go do it, but if you're going to do stand-up, you've got to get rid of every single word that doesn't help the punch line."

I sat down, crestfallen. I didn't understand the difference, but I was damned if I'd let all those kids see me lose face. Back home, I cut, cut, cut, and cut some more. Then I rewrote, and cut again. The next week, I was back with a new, improved version.

Pretty soon, I was in danger of ignoring everything else in my life. I lived with a continuous adrenaline rush just from *thinking* about doing comedy. Our final class was live, onstage at the Comic Strip, where we had six minutes to do our shtick in front of an audience of invited guests. I'm sure that nothing I ever did was as hard as trying to make an audience laugh. For one thing, you have to deliver the lines that you've spent weeks memorizing as though you'd just thought of them. It was worse than the opening moments in my third-grade play, when I realized that not only were my parents out there, but everyone else was looking at me, too, waiting for me to make the mistake I already *knew* I was going to make. The only consolation I had with stand-up was that if I forgot my lines, my material could cover for me—everyone knows that menopause makes you lose your memory. I ended up talking from deep personal experience about this profound but neglected subject.

I went on from there to perform in clubs, where I skewered my family, my background, my teenager, and just about anything else that caught my attention. Most nights, the audience laughed in all the right places, even in some I hadn't expected. Other times, the same routine, word for word, would fall flat. I was most surprised when middle-aged women in the audience would stare at me stonily while young black men in hoodies would laugh.

What I like best about comedy is that it's the most subversive art form around. I organized a show at the New Museum in 1982 called *The Art of Subversion,* which was about work that first made me laugh and then made me think. Humor can change someone's mind, jar a prejudice off its pedestal in the space of a single laugh. Every comedian takes some shortfall, some handicap, some part of themselves that's less than perfect, and turns it around through humor so that others not only empathize, but start thinking about the world differently. Richard Pryor, Eddie Murphy, Whoopi Goldberg, and Chris Rock have changed people's ideas about what it means to be black in America. Margaret Cho does the same thing for Korean bisexuals.

For a while, I thought maybe I could do stand-up about art, something that's a lot harder than joking about geriatric sex. I tried on a new persona, "Miss Mannerist," loosely based on Judith Martin's "Miss Manners," and billed myself as "*the* maven of mores and manners for career-impaired artists, visually challenged curators, and artistic big-fish-in-a-small-pond wanna-bes." I did my act at various art world gala events—and it was terrifying. People were so busy drinking and talking, and there I was, with six minutes to do my routine or fall flat on my face in front of people that I actually knew and respected. I'd been wrong—it was definitely easier to direct a museum than it was to do stand-up comedy.

But the part I liked best was the costume: a blonde wig, oversized zebra-print glasses, and a layered getup that borrowed from just about every culture there was, and some that weren't. After years of wearing nothing but solid black, I got to look and be outlandish, and I loved every minute of it.

It's the fall of 2004 and Ruby has gone back to college after the summer. She is a jewelry design major at the School of the Art Institute of Chicago.

Dean went with her to try to find her a place to live, furnish it, and get her set, wired up, fully functional, in the six days before she has to start classes. They spent a lifetime at Ikea, Target, Bed Bath & Beyond. But they got it all done. A cute little studio, on the second floor of a good building, ten minutes from school. A roof deck, a laundry room, and, most important, a tree she can see from her window. They found a futon, a desk, a kitchen table and chairs, lamps, a bookshelf, a rug, kitchen utensils, and a vacuum cleaner. Exhausted, Dean left on Friday afternoon, kissing her goodbye and leaving her alone to enjoy her very first apartment.

At 4:30, with Dean still en route, the phone rang. It was Ruby, sobbing so hard she couldn't get any words out. My heart did a double flip and missed, landing with a thud on the mat. Surely someone had died.

"What is it, sweetheart, what's happened?" I asked. "Please try to talk. Tell me what's wrong."

She caught her breath. "I had a dream that you died, and it was the most realistic dream I've ever had in my whole life." She began to sob again. "Daddy was there, and all our friends who used to babysit me, but they couldn't do anything, they couldn't help me. It was horrible, the worst thing that ever happened. Oh, no . . ." Her voice careened into a wail.

I interrupted frantically. "Ruby, Ruby, honey, I'm here, I'm fine. Can you hear me? Do you understand what I'm saying? Nothing's wrong, sweetheart. I feel fine, my health is stable, nothing's changed." I made soothing noises. When she was calm enough to listen, I said, "It's good that you dreamed this, because what doesn't come out can hurt you. This way you can look at it and deal with it."

I wasn't sure that was going to help, but I didn't know what else to say. After a while, she calmed down and began to talk more normally. I suggested that she take a walk, or go to a movie, change the scene a bit. I told her I was there if she needed me.

When I called her the next day to find out how she was, she said, "I'm totally traumatized. I'll never be the same again." I laughed.

"I know what you mean, sweetheart," I said. "Neither will I."

Now, a week or so later, we're on the phone again. This time, it's boyfriend problems. Young men fall hopelessly in love with her and then hold on too tight, so that she begins to feel suffocated. There are always about a half dozen potential boyfriends waiting in the wings, but she's loyal, only getting involved with one at a time. I refrain from saying "I told you so," remembering all those times she was inconsolable because she knew for sure she'd never ever in her life have a boyfriend and I'd tell her, "Just wait

till they're lined up around the block and I get to say 'I told you so!' " Then I say it anyhow. She giggles.

"I don't know what I'd do without you," Ruby says. "I wouldn't have anyone to talk to about all of this. You and Dad are the best parents anyone could ever have."

I wonder for a moment if my ear is filled with wax, or if I'm hearing voices. But no, it's Ruby, saying the words that I couldn't ever have imagined hearing. I burst into tears, thinking that now I can die happy.

———————

The Art Mob is still going strong after twenty-five years, and we're getting great audiences for our concerts. No advertising, just word of mouth, but there seems to be a real taste for the kind of salvage operation we perform for nineteenth-century songs that have long ago bitten the archival dust.

It's probably more fun to hear untrained voices sounding like the singers of all those years ago rather than like the smooth professional choral groups, with no rough edges, whose audiences don't for a single moment think that they could do it, too. Just like it's more fun to watch the Big Apple Circus than Ringling Brothers and Barnum & Bailey, because at the Big Apple the acrobat might actually fall off the horse.

Maybe that's what gave the New Museum its edge in the early days, too. We always bit off more than we could chew. We always had our mouths full when we were spoken to. We sometimes choked on the force of our own appetites. We were never altogether sure of what we were doing, which meant that, like the artists who were our lifeblood, we worked without knowing exactly what would emerge from our labors. We wanted it to be good but were never completely sure that it would be. Hope, yes. Effort, absolutely. Practice, patience, support. But we seemed to do everything as though it were the first time. For us, it was.

Recently, I was with friends, sharing horror stories about jobs we'd had. Barbara Niblock, who had been the museum's administrator and financial officer from 1988 to 1991, told us that she had never encountered a better working environment in her life. "And believe me," she said, "I've worked in a lot of places." She said that the museum's experiment in democracy had created an environment of trust and excitement unlike anything she'd experienced before or since. "It was hard to get any work done with all those

meetings, and people didn't really understand how important it was for Marcia to be promoting the museum outside the office, but still," she said, "everything got worked out. It was a heavenly constellation. I'll always remember all those teams making decisions—the hiring teams were the best, because everyone had a say and so no one single person ever felt that they had made a mistake. We had a wonderful time," she concluded. I was taken aback. I suppose it's normal (for me, at least) to remember what didn't work, but I nearly wept when she reminded me of what did.

I've had a substantial career based on really bad reviews of almost everything I've ever done, and I've also been turned down for every grant I've ever applied for personally. I'm proud to say, though, that one of my greatest accomplishments is that my name was added to the Christian Coalition's hit list, which finally won my relatives' approval—but maybe that's just because they're Jewish and don't really understand what it really means.

Actually, I've never had a career; I've had work that I wanted to do, which was my motivation for starting the New Museum. My job has been to rattle the institutional cage on a regular basis by asking questions that will make everyone else's eyes roll up into their heads. How does the museum replicate and perpetuate class systems? Why do we do exhibitions, anyhow? What *is* a work of art? What are we saying when we install things chronologically? Or, Why *walls?* What we need is more controversy and not less. More debate, more dialogue, more disagreement and discussion.

If being an expert means being deeply involved with what you already know, I have never been interested in being one. The most rewarding place from which to learn has been, for me, the mistakes. At the same time, perhaps there are no mistakes—there's just more than one right way to do things. As the French philosopher Michel Foucault wrote, "What would be the passion for knowledge if it resulted only in a certain amount of knowledgeableness and not . . . in the knower's straying afield of himself? There are times in life when the question of knowing if one can think differently than one thinks, and perceive differently than one sees, is absolutely necessary if one is to go on looking and reflecting at all."

What we need is more controversy and not less. More debate, more dialogue, more disagreement and discussion. Art, especially the work that doesn't yield itself to quick analysis and understanding, can be a catalyst for change. It can undermine authority, challenge dogma, upset convention, and unmask hypocrisy. Art, at its best, can query cherished values, force us

to acknowledge prejudices, and rethink our own and others' habits and assumptions. Art can make us see the world differently, and if we begin to see differently, we begin to think and act differently as well.

————

There's nothing like a bunch of fearless, smart old feminists to strike terror in the heart of the establishment. Forty years on and going strong, our consciousness-raising group still meets, only we don't really call it consciousness raising any more, we call it catching up. Some members don't feel like coming back, and there are always one or two who are out of town when we decide to get together. But mostly, there seems to be a desire to reconnect, to look critically at what's happened to us over the years. Some of us are single again, some in new marriages, three in long-term relationships with women. Only one of the women is with the same man, in what looks like a going concern. Two of us had children relatively late in life. Peg, a former hat model, is older than the rest of us by about twenty years. In her eighties now, she's beautiful, slim, elegant, with a crown of white hair like a halo around her head, and as outspoken, opinionated, and determined as ever. The only thing is, she's going blind and deaf. "Nothing to be done about it," she says. "It's shitty, but that's the way it is. Look on the bright side. I can still see well enough to walk, even if I can't read." After our last meeting, we left her at 10:30 at night, striding alone down Lexington Avenue, white shirt flowing, arms swinging at her sides.

afterword

LIZA LOU

"Santa Barbara is a great place to die," Marcia was saying.

We were driving past historic adobes, manicured lawns, and palm trees on our way to the Cancer Center for more tests. We came to a stop sign. "Just listen to those birds," she said as we pulled up to the front of the building, "and you see, there's always parking!"

Eight years earlier, in 1998, Marcia had been diagnosed with breast cancer, and then with lymphoma, which was found as a result of the breast surgery. She was misdiagnosed initially, so for the first few months she thought that she had only a short time to live. It turned out that she had chronic lymphocytic leukemia, an incurable but slow-growing form. The main outward symptom was a compromised immune system, and it required frequent surveillance. In order to avoid living a medicalized life filled with anxiety and dread, she instructed her doctors not to tell her the results of any more tests unless immediate treatment was needed. This helped make it possible for her to live free from fear and to do the things she'd always wanted to do.

Around 2000, Marcia started writing her memoir. She threw herself into writing in the same way she'd done everything else in her life: no holds barred, flat out, pedal to the metal. She did residencies at Yaddo, took memoir-writing workshops, and formed writing groups in New York and Santa Barbara. She worked on the memoir for a few years and, though she

199

admitted it still needed work, started sending off query letters to publishers. She figured she'd go back in and polish the book if she ever got a contract. Besides, she was already on to something new—she was writing short stories.

Marcia and Dean had talked for years about the possibility of moving to Santa Barbara, and in January 2006 they made it happen. They bought a tiny fixer-upper and within months they'd transformed it into a lovely garden cottage with polished wood floors, cozy furniture, lots of books, flowers from the farmer's market, and a fireplace; it was the perfect love nest.

But four months after they moved in, Marcia developed a cough that wouldn't go away and terrible pain in her back. She thought it was due to the stress of the move, but she went to the doctor to be sure. This time he told her the results: she had fourth-stage lung cancer, one lung had collapsed, and the pain in her spine was due to metastasis to the bone.

She needed more time. Ruby's graduation from college was coming up the following year, and there was the opening of the New Museum's new building to look forward to. Not only that, but Stephanie Fay of UC Press had written to say that if Marcia was willing to rework the memoir, she would present it for editorial review in the fall.

When my husband, Mick, and I drove up from LA to visit her in July, we half-expected to find her lying in bed. Instead, she was in the kitchen making raspberry scones. Her shock of silver hair was going off in every direction, she was dressed in a multicolored silk blouse with skinny black pants, and her arms were weighed down with Mexican jewelry. When Mick told her she looked great, Marcia laughed. "It's just that I'm wearing lipstick. I feel like shit!"

She was elated but also devastated by the news from the publisher. She'd been rejected for every publishing deal that had to do with her own writing; she'd published countless essays and catalogues about other people's work, but when it came to herself, there was a black hole. After receiving yet another rejection notice for a grant to publish her essays in 1999, she'd written to Dean, "It gives me the 'nobody likes me, nobody wants me' feeling, but I'll get over it in about two seconds." In healthier days she had bounced back quickly. But now that a publisher was finally giving her a chance, she simply didn't have the strength or time left to do the work.

It seemed a terrible shame to let the book drop into oblivion, so I offered to help. If she could write new pieces for the areas that needed further exposition, I would enter line edits and work on cuts. "What about your own

work?" she wanted to know. I said it could wait, and when I told her how much fun we'd have whipping her book into shape, she said she would be ready to start the next day.

I'd met Marcia in 1995. I was a struggling artist and aware of her reputation as a take-no-prisoners curator and museum director. I sent her a postcard with an image of a piece I'd been working on for five years, but I imagined my card buried in yet another museum slush pile and doubted I'd hear back. A few weeks later, the phone rang and there was Marcia, wanting to know if she could include my work in an exhibition at the New Museum the following year.

The show was *A Labor of Love,* and she explained that there would be fifty artists included, all of whom approached labor-intensive processes or craft in different ways. There would be the elaborate embroideries made out of unraveled prison socks by a former inmate, sculptures created on the head of a pin, as well as the work of contemporary artists—Jane Kaufman, Charles Le Dray, Beverly Semmes, and Oliver Herring, among others. She told me that the entire museum would be transformed into a domestic environment, with recliners, sofas, and rocking chairs in the galleries, and labor songs and folk music would be playing throughout the space.

I worried that by presenting the work in such a determined way she was reinforcing the very stereotypes she wanted to dismantle, but on Marcia's next trip to the West Coast she visited me in my studio, where we were able to talk at length about her ideas for the show. She wanted to challenge cherished hierarchies by including work that questioned not only what a work of art could be, but also the role of the art museum. She believed very strongly in giving viewers the opportunity to think for themselves, to have a stake in what they were looking at, rather than showing work from a lofty position of authority. There would be critics who would hate the show, but she didn't believe that any single exhibition was the be-all and end-all. For her, the process of curating shows was a continuum, which allowed room for experimentation and even failure.

After spending time with her, I saw that the risks she was taking were equal to the risks artists take in making their work, and I became excited to be a part of her show.

When the exhibition opened, people spent hours in the museum, kicking it in the Barcaloungers, listening to music on the headsets, drawing in the visitors' books, and looking, really looking, at the work. They came

back multiple times, and they brought their friends. People debated what was and wasn't art. Some critics argued that the show was messy and ungainly; others loved it for the questions it raised. By the time the show closed, Marcia and I were buddies.

After she retired from the New Museum, our friendship centered more around writing. We would send each other pieces we were working on for feedback, and whenever we'd meet in LA or New York, we'd go out to coffee with our laptops and write for a few hours, and then we'd read to each other what we'd written. Marcia was someone who wrote nonstop. I once asked her if she ever had writer's block, and she said, "Just write. What's the problem?"

The plan for working on her memoir was that I'd work on edits at home and then drive up every other day with the changes for her to approve. We agreed on the direction the book should take—cuts that were necessary and areas that needed expanding. She wrote new sections, and she also directed me to files of her earlier writing in the form of interviews, lectures, and journals. There were inspiring lectures to draw from, with titles like "A Sacred Cow in the China Shop: The Art Museum as an Educational Institution" and "Hookers, Hags, and Hysterics: Who Says Women Can't Take a Joke?," and excerpts from her early writing that often offered a more affecting account of events than their later retelling in the memoir's first draft.

When we took breaks, if Dean was at work, I'd take her to her various medical appointments. Driving along one day, Marcia mused that the next book she would write would be called *Death for Dummies*. It would be a runaway best-seller! "People don't know how to behave around the dying," she said, "and it's silly because it's the one thing we know for sure is going to happen to us." One day, standing in line at the pharmacy, she fell into a terrible coughing spell. When it subsided, she turned to the people in line and said, "Don't worry—it's a lot worse than it sounds!" Everybody cracked up.

On September 24, 2006, Marcia sent out a newsletter to friends and family:

> I had a really bad week, escalating pain that robs you of pretty much everything except its company. Spent an overnight in the hospital to get it under control, which was a big help, and now I'm home, although not quite comfortable yet. I signed on for hospice care this morning, so from here on I'm in their incredibly capable hands. Within the hour, someone

arrived at the door with a paper bag full of all the medications I have to take. They provide nursing care, counseling services, whatever you need. Dean will not be going back to work any time soon. So it's really ideal, and I love being able to be together. The only thing is that there's a lot more activity in the house with all this, which makes me crave quiet time. I'll work it out as soon as I can get on top of the pain, a matter of some trial and error. I haven't been able to work on the manuscript this week, but am hopeful that I can get back to it once that happens.

On the bright side, Ruby is visiting for the weekend, a joy. She's made us a pizza, did my nails, cheered me up by telling me great stories about school and friends. And I got some great news this week about the New Museum. I saw pictures of the building under construction, which was so exciting! The three of us gathered around the computer, celebrating this amazing accomplishment.

On October 17, Marcia died.

I realized I had been engaged in magical thinking. I'd fantasized that as long as she continued working, she could stave off death. She'd be like the woman in the Gabriel García Márquez story who, doomed to die once she has completed weaving her death shawl, spends her days weaving, only to unravel it again at night.

Overnight, Marcia's writing went from being lived experience to archival material, and from her cozy office in Santa Barbara I now took the tram up to the Getty Research Institute, where I was given access to the Marcia Tucker papers, which hadn't been fully entered into their system yet.

Working on the book over the next year, I missed Marcia terribly, but oddly I was getting to know her better every day. I was continually struck by what a principled person she was. She never lied or deluded herself about events or situations. She faced things head-on, whether it was the death of a loved one, a betrayal at work, or her own shortcomings. She cared and worried about the world around her. She wanted to make things better.

I was constantly measuring the memoir against the woman I knew and loved. I wanted it to reflect the generosity and tremendous force that was Marcia Tucker. This made it very hard to complete, because, of course, words can never measure up to a life.

I wonder what she would make of this book, now that it is finally finished.

I imagine her somewhere nearby, maybe perched on a telephone wire, hanging out with a bunch of birds, watching the scene below. I'm calling

up to her, telling her that her book's done, and that it's going to be published.

"That's great," she says. "But boy, the scene from up here is spectacular, and I've started a new singing group with the birds!"

"Don't you want to know about the book, and how it was resolved?"

"Nope," she says. "What's done is done. When your last show has closed, when the audience has filed out of your concluding lecture, when your final catalogue has been laid to rest deep in the library stacks, all that matters is the day-to-day joy of just doing things."

It dawns on me that she's just quoted a section we cut from her first draft.

"Hey," I tell her, "that's nice. Maybe we should put it back in."

author's acknowledgments

Special thanks to friends who read the manuscript in its early stages and gave valuable input and encouragement: Jackie Baas, Andrée Bober, Shena Crane, Jill Dunbar, Anne Ellegood, Martin Friedman, Cindy Gehrig, Gail Gregg, Jessica Hagedorn, Mick Haggerty, Lawrence Levi, Dean McNeil, Cissy Ross, Ira Shapiro, Lynn Shapiro, Warren Silverman, Michael Tucker, Susan Unterberg, and Tim Yohn.

Special thanks also to the Otis College of Art and Design, for providing me with the perfect teaching job and the perfect students, and to my writing group: Shena Crane, Cheryl Morrison, Kirsten Skrinde, and Barbara Tyler.

Dear friends offered love and support throughout: Connie Beckley, Charlie Bergman, Lynne Darcy, Aggie Gund, Betty Harris, Patrizia Levi, Stuart Levy, Meg Linton, Barbara Niblock, Barb Parmet, Yvonne Rand, and Ro and Rick Sanders.

To my doctors, Tom Woliver, Sanford Kempin, and Rob Wright, and my three graces, Gayatri Heesen, Monika McCoy, and Karen Mittlesadt.

For providing a writing space of one's own: Kippy Stroud, The Writers Room, Karol Nielson at Gotham Writers' Workshop, and the Corporation of Yaddo.

To Stephanie Fay of UC Press, a superb editor whom I want to thank for championing this project. And to Liza Lou, who put her own work aside

and spent months helping me to revise the manuscript, making it her day-to-day project to make sure that the book got done. It means more to me than I can say.

Finally, to my husband, Dean, and my daughter, Ruby, the two greatest joys of my life.

Marcia Tucker
Santa Barbara, California
October 11, 2006

editor's acknowledgments

Many thanks to Dean McNeil. Though it was a period of mourning, he helped me with the book in countless ways, from answering any and all questions to getting permissions for photographs, to tracking down obscure references that were needed.

I'd like to thank JoAnne Paradise and Nancy Perloff at the Getty Research Institute for giving me access to the Marcia Tucker papers.

Others generously provided information for the book: Victoria Barr, Connie Beckley, Marla Berns, Liz Brown, Lynne Darcy, Arlene Goldbard, Lola Goldring, John Hatfield, Ron Jagger, Ruby McNeil, Cheryl Morrison, Tucker Neel, Yvonne Rand, Paul Schnell, Warren Silverman, Pat Steir, Tim Yohn, and Barbara Zucker.

Stephanie Fay, acquisitions editor at University of California Press, guided this project through to completion and offered support and encouragement when they were needed most. Thanks also to project editor Sue Heinemann, copyeditor Jennifer Knox White, and publicity director Alexandra Dahne at UC Press for their belief in and hard work on this project.

Many thanks to Chris Niemi and Nadine Wells for keeping the studio afloat while I worked on the book. Pranans to Denise Kaufman, who

was there with music and laughter during the difficult days, and biggest love and gratitude to Mick Haggerty, who was there for me in every possible way.

Liza Lou
Durban, South Africa
February 3, 2008

index

ACT UP, 168

Adams, Don, 165–67, 181

Akalaitis, JoAnne, 75

Albers, Josef, 95

Alexander, Jane, 176

Alexander, John, 142

Allen, Terry, 129, 136, 138

American Civil Liberties Union, 180

American Family Association, 179

Andre, Carl, 111

Anti-Illusion: Procedures/Materials
 (exhibition), 81–85, 86, 111, 113, 129

Anzaldúa, Gloria, 91

Arcade, Penny, 175

Armstrong, Tom, 110–11, 117–19

Arp, Jean, 70, 75

Art After Modernism: Rethinking Represen-
 tation (New Museum), 165

Art and Ideology (exhibition), 161

Art Mob, 136–37, 139, 150, 196, *plate 36*

Art of Subversion, The (exhibition), 194

Arthur, Bea, 192

Artists Space, 123

Asher, Michael, 82

Ashley, Clarence, 29

Association of Art Museum Directors, 131,
 170–72, 185, 188

Astor, Brooke, 131

Astor Building, 145–46, *plate 21*

Auden, W. H., 42

Autry, Gene, 30

Avgikos, Jan, 177

Awards in the Visual Arts 7 (exhibition), 179

Azara, Nancy, *plate 12*

Baas, Jacquelynn, 188

Bad Girls (exhibition), 175–77

Bad Painting (exhibition), 128–31, 133, 155

Baez, Joan, 29, 31

Baker, Kenneth, 172

Band, The, 49

Barr, Alfred H., Jr., 67–68, 70, 75, 76, 120,
 plate 13

Barr, Margaret Scolari ("Marga"), 67–70,
 75, 76, 120, 163–64, *plate 13*

Barr, Victoria, *plate 12*

Baur, John I. H. ("Jack"), 76, 78, 79,
 96–98, 102, 108–10, 111, 113, 118

Becker, Carol, 166–67

Beckley, Connie, *plate 36*

Bellamy, Dick, 110
Benglis, Lynda, 74, 84
Berenson, Bernard, 68
Biddle, Flora, 109
Blanckenhagen, Peter von, 49–50, 68
Boadwee, Keith, 176, 177
Bollinger, Bill, 83
Bouché, Denise ("Den-Den"), 41, 51–52, 57
Bouché, René, 40–42, 46, 51, 57
Boulton, Jack, 116
Bourdon, David, 113
Bracken, Peg, 74
Brauner, Victor, 53
Brennan, Pat, *plate 12*
Brown, Joan, 129
Bryson, A.C., *plate 19*
Buchloch, Benjamin, 161
Burden, Chris, 74
Burns, Bob, 10–11
Burson, Nancy, 192
Byars, James Lee, 74

California Institute of the Arts,
 116–17
Cameron, Dan, 143–44, 187
Campopiano, Remo, 163
Canaletto, 60
Capa, Cornell, 181
Carter Family, 29
Cassirer, Ernst, 160
Castañeda, Consuelo, 192
Castelli, Leo, 104, 110
Castelli, Leo, Gallery (New York), 81
Cathcart, Linda, 92, 116, 154
Celmins, Vija, 54
Ceresa, Aldo, *plate 36*
Cézanne, Paul, 114
Cho, Margaret, 194
Choices (exhibition), 162
Christian Coalition, 197
Christo, 54
Clark, Stephen, 68
Clifford, James, 134
Clinton, Hillary, *plate 31*
Cohen, John, 31
Colescott, Robert, 175
Comic Strip (New York), 193–94
Connecticut College for Women, 13

Cooder, Ry, 142
Cooper, Lady Diana, 191
Copley, Billy, 54
Copley, Claire, 54, 55
Copley, Colonel, 53
Copley, Noma, 52–58, 62, 68, *plate 11*
Copley, William, 52–54, 57, *plate 11*
Cornell, Joseph, 54, 68, 69, 75
Coté, Gaynor, *plate 36*
CPLY, 53–54. *See also* Copley, William

Darcy, Lynn, *plate 34*
Davis, Adelle, 122
De Niro, Robert, 72
De Palma, Brian, 72
Decade Show, The (exhibition), 172
Dennison, Saul, 180, *plate 34*
Dillon, Douglas, 131
Donno, Frank, *plate 36*
Dove, Arthur, 76
Drier, Deborah, 178
Duchamp, Marcel, 53, 57, 129
Durham, Jimmie, 172
Dylan, Bob, 31, 49

Early Works by Five Contemporary Artists
 (exhibition), 128
École du Louvre, 16, 22–23
Edelstein, Johathan, *plate 20*
Ellegood, Anne, 191
En Foco, 170
English, Nancy, *plates 12, 18*
Ernst, Max, 53
Euripides, 72
Eversley, Fred, 93
*Extended Sensibilities: Homosexual Presence
 in Contemporary Art* (exhibition),
 143–44
Eyck, Jan van, 22

Fashion Moda, 170
Fay, Stephanie, 200
Ferdinand Howald Collection of American
 Art, 75
Ferrer, Rafael, 82, 93
Fine Arts Building, 123
Finster, Howard, 158
Fiore, Bob, 71–72, 75, 89–90, 99

Fischl, Eric, 158, 172
Flanagan, Bob, 177–78, *plate 30*
Flavin, Dan, 54
Flood, Richard, 143–44
Florio, Dennis, 164
Foucault, Michel, 197–98
Frankenstein, Alfred, 125
Friedan, Betty, 192
Friedenberg, Edgar, 48

Gallop, Jane, 92
Garabedian, Charles, 129, 158
García Márquez, Gabriel, 203
Gaudieri, Mimi, 171
Geldzahler, Henry, 79, 108
Giardina, Martha, *plate 36*
Glass, Philip, 75, 85, 131
Goldbard, Arlene, 165–67, 181–82
Goldberg, Whoopi, 194
Goldfarb, Brian, 134
Goldring, Allen, 122–23, 124, 152,
 plates 24, 34
Goldring, Lola, 122, *plate 34*
Gonzalez-Torres, Felix, 178
Goodrich, Lloyd, 96, 181
Gorchov, Ron, 128
Gorky, Arshile, 80, 97
Gornik, April, 158
Gran Fury, 168
Graves, Nancy, 74, 75, 86–87,
 93, 111
Greenberg, Clement, 82, 85
Grotowski, Jerzy, 73
Gumpert, Lynn, 158

Haggerty, Mick, 200
Haldeman, H. R., 122
Hammons, David, 172
Hanisch, Carol, 89
Happenings, 74
Harris, Bertha, 144
Harris, Betty, *plate 36*
Hartfield, John, 134
Hartley, Marsden, 75, 101
Hawks, The, 49
Heiss, Alanna, 75
Held, Al, 160
Helms, Jesse, 179

Hendon, Cham, 131
Henri (boyfriend), 14–25, 26, *plate 7*
Herring, Oliver, 201
Hess, Tom, 58
Hesse, Eva, 74, 83
Hesse, Herman, 63–64
Hill, James, 142
Hines, Kent, 139–41, 164, *plate 18*
Hofstadter, Douglas, 129
hooks, bell, 91
Hopkins, Henry, 115–16
Hopps, Walter, 54
Hotzman, Ellen, 167–68
Howald Collection, 75
Hsieh, Tehching, 162–63, *plate 25*
Hudson, Rock, 164
Hughes, Robert, 171
Humphry, Derek, 192
Hyppolyte, Jean, 160

Institute of Contemporary Art (Tokyo),
 124
Institute of Fine Arts, New York University,
 40, 48–49, 59, 67, 85–87, 88, 193
Iolas, Alexander, 53
Irwin, Robert, 116
Izzy Young's Folklore Center
 (New York), 31

Jackson, Harry, 37, 46–47
Jackson, Jesse, 122
Jeanne-Claude, 54
Jenney, Neil, 129
Jensen, Alfred, 130, 160
Johnson, Philip, 68
Johnson, Ray, 102
Jonas, Joan, 74, 89–90
Judd, Donald, 54

Kant, Immanuel, 83
Kaprow, Allan, 74
Kaufman, Jane, 66–67, 93, 201,
 plate 12
Kennedy, Florynce, 91
Kennedy, Jacqueline, 148
Kertess, Klaus, 110
Kitchen (theater space), 99
Koons, Jeff, 172

Kramer, Hilton, 83, 109, 114, 161
Krasner, Lee, 93, 104–5
Kruger, Barbara, 172
Kuspit, Donald, 161
Kwartler, Michael, *plate 18*

Labor of Love, A (exhibition), 201–2
Larson, Kay, 172
Le Dray, Charles, 201
Le Va, Barry, 74, 84, 111, 160
Lehman, Arnold, 171
Leonard, Elliot, *plate 20*
Leval, Susana Torruella, 148
Lewis, Joe, 123
Lichtenstein, Roy, 71
Lieberman, William, 33, 36
Limborch, Hendrik van, 22
Lindquist, Frank, *plate 36*
Lioni, Mannie, *plate 18*
Lippard, Lucy, 93, 160
List, Vera, 113–14, 128, 135–36, *plate 27*
Livingston, Jane, 102
Logan, Susan, 123, *plate 19*
Long, Richard, 74
Lopez-Rey, José, 59
Lou, Liza, 29–31, 199–204, *plate 32*
Louvre, 22
Loving, Alvin, 93
Luce, Clare Boothe, 130
Luce, Harry, 130
Luce, Henry ("Hank"), 130–133, 135–36,
 145, 151, 152, 165, 173–74, 180, 190,
 plate 27
Luna, James, 172
Lyons, Harriet, *plate 12*

Mabley, Moms, 192
Magritte, René, 53, 54
Manet, Edouard, 176–77
Man Ray, 53, 54, 75
Mapplethorpe, Robert, 179
Marioni, Tom, 74
Martin, Judith, 194
Masaccio, 75
McClennen, James, 187
McGrath, Noel, *plate 36*
McKay, Judith, 186
McNeil, Dean (husband), 139–43, 149–59,

164, 168–69, 190, 193, 195, 200, 202,
 203, *plates 22, 29, 31, 36, 37*
McNeil, Diane (sister-in-law), 154
McNeil, Evadne (mother-in-law), 154
McNeil, Ruby (daughter), 155–59, 168–69,
 176–77, 184, 186, 190, 194–96, 200,
 203, *plates 26, 29, 37*
Merleau-Ponty, Maurice, 83
Mesa-Bains, Amalia, 172
Michener, James, 131
Mighty Oaks Theater Company, 99, *plate 18*
Miró, Joan, 69
"Miss Mannerist" (Tucker), 194, *plate 35*
Mitchell, Joan, 93, 105–7
Miyamoto, Michiko, 124, 169, *plate 19*
Mole, Abraham, 160
Monk, Meredith, 74
Montano, Linda, 162, *plate 25*
Monte, Jim, 81–85, 97, 111, 113
Moraga, Cherríe, 91
Morimura, Yasumasa, 176–77
Morris, Robert, 81–82, 84, 93–95, 111
Morton, Ree, 93
Murphy, Eddie, 194
Murray, Elizabeth, 128
Museum of Contemporary Hispanic Art
 (New York), 172
Museum of Modern Art (New York), 33,
 35, 108, 125

Nanny, Chuck, 176
National Black Feminist Organization,
 91
National Endowment for the Arts (NEA),
 164, 172, 175–77, 179
Natkin, Robert, 58
Nauman, Bruce, 81, 84–85, 102–3, 111,
 139–40, *plate 15*
Nelson-Atkins Museum of Art (Kansas
 City), 129
New Lost City Ramblers, 31
New Museum (New York), 120–37, 143–48,
 155, 157–58, 160–82, 187–88, 190,
 191–92, 194, 196–97, 200, 201–2, 203,
 plates 19, 20, 21, 24, 28, 30, 33, 34, 38
New School for Social Research, 128, 145–46
Newcomer, Peg, 36, 38
Newcomer, Peter, 36, 38

Niblock, Barbara, 196–97
Nilsson, Gladys, 93
Nordstrom, Carl, 47–48
Nordstrom, Jane, 47–48

Ochs, Max, 31
O'Keeffe, Georgia, 96
Olander, William, 167–68
Oldenburg, Claes, 74
Oppenheim, Dennis, 128
Oppenheim, Meret, 53
Orr-Cahall, Christina, 179
Orwell, George, 158
Owen, Frank, 139–40

Paradise Lost/Paradise Regained: American Visions of the New Decade (exhibition), 158
Parsons School for Design, 127
Paxton, Steve, 74
Penrose, Roland, 54
Peraza, Nilda, 160
Performing Garage (New York), 72
PETA, 163
Phillips, Lisa, 190–91, *plate 33*
Piaget, Jean, 160
Picabia, Francis, 53, 54
Picasso, Pablo, 68, 76, 114
Piper, Adrian, 74, 172
Pollack, Jackson, 105
Pretto, Julian, Gallery (New York), 123
Printed Matter, 123
Pryor, Richard, 194
Puryear, Martin, 172

Rainer, Yvonne, 74
Rainey, Dean, *plate 36*
Rand, Yvonne, 188–89
Rauschenberg, Robert, 74
Reagan, Ronald, 164
Redstockings, 88
Reich, Steve, 75, 85
Reichenbach, Hans, 160
Reno, 175
Richardson, Brenda, 116
Richardson, John, 68
Rifkin, Ned, 158
Riopelle, Jean-Paul, 106

Risa, 114–15, 127
Rizzie, Dan, 142
Rock, Chris, 194
Rockburne, Dorothea, 128
Rodgers, Jimmie, 30
Rogers, Roy, 30
Rorimer, James, 79
Rose, Barbara, 111
Rose, Sheree, 177–78
Rosenquist, James, 104
Ross, Cissy, 168
Ross, Leela, 168
Ross, Richard, 168
Roth, Dieter, 53
Rothko, Mark, 86
Rubin, Bruce, 72
Ruisdael, Jacob van, 22

Saar, Betye, 93, 172
Salle, David, 172
Samaras, Lucas, 53
San Francisco Museum of Modern Art, 115–16
Santlofer, Jonathan, 124
Saret, Alan, 84
Sarton, May, 150
Sartre, Jean-Paul, 61
Saslow, James, 144
Schechner, Richard, 72–73
Schnabel, Julian, 158, 172
Schwartzman, Allan, 120, 123, *plate 19*
Schwartzman, Herman, 120–21, *plate 20*
Schwedler, D.F., 193
Sejima + Nishizawa (architects), *plate 38*
Semmes, Beverly, 201
Serra, Richard, 74, 75, 86–87, 111, 140
Serrano, Andres, 178–79, 180
Shapiro, Joel, 84, 128
Sheeler, Charles, 75
Shuster, Rosie, 142
Silverman, Dorothy ("Dora"; mother), 3–10, 13–14, 16–17, 19, 23–24, 26–27, 28, 30, 43, 49, 53, 154, *plates 1, 2, 4*
Silverman, Emmanuel (father), 4, 6–7, 8–11, 13–14, 16–17, 19, 23–25, 26–27, 29, 30, 33, 34–35, 40, 43–44, 45, 49, 53, 100, 108, 145–46, 154, *plates 2, 4*

Silverman, Warren (brother), 4, 6, 8–9, 23, 27–29, 34, 36, 39, 40, 53, 63, 154, *plates 3, 4, 34*
Simpson, Lorna, 172
Simpson, Nancy, *plate 36*
Sims, Lowery, 161
Skrinde, Kirsten, *plate 36*
Slavin, Arlene, *plate 18*
Sloan, Margaret, 91
Smithson, Robert, 111
Snelson, Ken, 98
Sokolnikoff, Katherine, 119
Solinger, David, 77–78
Solomon, Elke, 92–93, 110, *plates 12, 18*
Sons of the Pioneers, 30
Sorrels, Rosalie, 139
Southeast Center for Contemporary Art, 179
Spivak, Gayatri, 169–70
Staley, Earl, 129, 154–55, 158
Steinberg, Leo, 68
Steir, Pat, *plate 12*
Stevens Mark, 129
Still, Clyfford, 86
Studio Museum in Harlem, 172
Supreme Court, U.S., 169
Surls, James, 142
Sussman, Blanche Risa, 114–15, 127
Sweet Briar College, 13–14

Taller Boriqua, 170
Tanning, Dorothea, 53
Temporarily Possessed: The Semi-Permanent Collection (exhibition), 134
Thorn, Joan, *plate 12*
Time of Our Lives, The (exhibition), 191–92
Tin Nyo, Elaine, 176
Trippi, Laura, 134
Tropicana, Carmelita, 175
Troy, David, *plate 18*
Truitt, Anne, 96
Tucker, Michael (husband), 32–45, 46–52, 61–63, 67, 68, *plate 9*
Tuttle, Richard, 84, 111–14, *plate 16*
200 Years of American Sculpture (exhibition), 110–11

University of Rhode Island, 65–66

Venice Biennale (1948), *plate 13*
Venice Biennale (1984), 150, 157–58
Veronese, Paolo, 60

Wagner, Jane, 46
Walker, Alice, 91
Wallace, Michele, 91
Ward, Terry, *plate 36*
Warhol, Andy, 56
Watson, Doc, 29
Watson, Vicki, 180
Watts, Alan, 65
Wegman, William, 175
West, Rebecca, 91
Westermann, H. C., 53, 54
Weyden, Rogier van der, 22
White House, Sculpture Garden, 187, *plate 31*
Whitney, Gertrude Vanderbilt, 109, 118
Whitney Annual of 1972 (exhibition), 95
Whitney Museum of American Art, 76–85, 86, 92–98, 101–19, *plates 14, 16*; New Museum vs., 121, 123, 124, 125, 126, 127, 128, 130
Whitten, Jack, 93
Wilde, Oscar, 120
Wildmon, Donald, 179
Williams, Sue, 176
Wojnarowicz, David, 172
Wolff, Mark, *plate 36*
Women in the Permanent Collection (exhibition), 93
Women's March (1970), 92

Yaddo, 199
Yoakum, Joseph, 93
Yohn, Tim, 99–100, 137, 138, *plate 18*
Young, Mimi, 134
Young Presidents' Organization (YPO), 122

Žižek, Slavoj, 183

credits

The photography credits are as follows: 1–10, courtesy the estate of Marcia Tucker; 11, courtesy the estate of William Copley; 12, photo by Warren Silverman; 13, courtesy The Museum of Modern Art, New York; 14, courtesy the estate of Marcia Tucker; 15, photo by Gianfranco Gorgoni, courtesy Bruce Nauman; 16–17, courtesy the estate of Marcia Tucker; 18, photo by Warren Silverman; 19, photo by Warren Silverman, courtesy New Museum, New York; 20, photo by Charles A. Schwefel, courtesy New Museum, New York; 21, photo by Dirk Rowntree, courtesy New Museum, New York; 22, courtesy the estate of Marcia Tucker; 23, photo by Arnold Newman, Arnold Newman Collection, Getty Images; 24, photo by David Lubarsky, courtesy of Lola Goldring; 25, photo courtesy Tehching Hsieh and Linda Montano; 26, photo by Dean McNeil; 27, photo by Marcia Tanner, courtesy the estate of Marcia Tucker; 28, photo by Catherine McGann, courtesy of New Museum, New York; 29, courtesy estate of Marcia Tucker; 30, photo by Bob Flanagan and Sheree Rose, courtesy New Museum, New York; 31, official White House photo, courtesy estate of Marcia Tucker; 32, photo by Ruby McNeil; 33–34, photos by Lyn Hughes; 35, photo by Dean McNeil; 36, photo by Connie Beckley; 37, courtesy estate of Marcia Tucker; 38, photo by Suzanne DeChillo/The New York Times/Redux.

Text: 11.25/13.5 Adobe Garamond
Display: Trixie Text
Compositor: Binghamton Valley Composition
Printer/binder: Thomson-Shore